THE WEIMAR YEARS
A CULTURE CUT SHORT

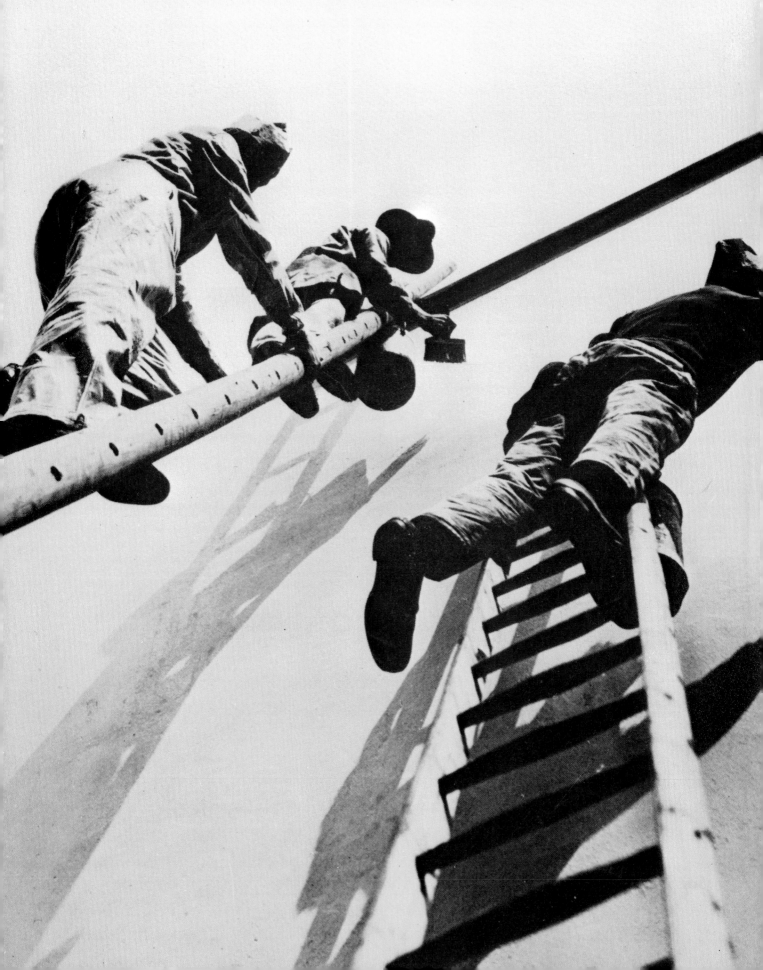

JOHN WILLETT

THE WEIMAR YEARS
A CULTURE CUT SHORT

Abbeville Press Publishers New York

Front cover
Head, a photocollage by Willi Baumeister,
1923.

Back cover
Through Light to Night. John Heartfield's
photomontage shows Goebbels in front of
the burning of the books and the blazing
Reichstag, 1933.

Frontispiece
Bauhaus students in 1926, painting one of
the new staff houses designed for the
school by Walter Gropius. A photograph by
Lux Feininger, himself a Bauhaus student.

Designed by Ruth Rosenberg

Picture research by Alla Weaver

First published in Great Britain
by Thames and Hudson Ltd, London

Text © 1984 John Willett
Illustrations and layout
© 1984 Thames and Hudson Ltd

First published in the USA in
1984 by Abbeville Press, Inc.

Library of Congress Cataloging in
Publication Data

Willett, John.
 The Weimar years.

 Includes index.
 1. Germany – Intellectual life – 20th century.
2. Germany – Politics and government – 1918–1933.
I. Title.
DD239.W44 1984 943.085 83-7243
ISBN 0-89659-409-2
ISBN 0-89659-410-6 (pbk.)

CONTENTS

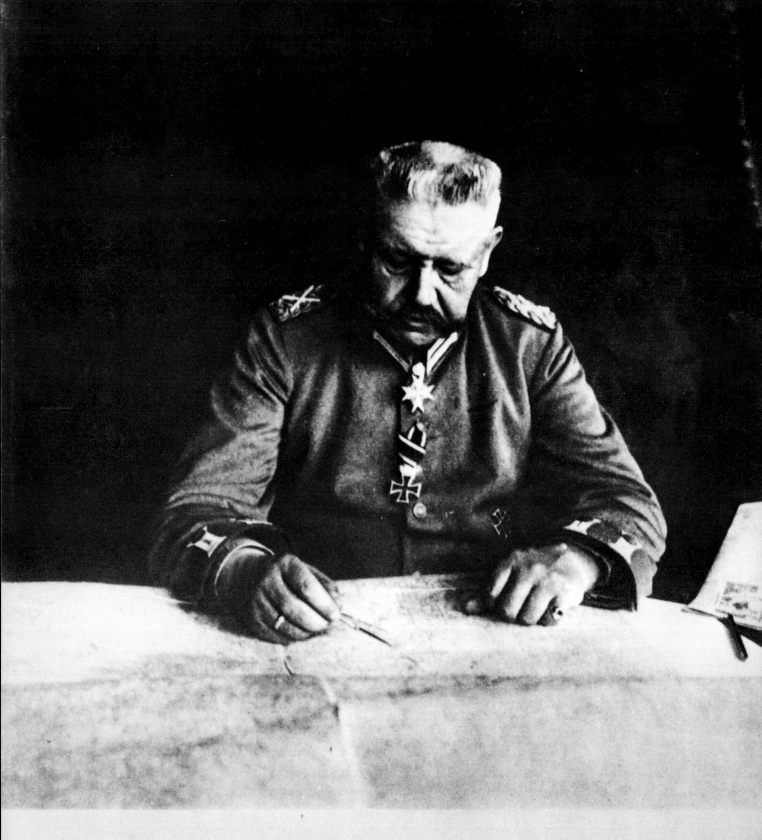

Möge uns der Geist von 1914/15 erhalten bleiben!

von Hindenburg.

INTRODUCTION

In the arts as in politics, the short lifetime of the Weimar Republic was a period of sharp conflicts and contrasts, whose ambiguous history and tragic outcome are still a matter for passionate debate. Known by the name of the city where Germany's first republic was founded and constituted in 1919, yet associated in many minds above all with 1920s Berlin, this clearly defined slice of the twentieth century has a special relevance for us today, above all for anyone concerned with the always controversial relations between politics and the arts. For it was those fifteen years between 1918 and 1933 which saw the fiercest, most concentrated and least one-sided contest between the modern movement in the arts and the primitive-conservative resentments with which it has long had to contend. Fought out at the centre of Europe, it was in its way one of the world's decisive battles. And unhappily it was lost.

The visual, written and phonographic records of these years still act as a stimulus and a challenge; they have a power quite distinct from the usual appeal of such things to nostalgia and fashionable revivalism; even today they raise issues and pose questions. Moreover they retain a certain freshness due to the relative newness of the media in which many of them were conveyed: photojournalism, the documentary cinema, broadcasting and sound recording, all of which were then being developed and practised by some highly original talents. Here, as also in the immediacy of much of the more traditional art, is a rich store of images for the modern eye, mind and ear, and some of them have acquired a quasi-symbolic status. Peter Lorre's look in Fritz Lang's film *M* as he peers at the mark on his back; Marlene Dietrich's swinging legs in *The Blue Angel*; the cigar-smoking, crop-haired young Brecht in his leather jacket; even Christopher Isherwood's giggling Mr Norris in his lavender socks. If such overexposed icons still exert their appeal in the 1980s it is because they have deeper associations.

Any predominantly visual survey of this period needs to have comparably memorable starting and finishing points. We could, for example, begin with the dead Rosa Luxemburg in January 1919 and end with the triumphant Adolf

Field-Marshal von Hindenburg.
From the *Illustrated London News*,
4 September 1915.

Hitler in 1933: Luxemburg, whose murder by the Right went virtually unpunished by Germany's first Socialist government and led to bitter feuding on the Left throughout the period; Hitler, heir to her murderers, a man who might never have come to power but for the feud. At one end the brutal extinction of revolutionary hopes; at the other, the entry of a Fascist leader with a programme of racial purification and national resurgence. Or we could turn to the cinema as being the characteristic new medium of the period, and frame our theme between the sinister fantasies of *The Cabinet of Dr Caligari* (1919), with its mad myopic scientist and splintered architecture, and the communist agitprop of *Kuhle Wampe* (1932) or the realistic pacificism of *All Quiet on the Western Front* (1930): at one end of the scale the demented swansong of Expressionism; at the other the purposeful social criticism that emerged from the more sober years which followed.

For 'Weimar' has various boundary marks according to how you choose to approach it: politically, economically, socially, ideologically, artistically. And one of the excitements for the observer is to see how closely the resulting frameworks seem to coincide with one another, then try to find out why. This however could only be shown by a whole series of images in contrasting pairs such as we have used in the second section of this book (pp. 40–55) to mark the pivotal point around 1922 when the Republic acquired its most distinctive culture. So, instead, we have chosen to mark the beginning and end of the story by showing two aspects of its outward continuity: the opening and closing public images of Field-Marshal von Hindenburg, the great military commander and tactician who presided over the origins of the Republic, retained the nation's respect while more ordinary men governed and then, following his election as head of state in 1925, presided over the breaking up of its democratic system. For it was the immunity and tacit priority given to the views of the German army that so undermined the ideals of the 1918 revolution, first provoking, then eventually frustrating, the cultural rebirth to which these ideals had given rise. There was continuity; but a continuity that bred contradictions.

We start with the portrait made familiar by the First World War: the victor of Tannenberg and the Masurian Lakes, the sixty-eight year old model of decisiveness, authority and military competence. Made chief of William II's general staff in 1916, this bristle-headed bulldog personified a war increasingly opposed by the German artistic and intellectual community, many of whose members it traumatically affected. More equivocally, when defeat followed, Hindenburg thought it wise to let the Socialists take over the responsibility of guiding the country back to peace and accepting the terms dictated at Versailles, but only once he had made sure that they would collaborate with the Supreme Command to put down any threat of Bolshevism such as had emerged from the Russian revolutions of 1917. The German November Revolution of 1918 did indeed at first parallel the Soviets with its system of Workers' and Soldiers' Councils, in which a number of subsequently prominent cultural figures took part, including Erwin Piscator, Carl Zuckmayer and

the student Brecht. Behind the scenes however it was a revolution on licence from Hindenburg and his deputy, General Groener, who soon encouraged the formation of unofficial *Freikorps* (or private armies) of disbanded troops under officers keen to fight foreign Bolshevism and maintain domestic order. While Hindenburg himself went into a dignified retirement it was people like these who murdered the more extreme revolutionary leaders (such as Luxemburg and Karl Liebknecht) and then were given sympathetic hearings by exclusively military courts. From then on the hatreds thus engendered were kept alive by the Communists on the one side and the *Freikorps*'s heirs the Nazis on the other. They explain not only the persistent attempts at further risings over the next four years but also the savage venom which so strikes us in the anti-militarist, anti-establishment art of the German Left right up to the present day.

The experience of the war and the unsettled years that followed was not unique to Germany. All over Europe, and to a lesser extent in the United States too, a whole generation of creative and sensitive people was marked by it for life. But what was special was the extent of the anti-war feeling, which in Germany became stronger and more diffusedly humanitarian from 1916 on till it culminated in a utopian, near-anarchistic Expressionism such as only the Russians perhaps matched. Certainly the hopes and some of the artistic forms of the revolutionary movement seemed almost as high-flown during the first months of Weimar as in Russia or Soviet Hungary around the same time, and its cultural manifestations often were deceptively similar: mass theatre, attempts at 'proletarian culture', posters and pamphlets by sympathetic artists, projects for temples of socialism, rhapsodic odes to Man, and the like. It was just this surface similarity which made the absence of any profounder transformation of the country's social and economic bases such an ironic let-down for the revolution's supporters. Then the hopes turned sour, the forms were deflated, and an uneasy cynicism took their place as their whole foundation crumbled. So the young Brecht in his anti-militarist play *Man equals Man* tells the audience that he

> Hopes you'll feel the ground on which you stand
> Slither between your toes like shifting sand
> So that [the story of the play's hero] makes you aware
> Life on this earth is a hazardous affair

while in his much later autobiography the artist George Grosz notes: 'I felt the ground shaking beneath my feet, and the shaking was visible in my work.' His motto in those days was 'How shall I be thinking tomorrow?'

To such people the realization that socialism was powerless, and democracy just a crust under which the lava of the future reaction was bubbling, was in its way a stimulus. And so were the changes which took place in the actual establishment of the arts. Here again the immediate effects of the revolution were not unlike what happened in Hungary and Russia, and this too helped to create a slightly misleading sense of kinship between the artistic avant-gardes in all three countries. For the 1918 revolution transferred many of the chief galleries, theatres, opera houses and art schools from the old imperial, royal

and petty princely patrons to the new provincial state authorities, and thereby gave an immediate boost to the chief modernists of 1918–19. Indeed it created what seemed an amazingly widespread acceptance of modern art, music and theatre, at first of a predominantly Expressionist kind. So all over Germany pre-1914 modernists like the Brücke and Blaue Reiter artists entered the museums, and Georg Kaiser and Ernst Toller the theatrical repertoire. At Weimar itself moreover the Bauhaus was set up in 1919 as a successor to the old grand-ducal art and design schools where a new infusion of modernist teachers would realize the radical conception of art, craft and building which had been hammered out by Gropius and others in the revolution's Working Council for Art. Expressionism itself declined thereafter along with the early high hopes. But the modernist grip on the 'apparatus' of the arts lasted till the end of the Republic.

The successive stages of this process of disenchantment are fairly clear. All along there had been the Dadaists, who adopted the nihilism of wartime Zürich Dada but then began aiming their explosive anti-art mainly at political targets, the military first and foremost. By the middle of 1919, when the Weimar Constitution was approved and the Munich Soviet suppressed, the limits of the November Revolution had become plain enough; within a few months Hindenburg was adding insult to injury by his claim that the German army had not been defeated so much as 'stabbed in the back' by opponents of the war. In the Kapp Putsch of March 1920 some of the *Freikorps* tried to overthrow the Berlin government, which the army refused to defend against them; they were defeated instead by a general strike and a certain amount of armed popular resistance. That year Expressionism and Dada both lost much of their impetus, and the following March Max Hölz's Communist rising in central Germany was put down. Finally in the autumn of 1923 the Comintern's last effort to promote a German Bolshevik Revolution fizzled tamely out, and even Moscow had to admit that with the stabilization of the German economy the social order had become stabilized too. When Hindenburg became president at the beginning of 1925 it was like a formal admission that a restoration had occurred.

Seen in a wider European context such developments may look merely like part of the universal postwar 'return to order', '*le rappel à l'ordre*' in Jean Cocteau's phrase. For elsewhere too the peace settlements were being completed and the tide of revolution falling back, while even in Russia the ending of the Civil War was followed by a New Economic Policy (1921) comparable in some ways to the German currency stabilization. Political control was in most places consolidated or successfully imposed (as in the case of Mussolini's March on Rome, 1922), the immediate postwar confusion ended. And with this went the virtual death of such pioneering movements as Cubism, Futurism and Metaphysical Painting in favour of the new classicism being practised in France by ex-avant-gardists like Derain, André Lhote and Auguste Herbin, or preached in the Italian art reviews. More promisingly there was the machine-based aesthetic elaborated by Amédée Ozenfant and Le Corbusier in the

Paris magazine *L'Esprit nouveau* from the end of 1920 on. This radically funct-ionalist creed aimed not so much to adapt mechanical forms as to re-found architectural and industrial design on the same principles of economy and applied logic as were used in the making of machines.

Up to a point the death of Expressionism fitted into the general consolid-ation and in some ways echoed it, as can be seen from the German avant-garde's interest in the postwar music of Stravinsky and the ideas of *L'Esprit nouveau* and 'Les Six'. But that point can be located, and from then on they di-verged. Thus whereas in the other Western countries the return to order, once achieved, was no longer so creatively stimulating as during the years of tran-sition – and was in effect a mainly conservative phase – in Weimar Germany such events of the mid-1920s as the start of serious town-planning, the Neue Sachlichkeit exhibition at Mannheim, the Bauhaus's move to Dessau, Brecht's arrival to work in Berlin and the founding of the Büchergilde Gutenberg socia-list book club, together lifted the modern movement on to a new level where some of its most exciting works could now be produced. The actual forms ap-plied here had been in evidence for some time; it was the attitude of the movement to the social and technical world around it that had gone a stage further. Some idea of the distance travelled can be got from the second sec-tion of this book, whose pictorial contrasts show more succinctly than any purely verbal criticism the general direction of what was taking place.

It has not always been easy to see this, and for some twenty years after Hitler took over it was rare for anyone but the movement's harrassed survivors to believe that the Weimar culture had anything all that original to offer. Admirers of the Nazis of course dismissed the whole period as reflecting the general moral and racial pollution brought about by the 'November criminals' of 1918, of whom all traces had to be expunged. Elsewhere the ruling interpre-tation of the modern movement seemed hygienically insulated against all mundane considerations (such as machinery, politics, money and the popular audience); except where focused on Surrealism it was based above all on formal criteria; and the centre of its vision until well into the 1950s was still Paris. All the same there was a creeping awareness that by any standards the Weimar Republic had produced a number of unforgettable works of art, how-ever puzzling their relationship to one another. Thus there were Thomas Mann's *The Magic Mountain* and Klee's *The Goldfish*; there was the new German cinema with *Caligari*, *M* and the amazing Lulu of Louise Brooks in *Pandora's Box*; there were *The Threepenny Opera*, Piscator's political theatre and the Pirandello productions staged by Max Reinhardt; there was the world première of Berg's *Wozzeck* in 1925. German architects had realized the International Style, German publishers the works of Rilke and Kafka; as for the Bauhaus, it was already revolutionizing design practice and art teaching throughout the Western world. All this added up to something: but what?

Generalizations admittedly are tricky. There will always be individual geni-uses like Klee who cannot easily be identified with any wider movement; while national affiliations too are often blurred in the arts, as the variety of na-

tionalities among the Bauhaus staff shows. Moreover just because the Weimar period is of such concern to today's world, the exact nature of its contribution has become a matter for debate, and an unsettled one at that. There are still, for instance, relics of the pre-1950s view according to which the primary characteristic of Weimar culture was its 'decadence': something that the Nazis and the Stalinists alike thought deplorable but the more sophisticated West treated as rather amusing, with its aggressiveness and brutality and its undercurrent of erotic perversion. Next came the suggestion that this culture's undoubted vitality, while more impressive than had so far been thought, was not really new: that everything significant in it was due to the prewar modern movement, the new forms evolved by Cubism, Expressionism, the German designers' Werkbund and so on. More recently we have had the neo-Marxist interpretation according to which Weimar was in effect just a phase of bourgeois society in its natural progression from the Hohenzollerns' Second Reich to Hitler's Third; the continuity of its culture being allegedly shown by formal similarities such as emerge if one sets aside all value judgments. In this interpretation the sole truly creditable aspect of Weimar culture was the aggressive campaign launched by some of its representatives against bourgeois society itself, particularly from 1929 on.

But there is also another way of looking at Weimar. This sees something quite distinctive in the sober, technologically conscious approach to the arts and their relation to society which followed Chancellor Stresemann's stabilization of the currency and the ensuing influx of American capital under the Dawes Plan. A wide-ranging change of attitude dominated the arts throughout the second half of the 1920s, and it related less to any formal novelties than to the new material and technical possibilities on the one hand and, on the other, to the easing of international relations which for a few years allowed an active cultural and intellectual traffic with both East and West, such as was experienced in no other country. The third and fourth sections of this book (pp. 56–143) accordingly concentrate on what seems the new hard core of the Weimar culture following the shift of direction recorded in the second section. The third section tries to deal with the various arts or departments of the arts, and to show how the same socio-aesthetic principles visibly affected them all – principles arising from some basic new techniques and the structural methods which they suggested. The fourth section starts with the country and its capital, then shows the degree to which various big cities and social or economic groupings reflected this re-siting of the modern movement on a new level. The homogeneity which characterizes them both looks even now like the possible foundation for a new civilization.

In Germany, alone of the major European countries, the arts at that time seemed to have overcome the -Isms and broken into a new zone. The discoveries made by the prewar pioneers of Cubism, Futurism, Atonalism and the rest were not by any means ignored, let alone treated with hostility as they were to be a few years later; nor on the other hand were they commercially exploited as adjuncts to fashion, as occurred in Paris Arts-Déco. They were

simply absorbed and made use of in the context of a changed society. Here the formal principles of modernism were applied realistically, whether to practical, socially orientated tasks, or to the communication of intelligible statements and messages, whether narrative, objective or socially critical. But if this was a return to realism it had little to do with the Realist movement of the mid-nineteenth century on which both Nazi and Soviet art of the 1930s were so to lean. Rather it was acknowledgment of the concerns of the real world, including some which more idealistic artists (like the utopians at the beginning of the period) would have despised as ugly and ignoble. At the same time this modernism was realistic in another, related, sense, for it took into account economic realities by husbanding its emotions and energies, adjusting its scale of operation to the resources available, and quickly invest-igating any new technical possibilities. Nowhere was this approach more stri-king than in the modern music festivals which Hindemith directed at Donaue-schingen and Baden-Baden, for here the orchestral forces were cut down to chamber proportions, the notes became easier to play and clearer to take in, there were experiments with mechanical music and with the new radio and cinema media; nor were the social implications ever lost sight of. All this par-alleled what was going on in the other arts, even if it cannot easily be illus-trated in this book.

Putting it into the conventional language of modern art criticism we can start with German Expressionism (1910–22) which incorporated Fauvism, Cubism and Futurism within its own area. Dada (1916–20) then came out of Expressionism, reacted against it and sub-divided in various directions. The French branch, reinforced by Max Ernst from Cologne, was converted into Surrealism (1924–39), whereas the German allied itself with Russian and Hun-garian Constructivism around 1921–2. In Hanover Kurt Schwitters's maverick offshoot was disowned by the Berlin group, whereupon he made contact with De Stijl (c. 1917–23) and continued as the one-man 'Merz' movement till he left the country. Meanwhile the Berlin core split in three: the Secessionists from Dresden who developed a harsh figurative Verism, the more objective Novembergruppe Left, and the Communists – including George Grosz and John Heartfield – around the Malik publishing house who concentrated on ferocious graphic (and photographic) satire aimed mainly at political targets. All three of these subdivisions found their way into Neue Sachlichkeit (1925–9) when this coalesced around the Mannheim exhibition of the same name, which was devoted in the first place to the new realistic socially critical paint-ing. There they were brought together with certain Munich artists who had shied away from their own earlier Expressionism in the direction of the neo-classical Italian art favoured under Mussolini; this southern wing of the ensu-ing movement was called Magic Realism and generally avoided social com-ment. The combined result was a wide range of coolly figurative art embrac-ing anything from Otto Dix's unflattering Verism to Georg Schrimpf's placid Italianate figures. Only certain Magic Realist still-lifes bore even the remotest relation (via the common Metaphysical heritage) to the Surrealism practised in France.

'Neue Sachlichkeit' then was a term coined to describe the 1925 exhibition, and it is often translated as 'New Objectivity' though this is not very exact. Like 'Expressionism', it began as a critical description of a new attitude in painting, but quickly started to be used to cover manifestations of the same spirit in the other arts: that is, for functional architecture, unembellished design, Hindemith's and Kurt Weill's utilitarian music (or *Gebrauchsmusik*), the down-to-earth verse of Brecht, Kurt Tucholsky and Erich Kästner, even for detective stories and children's books. Like Expressionism and Dada it differed from other -Ismic terms by signifying a changed approach rather than a new formal language, and indeed most of its forms derived from the movements that went before. What was distinctive about it – and equally so in all the arts – was its playing-down of the artist's personality in favour of a new concern with the collectivity and the changing realities of modern society. Thus it accepted new techniques like photography and sound recording, along with the new emphasis consequently given to documentation and factual reporting, treating them not so much as extensions of its possible market, but as major creative challenges which would leave no aspect of art untouched. From this stemmed not only its interest in the documentary approach – which extended to writing and the theatre, as well as to the latest mechanical and collective media – but also its use of a new structural principle for selecting and sticking together the elements of an increasingly overpowering recorded reality. Based ultimately on the dissective analytical researches of the prewar Cubists, the result was various types of montage.

The practical simulus to this striking new sobriety of the Weimar culture was the economic revival which took place following the influx of American money. It was this, most directly, which led to the great rehousing drive and the development of a socialist architecture by men like Ernst May and the former utopian Bruno Taut, and allowed Berlin for a time to support three opera houses, one of which under Otto Klemperer became a centre for modern opera that is exemplary even half a century after. There was not only a tradition of patronage based on the old German concept of *Bildung* – or the formation of a cultured and civilized humanity – but there were also enough newly rich or newly powerful groups and individuals exercising this to make for a kind of modern thrustfulness that was far less evident in France or England: creative patrons such as the Erfurt shoe manufacturer Alfred Hess for instance, the grain merchant Felix Weil, who founded the Frankfurt Institute for Social Research, or the Book Printers' Union whose Büchergilde Gutenberg published the works of B. Traven. Such support for the arts had always been decentralized in Germany, thanks to the historical development of the country out of a large number of linked states, many of them quite small but still boasting their own court theatres and orchestras. Partly because of this, the cultural modernization of Weimar Germany was not confined to Berlin or to socialist-run Prussia but spread, as we shall try to show in the fourth section (pp. 110–143), far and wide into the provinces. Obviously it was an urban culture without much influence on, or understanding of, what was taking place outside the major towns. But with that one politically vital proviso it reached

surprisingly deep, giving a lift to a great number of second- and third-grade artists and changing many aspects of everyday living: the kitchen arrangements, the cult of sunbathing and physical exercise, even the use or otherwise of capital letters and gothic type.

In the summer of 1930, only three years before Hitler began his ruthless demolition of the whole Weimar system – from its trade unions right down to its typefaces – the 'Red Count' Harry Kessler showed Aristide Maillol round Ernst May's new developments in Frankfurt, where nearly a tenth of the population had been rehoused since 1925. The ageing French sculptor was bowled over by the beauty of the young swimmers and sunbathers of both sexes and their 'unabashed nudity', then went on to praise the new architecture of the Römerstadt estate, which was both modern and humane to an extent that he had never experienced before. Such advanced rehousing, so Kessler told him, and the assumption of physical freedom were two aspects of a single process: 'This German architecture cannot be understood unless it is visualized as part of an entirely new *Weltanschauung* [world view].'

Yet by then the collapse had already begun. Stresemann, perhaps the single most important check to German nationalism, had died, and the Wall Street crash, happening at almost exactly the same moment, was making the country's American investors call in their loans. Unemployment rose steeply – from under two million in 1929 to over three million the following spring and nearly four and a half million by the end of 1931 – leading to a spectacular resurgence of the Nazi party, which had been lurking ineffectively in the shadows since the failure of its 1923 Munich 'beer-cellar *putsch*'. At the beginning of 1930 the first Nazi entered a state government and began a minor campaign against Bolshevist, decadent and non-Aryan art; in March the Socialists withdrew from the Reich government, leaving the way clear for Hindenburg and his new chancellor Brüning to start by-passing parliamentary democracy and ruling by emergency decree.

The financial, political and cultural developments which followed were aspects of a single disastrous process. It was the economic cutbacks which stopped Frankfurt's ten-year rehousing programme when barely half fulfilled and killed off Klemperer's Berlin opera; it was the right-wing backlash which caused the sacking of Walter Gropius's successor Hannes Meyer from the Bauhaus, the bankrupting of Piscator's second company, the obliteration of Oskar Schlemmer's Weimar murals, and the cancelling of two of Ernst Barlach's war memorial commissions and other important modern works. This two-pronged assault against many of the major outposts of the new culture from 1929 on would doubtless anyway have driven the avant-garde artists to take a firmer political stance. As it was however the Communists among them had already started to become more militant as a result of their party's campaign against the Socialists, and of the founding of the new, aggressively 'proletarian' cultural groupings in Russia. As early as the winter of 1927–8 the Left were thus splitting off from Neue Sachlichkeit to found their own alternative culture which sought its outlets outside the established bourgeois appara-

tus of theatres, concert halls and the like. Even when it turned out that the Nazis rather than the Social Democrats were the real enemy, this new closed culture felt safe in its positions and confident of being able to fall back securely on the USSR.

The last section of this book deals therefore not merely with the savage confrontations that led up to Hitler's chancellorship but above all with this politicization of a significant part of the avant-garde: a late development which, while politically ineffective, had important effects on the forms and practical framework of the arts. Thus of five artists later referred to by Brecht as having 'taken up the cause of the People, which had been abused in the [First] World War and not compensated under the Republic', only Grosz and Piscator had created exciting political art before the crash; Hanns Eisler's militant choruses, Heartfield's topical photomontages and Brecht's own didactic plays and sketches all arose, as did the new political cinema, in Weimar's last few years. Whether any less uncompromising and self-sufficient attitude on the part of the artists concerned would have helped heal the fatal split with the Socialists is open to debate. But as it was, nothing did, and so it was easy for anybody who had campaigned against the counter-revolution after 1918 and seen the restoration of military power as a betrayal of the Republic to claim that his worst fears were coming true. He could look sadly at our last image of the old but still uniformed and bemedalled president sandwiched between the two Nazi leaders, think back to the first, and say 'We told you so'.

Fifty years after that picture was taken the story remains a fascinating one, with much more shape and drive to it than has the usual history of the modern arts. But alas, it has to be judged by the outcome, and this was the almost complete extinction not only of the Weimar culture but of the entire modern movement in the arts over a widening area of central Europe: something that coincided fatally with a similar operation in the USSR. Some attempts, certainly, were made in Nazi Germany to preserve aspects of modernism from the deliberate campaign against it, as manifested in the burning of the books, the shows of 'degenerate' art and music, and the conversion of the Dessau Bauhaus into a party school, complete with cornices and other embroideries to hide its once functional architecture. What is more, some of the artists concerned stayed on, though it was difficult if not impossible for them to continue working in the same style. Only in the most superficial analysis was there any continuity between Expressionism or Neue Sachlichkeit and the Nazi culture that followed, with its ponderous music, its heavy classical architecture, its slick, often old-masterly naturalistic painting, its hearty or heroic films and the glossy productions of what became known as the 'Goering theatre'. The whole spirit, purpose and social attitude was different, and if we look for the causes it becomes difficult not to blame the skin-deep democracy of the Weimar Republic and its suicidal tendency to uncompromising confrontations in art and politics alike.

That this tendency also had its very positive, artistically fruitful side does not make it a model for unquestioning imitation today. Admittedly the social

and technical awareness shown by the Weimar artists was what made the second half of the 1920s so remarkable, just as it was the underlying political tensions that helped keep their creative nerve so taut. Admittedly, too, the wholly committed political art that emerged at the end of the decade was based on new thinking not only about art forms but about the whole cultural 'apparatus', to an extent that can still surprise and stimulate students in our own time. All along there is much to be learned from the period, not least the changed view of Germany which it can give anyone brought up on the old clichés about everything 'Germanic' or 'Teutonic'. But if its characteristic attitudes served in such ways to extend and enlarge the arts, their contribution was a great deal less helpful where politics itself was concerned, for the same aggressive 'sharpness' – still a much-favoured quality in the arts in both Germanys today – which enlivened the former also helped to keep the anti-Nazi forces divided. Nor was this the only way in which Weimar culture contained the seeds of its own destruction, for despite all its concern with diffusion and accessibility it proved to have remarkably little support once the Nazis got to work. Never before had the ideas of an artistic avant-garde penetrated so widely; never had its members so played down their own egos or done so much to shake up the traditional values of bourgeois cultural 'excellence'. And yet the old grudging resentment against modernism was still there, not far below the surface. Three years of economic stringency and political reaction, and it came to the top once more, far more disastrously than in the heyday of William II.

Such views may strike an echo in those who know my *The New Sobriety. Art and Politics in the Weimar Period* (or its American edition, where the title is inverted), so I should explain that the present book is not simply a pictorial digest of the previous work. Suggested by the publishers but planned and wholly written by me, it includes 267 new illustrations and directs its view into rather different areas. Thus it concentrates entirely on Germany, leaving the important contributory currents from France in the early stages and from Soviet Russia throughout for the reader to find out about elsewhere. It starts slightly later but pays more attention to the far from sober art of Weimar's beginnings: to utopian Expressionism and the like. Even more than before, its main emphasis is on the central interlude, where it illustrates certain further aspects which were neglected in the previous book. It does however divide the story up in the same way: an unsettled beginning, a pivotal moment of change, a few years of sobriety when Germany seemed to have found the middle of the road, then its mounting crisis which ushered in Hitler's Third Reich by demolishing many of Weimar's best features. Increasingly this seems to be a warning for our own time.

The Brecht poem on p. 19 is from his *Poems 1913–1956*, © 1976 Eyre Methuen Ltd. It was translated by Frank Jellinek.

Give up your dream that they will make
An exception in your case.
What your mothers told you
Binds no one.

Keep your contracts in your pockets
They will not be honoured here.

Give up your hopes that you are all destined
To finish up Chairman.
Get on with your work.
You will need to pull yourselves together
If you are to be tolerated in the kitchen.

You still have to learn the ABC.
The ABC says:
They will get you down.

Do not think about what you have to say:
You will not be asked.
There are plenty of mouths for the meal
What's needed here is mincemeat.

(Not that anyone should be discouraged by that.)

BERTOLT BRECHT, 1926

Upsurge and aftermath 1918–20

In no country did the experience of the First World War leave a more lasting cultural trauma than in Germany. First and foremost it hit those who served at the front, where artists like Dix and Max Beckmann, writers like Toller, Gottfried Benn and Zuckmayer, as well as others like Gropius, Eisler and Piscator were marked by it for life. Secondly there was the mounting antiwar campaign conducted at home by the activist wing of Expressionism from the middle of the war onwards; this resulted in a highfalutin humanitarian poetry very unlike the more directly personal war poems then being written in English. Finally there were the internationalist pacifists in Zürich and Geneva, ranging from the German Dada contingent to such establishment figures as Count Harry Kessler and Stefan Zweig. Through the resulting mixture of hopes and hatreds, brought to near boiling point by the Russian revolutions of 1917, ran a clearly marked distinction of age, for those most deeply affected were born between roughly 1885 and 1895 and some of the student Dadaists were younger. This became the twenty-to-thirty-five-year-old generation that gave its particular character to Weimar culture.

The initial hopes were high, and their imprint is seen in many of the utopian and Expressionist conceptions which follow. It is even more evident perhaps in the rhapsodic verse of men like Franz Werfel, Johannes R. Becher and Walter Hasenclever, which filled the new fat literary anthologies, or in the lofty and humanistic plays that now for the first time reached the German stage. All the more disastrous was the disillusionment which followed, only months after the armistice and Germany's November Revolution, when it became clear that the new Socialist leaders were concerned first and foremost with law and order, and that the same old military establishment would remain at the other end of President Ebert's private line. The shock might have been less intense if the civil authority had been more firmly in control, but it was the army who tolerated the irregular counter-revolutionary forces and judged their excesses with a leniency never shown to the Left. Thus Toller, for his share in the Munich Soviet, did a harsh five-year term in prison, whereas even Hitler, for his leadership of the 'beer-cellar *putsch*' in the same city was released after nine months spent in much easier conditions, while ex-officers (like those who helped murder the Spartacist leaders in January 1919) were let off more lightly still.

'Expressionism', wrote the internationalist Iwan Goll, 'was a great and noble cause. Solidarity of the intellectuals. Parade of the sincere. But the result, alas, by no fault of the Expressionists, is the German Republic

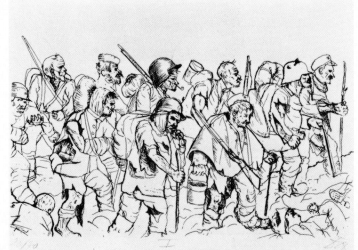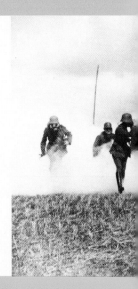

1920.' Hence the conclusive title of his essay: 'Expressionism is dying'. Some, like the Dadaists, had never shared its idealism and were delighted to see it go. But they too ran out of steam after their Berlin Dada Fair, except in so far as they had already grouped themselves round the Malik publishing house, a centre of aggressive left-wing satire, or could maintain an equally ruthless anti-militarist line. This was where the much cooler, machine-conditioned ideas of the Constructivists became influential, whether derived from preliminary reports from Russia or demonstrated by the Hungarians who had emigrated to Germany following Admiral Horthy's successful counter-revolution in their country in late 1919. The commonest reaction for anyone who, like Dix and Felixmüller, had been through an Expressionist phase was a down-to-earth socially critical Verism, often using a harder-edged version of the old angular expressive distortions. This became the main element in that new naturalism with a social twist on which such 1920s critics as Paul Westheim and G. F. Hartlaub now remarked. Meanwhile in the other arts the influence of neoclassical music and jazz were also beginning to make themselves felt, though there was still something of a vacuum in writing, where nothing much had come along to replace the exhausted Expressionist mode.

An immediate reaction to the First World War, like Kirchner's 1915 self-portrait with his imaginary wound (*opposite, left*), was a rarity in German art, perhaps because the conventions of Expressionism made it difficult to be direct and precise. More often, as in the case of Dix, whose etching of soldiers adjoins this, the most powerful works came some years later – in this case from the cycle 'The War' which appeared in 1924. Similarly with the poetry, which tended at first to be generalized and rhetorical and only later took a sharper and more satirical form. As for the novelists, it was not till 1928 that they published their major war books, of which Remarque's *All Quiet on the Western Front* made the most impact. Lewis Milestone's film version (*below, right*) shows how the real images of a decade earlier (such as the actual gas attack *below, left*) surfaced in this immensely popular, unpretentious work.

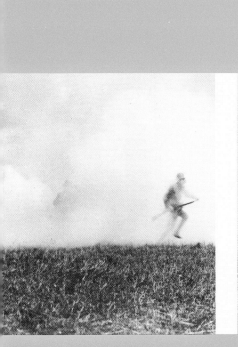
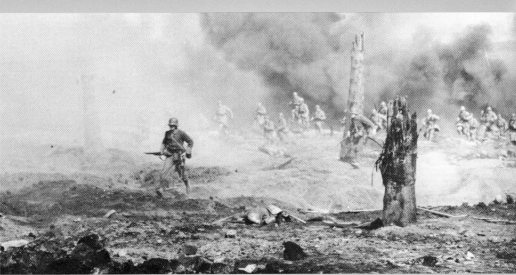

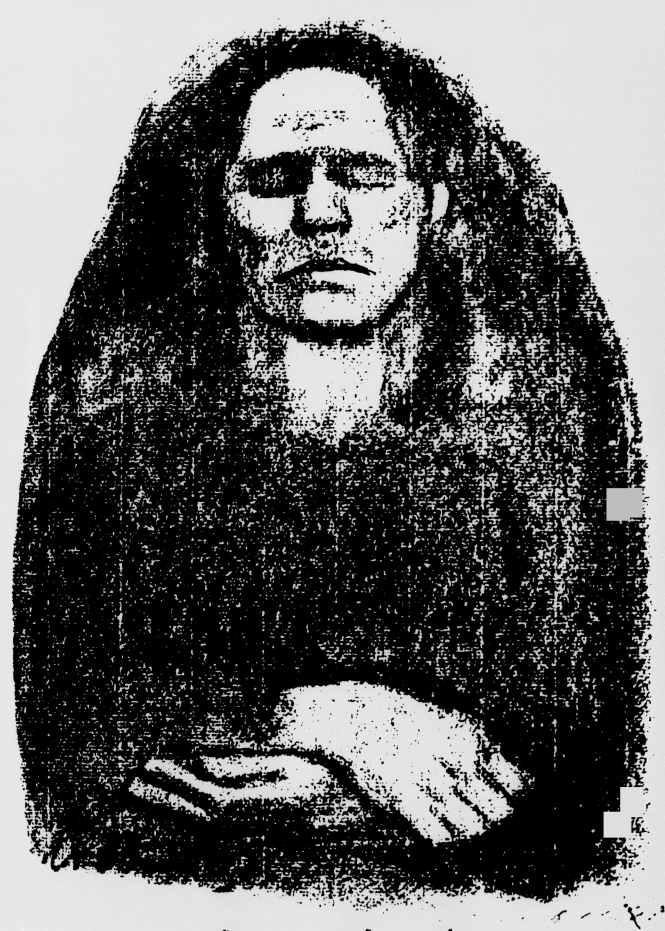

Das Warten

THE WOUNDS OF WAR

The scarred images of the new art. Käthe Kollwitz's deeply humane lithograph *Waiting* (1914), *left*, anticipates the women's war. She herself lost her son Peter in the first months of the fighting. *Right*, Otto Dix's drawing of 1923 seems to relate to Ernst Friedrich's tract *War against the War*, whose photographs (*below*, for example) helped to convince Germans throughout the 1920s that there were closed institutions for soldiers too horribly wounded to be released. The title of Dix's drawing, *Two Victims of Capitalism*, shows how the German Left used this powerful myth: mutilation and prostitution were twin horrors which socialism would in due course diminish.

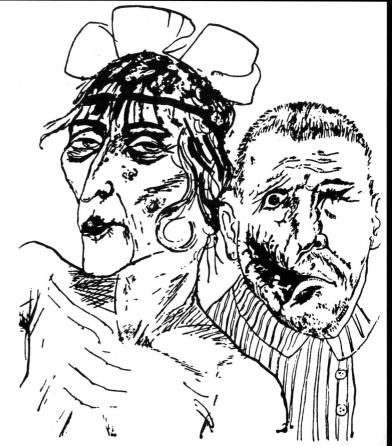

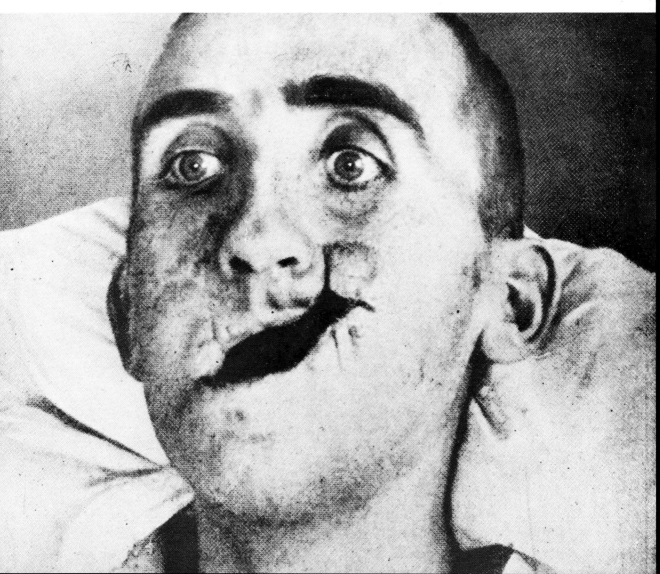

The November Revolution which ended the war was a mixture of romantic gesture (the Mercedes-load of republican insurgent soldiers and sailors seen at Berlin's Brandenburg Gate, *opposite*) and orderly acceptance (as with the largely middle-class crowd *below left*). Artists and writers joined the Workers' and Soldiers' Councils, who set up a quasi-Soviet assembly in Berlin (*bottom right*, photographed on 24 November), and formed their own consultative Working Council for Art, whose verdict on the revolution was an emotional Expressionistic 'Yes' (*top right*). The cover of its manifesto was by Bruno Taut. He, with Gropius, Lyonel Feininger and the critic Adolf Behne, was among its active members.

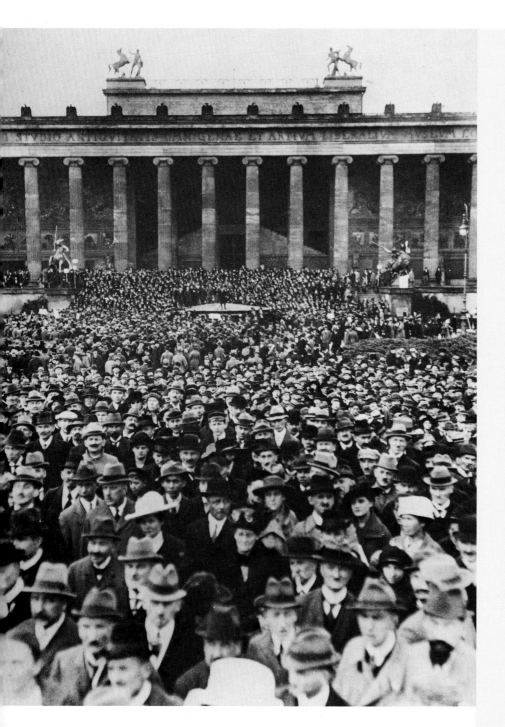

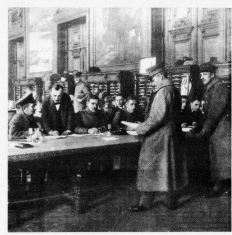

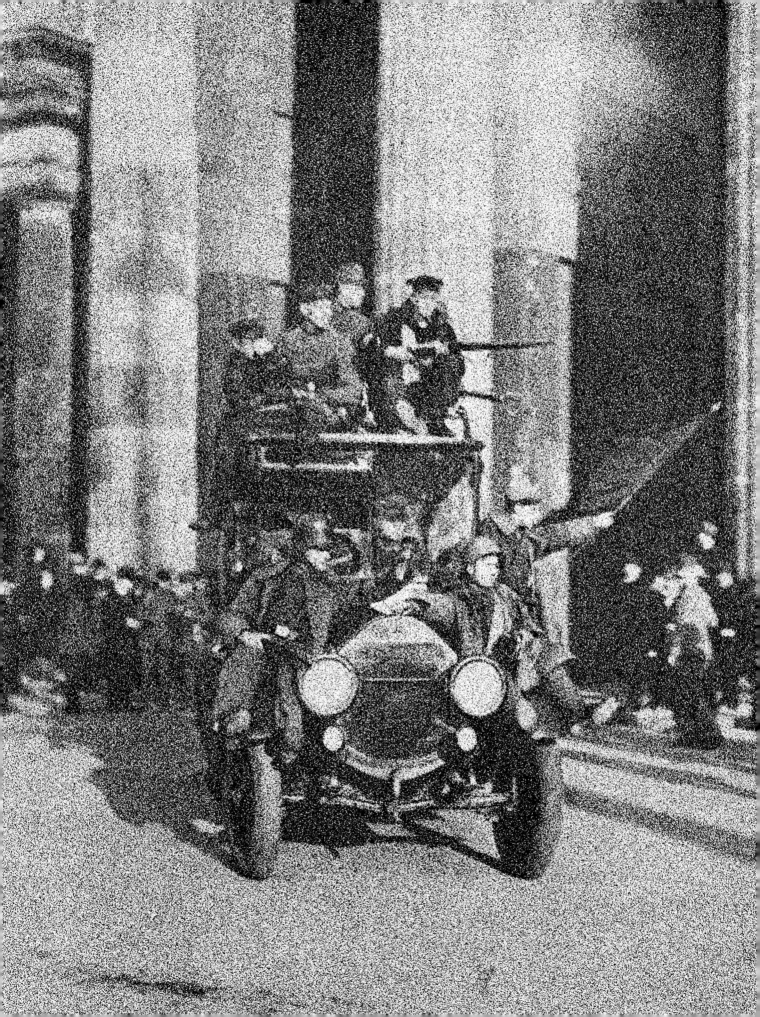

UTOPIA FINDS EXPRESSION

Though the ideals of the Expressionists could as yet hardly be realized materially, they flourished in graphic form. Utopian architects like Hermann Finsterlin (whose *Glass Dream* is *below*) and Bruno Taut (page from *The Dissolution of the Cities*, 1920, *right*) showed their projects under the Working Council's auspices. Taut's odd symbolism of 'phallus and rosette' calls for the use of solar energy, 'ancient wisdom' and 'total frankness in sexual matters'.

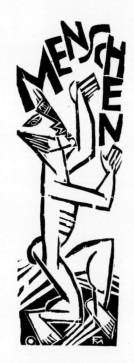

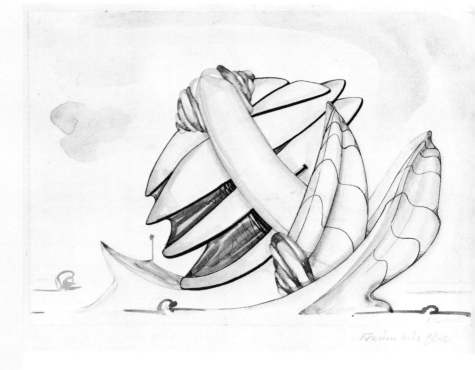

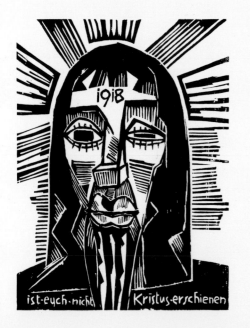

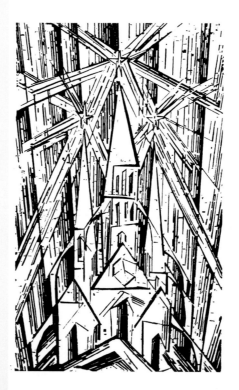

Left and *far left* wood engravings constitute what Johannes Itten's title design (*top left*) calls 'Documents of Utopia'. Thus Felixmüller's cover for *Menschen* (*centre left*) voices the humanitarian cry of the Expressionism of 1916–18; Karl Schmidt-Rottluff of the Brücke group of artists asks 'Hasn't Christ appeared to you?' in 1918 (*bottom left*); Feininger's *Cathedral of Socialism* of 1919 (*bottom right*) was on the cover of the Bauhaus manifesto.

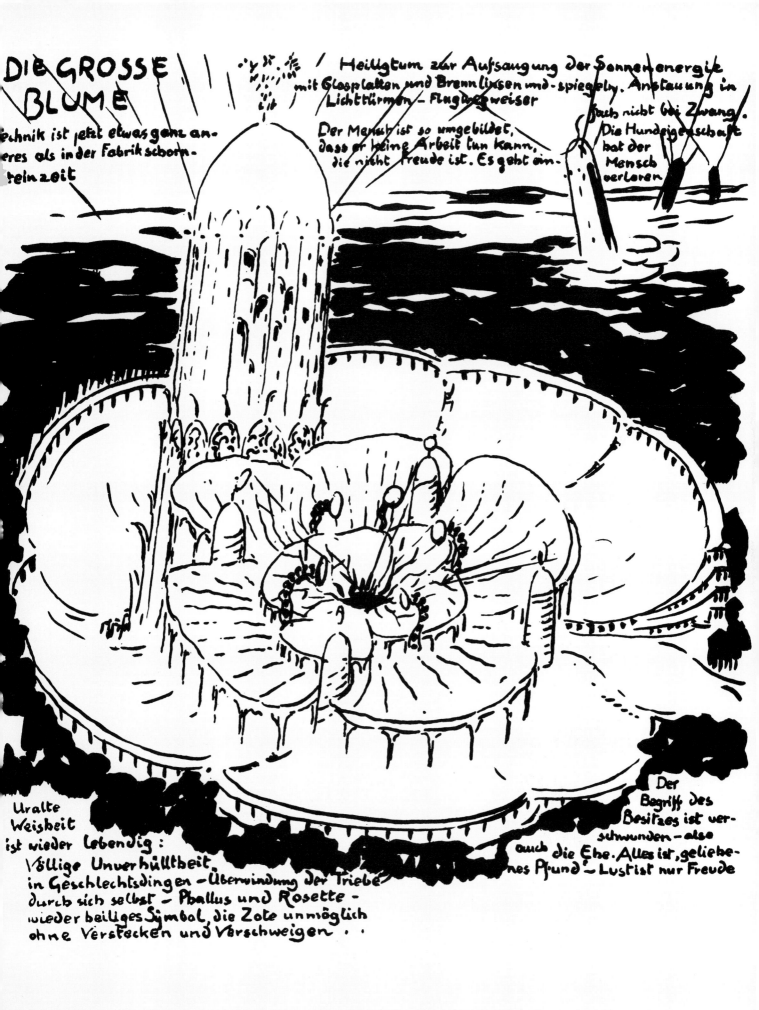

DIE GROSSE BLUME

Technik ist jetzt etwas ganz anderes als in der Fabrikschornstein zeit

Heiligtum zur Aufsaugung der Sonnenenergie mit Glasplatten und Brennlinsen und -spiegeln. Anstauung in Lichttürmen - Flugwegweiser

Der Mensch ist so umgebildet, dass er keine Arbeit tun kann, die nicht Freude ist. Es geht ein-

auch nicht bei Zwang. Die Hundeigenschaft hat der Mensch verloren

Uralte Weisheit ist wieder lebendig: Völlige Unverhülltheit in Geschlechtsdingen - Überwindung der Triebe durch sich selbst - Phallus und Rosette - wieder heiliges Symbol, die Zote unmöglich ohne Verstecken und Verschweigen . .

Der Begriff des Besitzes ist verschwunden - also auch die Ehe. Alles ist geliehenes Pfund - Lust ist nur Freude

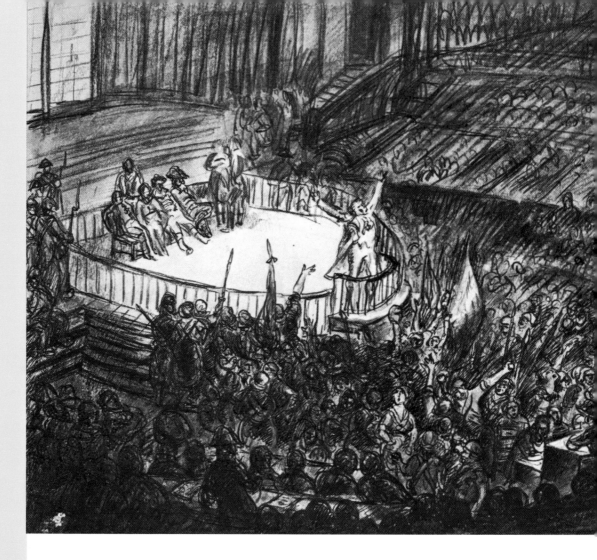

EXPRESSIONISM IN PERFORMANCE

ZWEITES BUCH

DIE ERHEBUNG

JAHRBUCH FÜR NEUE DICHTUNG U. WERTUNG

Though the first Expressionist plays date from about 1912, it was only at the end of the war that they reached the stage. Max Reinhardt's mass theatre in the Berlin Grosses Schauspielhaus paralleled the great Soviet pageants with productions like *Danton* by Romain Rolland (February 1920, *left, above*); the drawing is by Ernst Stern. Ernst Toller's *The Transformation* (September 1919, *left, below*) was a poetic anti-war drama by a leading Munich revolutionary, staged in a small 'proletarian' theatre with Fritz Kortner as its leading actor and sets by Robert Neppach. *Below*, *The Cabinet of Dr Caligari* (1919), the first and most famous Expressionist film, had splintery Brücke-style sets by Walter Reimann and others. By the time such major collective works reached the public, along with the classic anthologies like *Menschheitsdämmerung* (*Dawn of Humanity*) and *Die Erhebung* (*The Upsurge*; *left*) the impetus of the movement on a more individual level had already started to fall off.

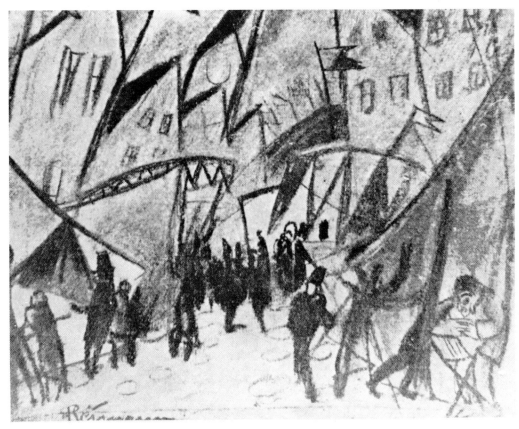

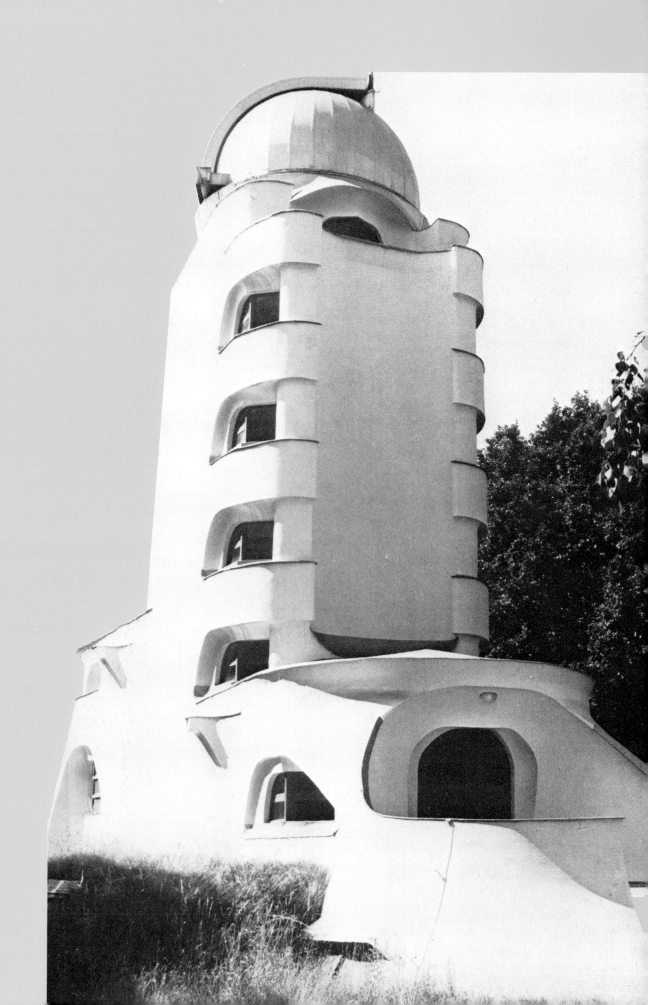

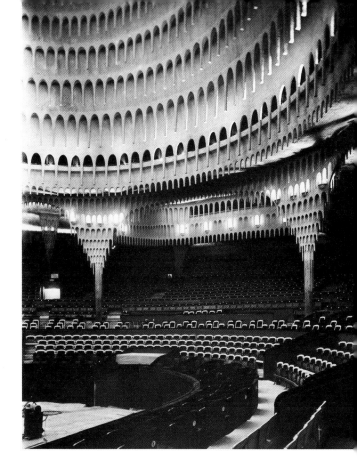

EXPRESSIONISM STARTS BUILDING

Erich Mendelsohn, whose observatory at Potsdam known as the 'Einstein Tower' (*left*) was built in 1920, was a leading Expressionist architect and member of the 'November Group' – an exhibiting body which had fused with the 'Working Council for Art' in late 1919. Hans Poelzig, whose romantic modernism dated from before the First World War, adapted the Schumann circus building in Berlin to make Reinhardt's so-called 'theatre of 5000', the Grosses Schauspielhaus (*right and below*). Here Reinhardt and the director Karlheinz Martin staged their great classical, Expressionist and revolutionary spectacles from 1919 until the enterprise collapsed at the beginning of 1923.

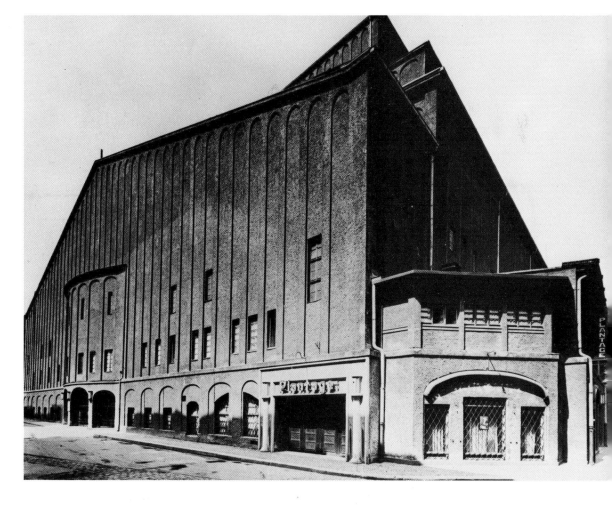

THE COUNTER-REVOLUTION

In Berlin and Munich there were attempts early in 1919 by Communists, anarchists and Left Socialists to complete the November Revolution on more or less Bolshevik lines. Both were bloodily repressed by the irregular *Freikorps* of ex-soldiers sponsored by the army leaders and used as 'law and order' troops by the Social Democratic governments of Germany and its two biggest provinces, Prussia and Bavaria. The effect on progressive artists and writers was searing. In Berlin (*right*) George Grosz's drawing shows an officer of the Reinhardt (*Freikorps*) Brigade toasting the Social Democrat minister Gustav Noske; Kollwitz's sketch for her 'Liebknecht Memorial' (*below*) shows the revolutionary leader just after his murder by *Freikorps* members. In Munich (*opposite page, top left*) Grosz depicts *Time Out in Noske's Republic*; *top right* the police offer a reward of 10,000 marks for the poet Ernst Toller, soon after convicted of high treason and imprisoned for 5 years. The drawing by Heinrich Ehmsen (*opposite below*) shows government troops executing other supporters of the Bavarian Soviet.

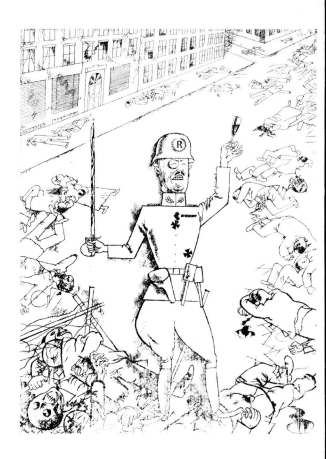

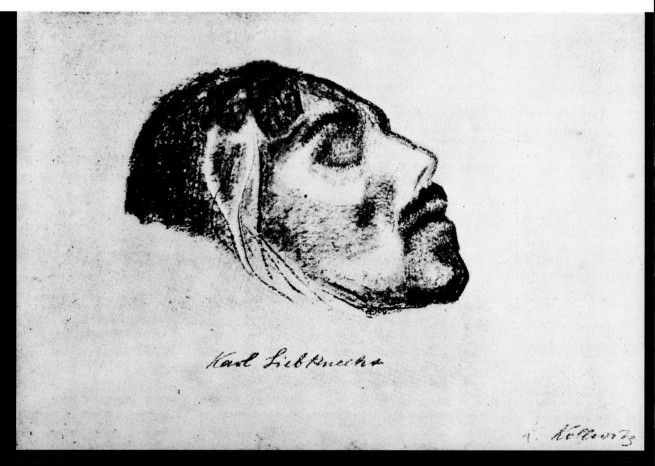

Karl Liebknecht

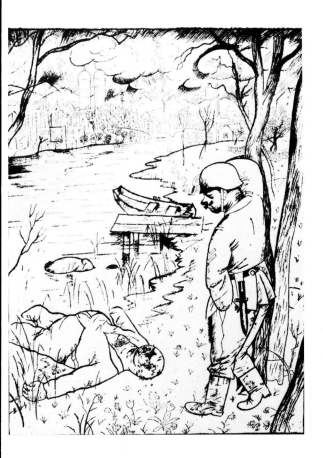

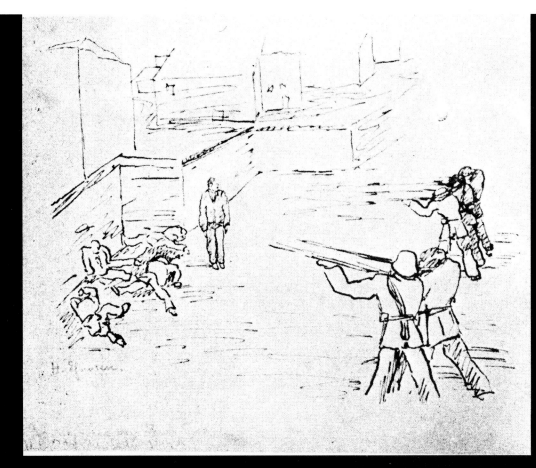

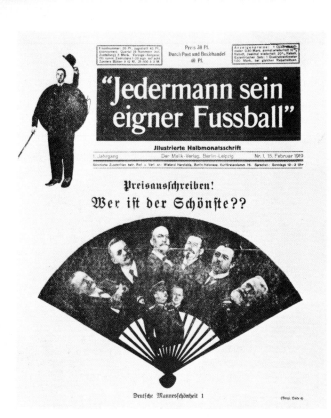

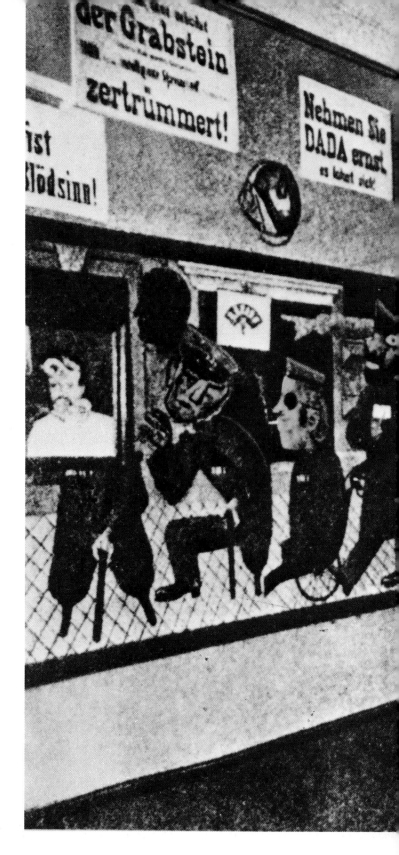

UTOPIA ABANDONED:
THE RESPONSE OF DADA

One of the leaders of the original Dada movement in Zürich, the medical student Richard Hülsenbeck, taught Berlin Dada the generally nihilistic approach to bourgeois art and ideology adopted by the Zürich group. But the Berlin Dadaists, who published the almanac

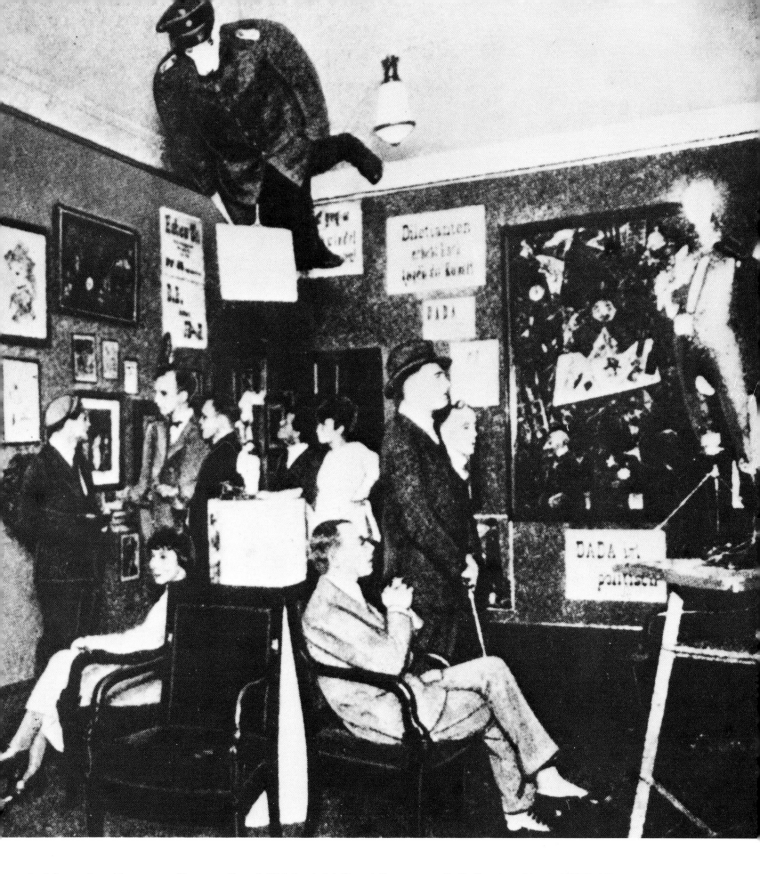

centre left, soon focused on more political targets. At the Berlin 'Dada Fair' of 1920, a stuffed soldier dangled from the ceiling while Dix's war cripples hobbled along the left-hand wall; those present include Raoul Hausmann (in cap, left) and Johannes Baader (with beard),

Hannah Höch (seated, left), and Grosz and John Heartfield (standing, right). At the back is Grosz's socially critical painting of 1919 *Germany, a Winter's Tale*. Meanwhile as Grosz and Heartfield devoted themselves to political polemic (*top left* 'Every Man His Own

Football', a broadsheet of 1919), Hülsenbeck and Hausmann set out, correctly dressed, to spread the Dada gospel further. Both right and left (or 'Malik-Verlag') wings of the movement were concerned in evolving its one major innovation, the use of photomontage.

MECHANIZATION TAKES COMMAND

With Lenin in Moscow preaching the need for 'electrification' and the Russian and Hungarian Constructivists developing a new machine aesthetic, the Dadaists depicted man no longer as an Expressionist martyr, saint or madman but as a faceless, mechanically articulated figure somewhat akin to the dummies painted by the Italian 'Metaphysicals' Chirico and Carrà. Here, *right*, are Grosz and Heartfield at the Dada Fair holding a sign which says 'Art is dead. Long live the new machine art of Tatlin' (Tatlin being a pioneer of Constructivism). To their right, Hausmann's *The* Iron *Hindenburg*: his sword is inscribed 'Blood!' and a shout of 'Victory hurrah!' comes from his megaphone. *Opposite* Grosz's watercolour *Republican Automata*; the bowler-hatted figure waves the republican black, red and gold flag. *Below*: the etched version of Dix's *War Cripples*. All these pictures date from 1920; all incidentally mock the EKI or first class Iron Cross.

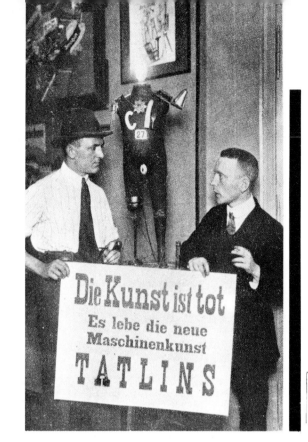

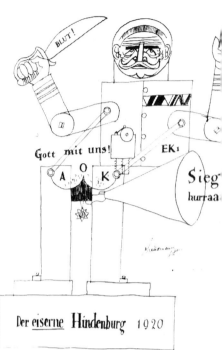

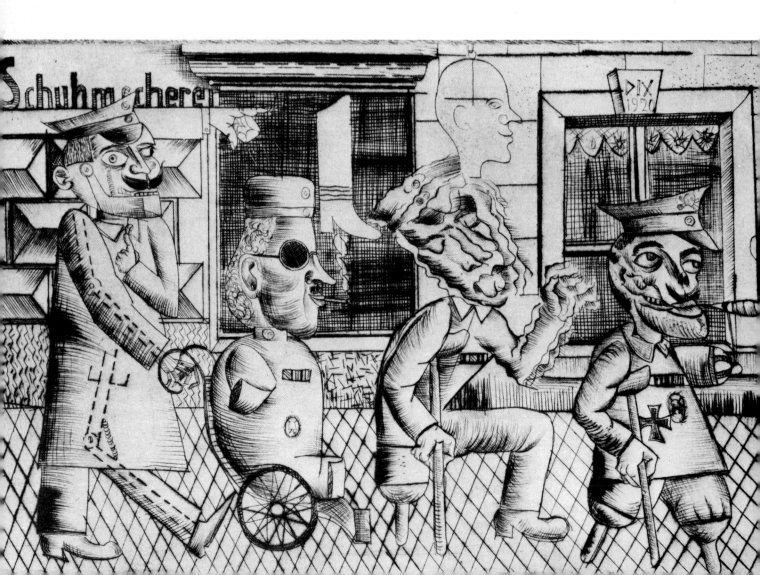

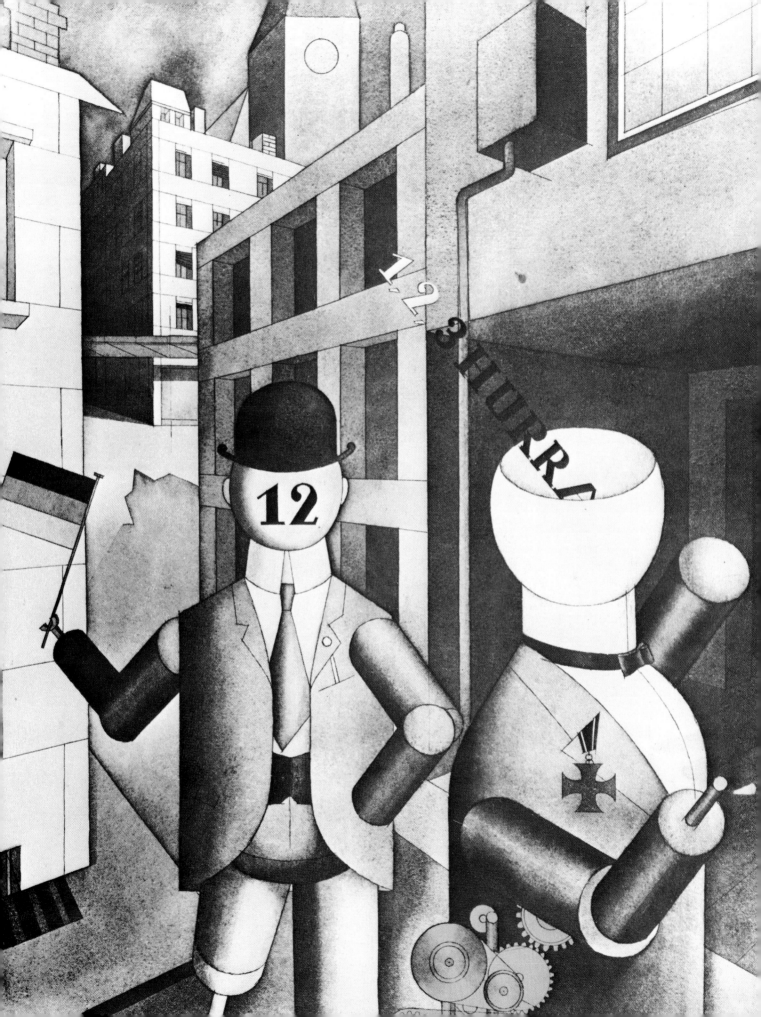

FACING THE NASTY TRUTH

The chilly unflattering Verism to which some former Expressionists turned around 1919–20 was another product of the same disenchantment. Here, *opposite, top left*, is Beckmann's print *The Disillusioned*; after 4 unsettled years the works of Marx and Liebknecht only make them yawn. *Opposite, bot-* *tom left*, is a now vanished portrait of a worker by Dix. *Opposite, right* are two of the artists: at the top Dix himself drawing, by Felixmüller, his colleague in the very socially conscious Dresden Sezession. Below it, a self-portrait by Georg Schrimpf, a supporter of the Munich Soviet: its hardness is interesting in the

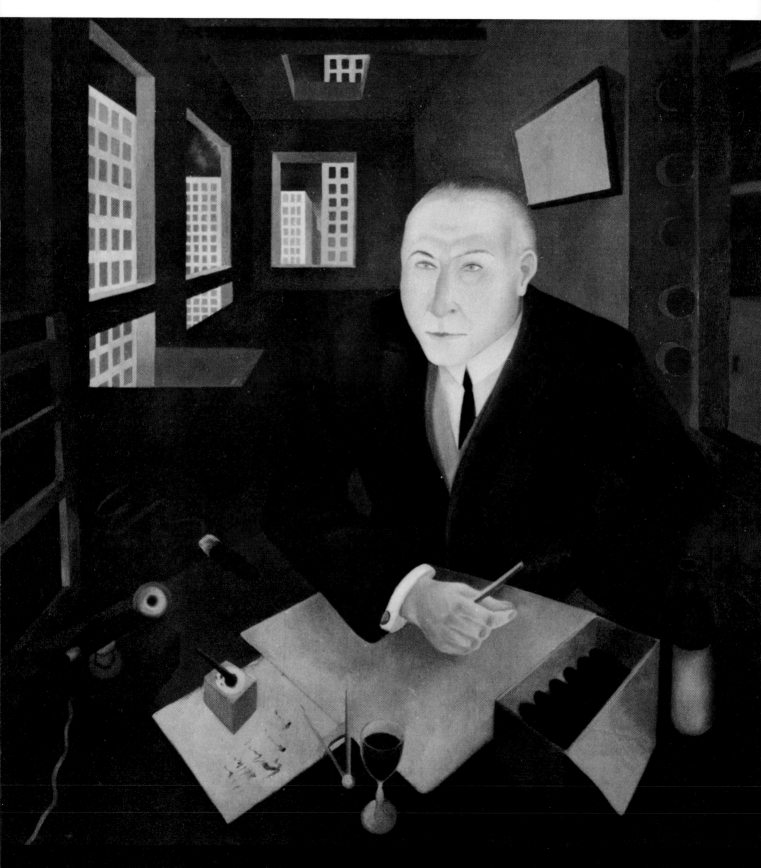

light of Schrimpf's later evolution (see pp. 80–81). Finally, a characteristic figure of this unsettled time: H. M. Davringhausen's *Profiteer*. As in Dix's, Schrimpf's and Grosz's paintings the blank-windowed architectural perspective recalls Carrà.

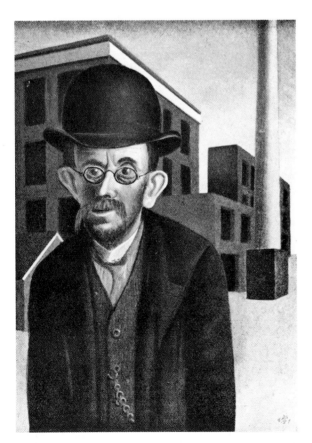

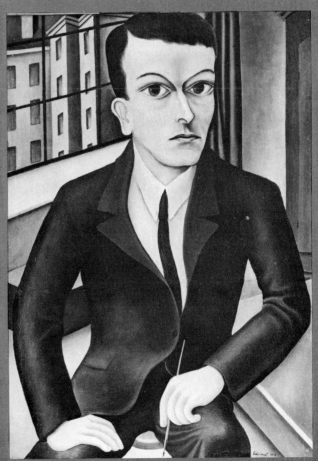

The turning-point 1921–3

The great 'change of landmarks' in Weimar culture was effected within the three years that followed, but it centred on 1922. This was the year of such modern classics as *Ulysses*, *Schweik*, *The Waste Land* and the première of *Drums in the Night*; it also saw the start of public broadcasting and of the film careers of Eisenstein and René Clair, as well as the failure of the 'Congrès de Paris' scheme for establishing the headquarters of the international avant-garde in that city. For the Germans it was decisive in that it saw not only the restoration of normal relations with Bolshevik Russia and an ensuing influx of artists and writers from that country, but also the beginnings of a new policy of cultural exchanges promoted by the IAH (International Workers' Aid) organization founded by Willi Muenzenberg a few months before. This made Germany henceforward the chief foreign outlet for the new Soviet art, literature and films.

The transformation can be seen most concentratedly at Gropius's Bauhaus, which veered sharply away from its mystical-utopian craft-centred beginnings: 'no longer cathedrals but machines for living', as Oskar Schlemmer put it. A new practicality set in, geared more and more to industrial production and social housing. Kandinsky arrived in the autumn of 1922, bringing his knowledge of the new developments in Russia; Lissitzky's follower the Hungarian Constructivist Moholy-Nagy a few months later. During much of the year the Dutch De Stijl movement

was being conducted on the Bauhaus's doorstep, with Van Doesburg exhibiting in Weimar and teaching some of that school's more disgruntled students. The consequent change of orientation – and indeed of philosophy – did much for the school's reputation both internationally and in Berlin; and from then on Gropius insisted that it must be non-political. None the less the simultaneous shift to the Right in national and state politics led to the Weimar Bauhaus's dissolution after the end of 1924, and in this the presence of foreign staff and students was certainly a factor.

In June 1922 Walter Rathenau, the industrialist who had concluded the Treaty of Rapallo with Russia, was murdered by *Freikorps* members. In November the Republic's first entirely non-Socialist government was formed. Soon after, the French decided to accelerate Germany's overdue reparations payments by occupying the Ruhr coal and steel area, and a vast movement of passive resistance ensued. The financial crisis which this caused had two main consequences: first, the reckless inflation of the currency had to be stabilized by calling off the resistance and introducing a new Mark, largely backed (under the plan of a banker called Charles G. Dawes) by short-term American loans; secondly the Comintern in Moscow thought the climate right for a new German revolution, and this was timed to happen only a few weeks after the stabilization. The first operation was a spec-

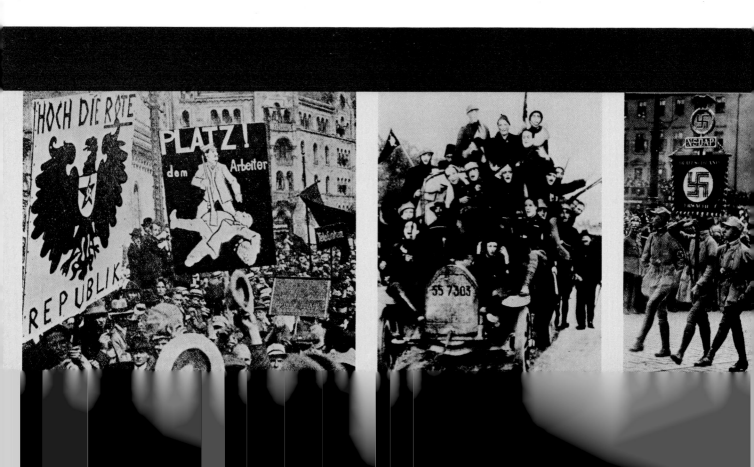

tacular success, determining the recovery of the country for the next five or six years; the second was a flop, leading to a weakening of the extremist parties and the overdue disbanding of the *Freikorps*. So Germany settled down, and the climate for the arts became not only more prosperous but also calmer, giving them a chance to digest the new influences which they had absorbed.

Once again the Bauhaus, in its new custom-built home at Dessau, was symptomatic. But throughout the arts the changes over this three-year period were equally marked, and broadly similar in direction, as our two pages of other examples are designed to show. There were many further contrasts of the same sort as those which we reproduce: Taut's shift from utopian projects to working-class housing, Goll's from the Expressionism of his poem 'The Panama Canal' to the absurdist satire of his short plays; Hans Richter's from Expressionist painter to Constructivist film-maker; Hans Fallada's from the frenzied Expressionism of his novel *Young Goedeschal* to the wry lightness of *Little Man, What Now?*; Toller's from *Masses and Man* to *Hoppla, We're Living!* and so on. Meanwhile some of the more aggressive satirists were losing their edge: Grosz, for instance, whose line becomes increasingly uncertain, or Dix in his progress towards academicism. The way was clear for the first coherent culture based on a recognition of the modern movement.

Some aspects of the turning-point, 1921–3. *Reading from left to right*: a Berlin demonstration against the murder by *Freikorps* members of Walter Rathenau, the liberal foreign minister who made the Rapallo Treaty with Russia (1922); the banners saying 'Up with the Red Republic' and 'Make way for the Worker!' were painted by the ex-Dadaists of the Malik publishing house. Next, Ullstein's *Berliner Illustrirte* reports Mussolini's March on Rome of 1922; a year later Hitler's Nazis too march through Munich at the time of their 'beer-cellar *putsch*'. Next, also in 1922, an international set of Dadaists and Constructivists try to formalize their *rapprochement* at Weimar: the group includes El Lissitzky (in check cap), László Moholy-Nagy (at back), Theo van Doesburg and (seated) Werner Graeff; Sophie Arp, Cornelis van Eesteren, Hans Richter, Tristan Tzara and Hans Arp. Finally, two key exhibitions: the first foreign showing of the new Soviet art at Van Diemen's Berlin gallery and the Bauhaus's 1923 show under the slogan 'Art and technology. A new unity'.

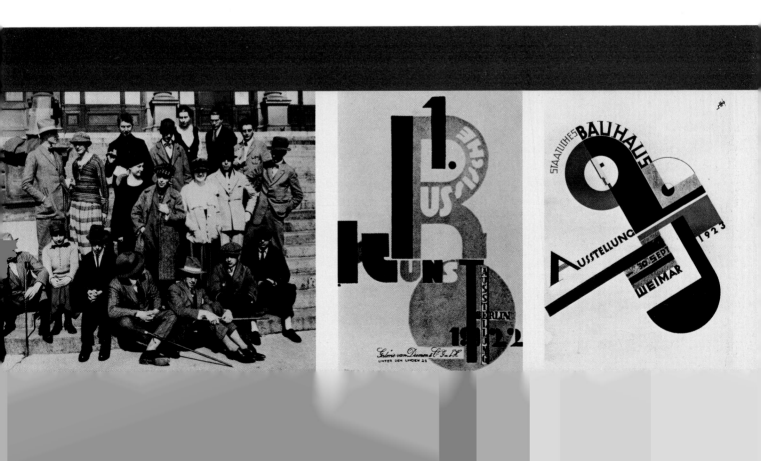

INFLATION: THE LAST STRAW

The inflation of the Mark, which had been accelerating during 1922, got out of all control following the French occupation of the Ruhr steel and coal producing area in 1923. Carl Fernstadt's photograph, *right*, gives some idea of the popular opposition to this forcible insistence on reparation payments overdue under the Versailles Treaty. The vast crowd centres round William I's Victory Column erected after the Franco-Prussian War. The German resistance to the occupation lasted nine months and its effect on the economy was soon disastrous, sending prices throughout the country zooming skywards until the vast bundles of newly printed notes became unmanageable and cash was no longer wanted. *Below right* a worthless thousand-mark note is used as a wine label; *below left*, other notes, one of them a locally printed emergency note for a hundred thousand million, figure in a Dada collage by a recent newcomer, the Hungarian refugee Moholy-Nagy, who had joined the Bauhaus staff in the spring of 1923.

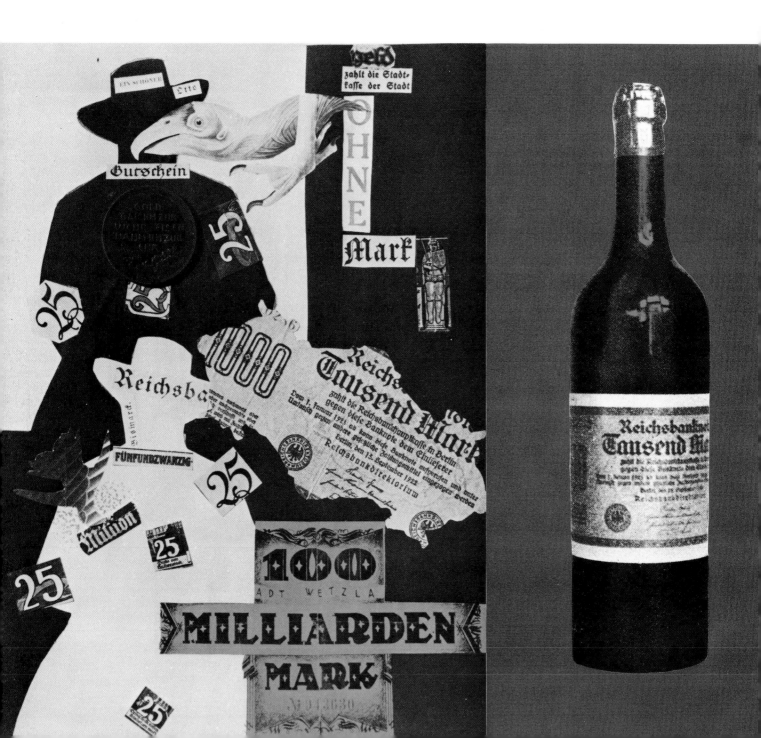

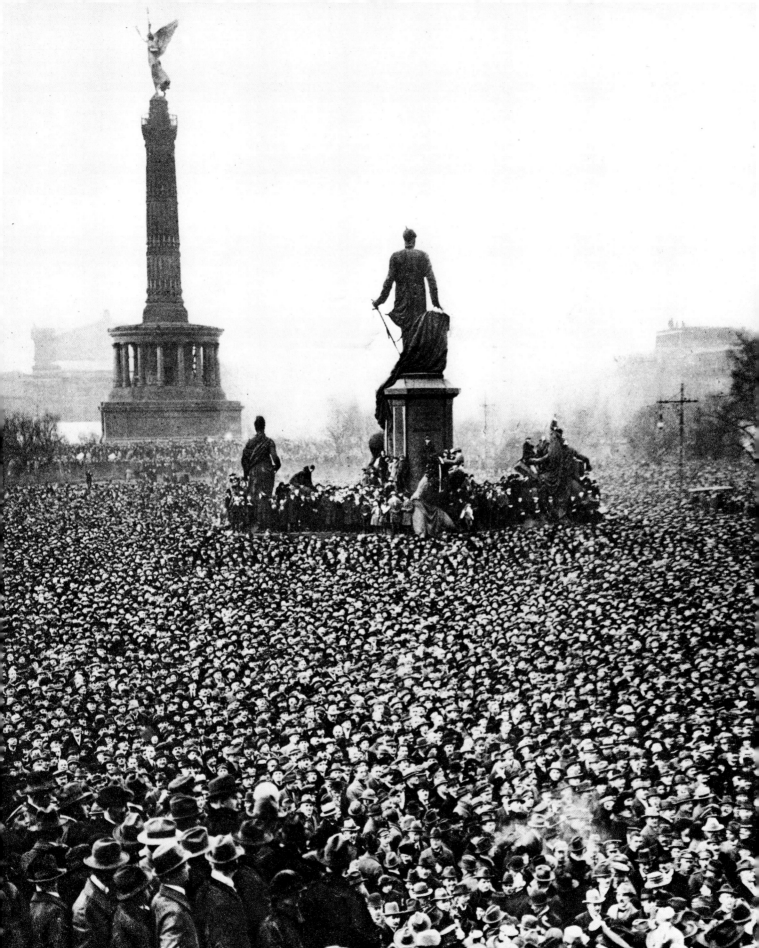

Der Austausch

MAI ⁄ Veröffentlichungen der Studierenden am Staatlichen Bauhaus zu Weimar ⁄ **1919**

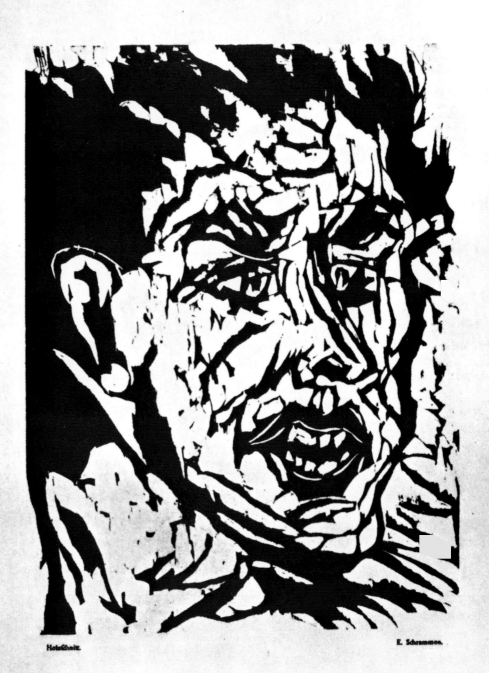

Holzschnitt.　　　　　　　　　　　　　E. Schrammen.

THE BAUHAUS TURNS: TYPOGRAPHY

For three years after its foundation by Gropius in 1919 this new type of art and design school largely reflected the ideas of utopian Expressionism and the Working Council for Art. In 1923, however, Moholy-Nagy supplanted Itten as Gropius's right-hand man and the policy became 'Art and technology, a new unity'. This shift of emphasis was demonstrated first at the school's exhibition in Weimar that year, then still more conclusively after the provincial government had swung to the right and forced the Bauhaus to move to the modern industrial city of Dessau. At Weimar it had been located in the buildings of the prewar grand-ducal design school: an art nouveau structure by Henry van de Velde, once the court's adviser on all design matters. At Dessau it moved into Gropius's own specially designed modern buildings and for the first time had a proper architectural department under the direction of the Swiss Left functionalist Hannes Meyer. The six pages of illustration that now follow show how the change affected various aspects of Bauhaus life and work. Here, to start with, are two examples to show the development of its layout and publicity technique: first, a student publication of 1919 with an Expressionist woodcut by the little known E. Schrammen, then a cover design by Herbert Bayer for the Bauhaus magazine following the move to Dessau. Bayer was one of the first batch of ex-students to be appointed teachers.

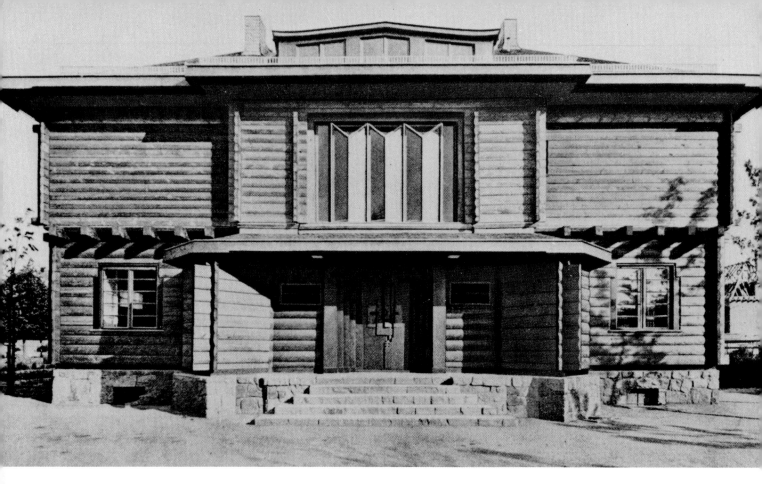

THE BAUHAUS TURNS: BUILDING AND SEATING

The Sommerfeld House, 1921 (*above left*), was designed by Gropius and his partner Adolf Meyer for the Berlin builder Adolf Sommerfeld, one of the school's early patrons. The Haus am Horn (*above right*) was designed by Adolf Meyer and Georg Muche for the

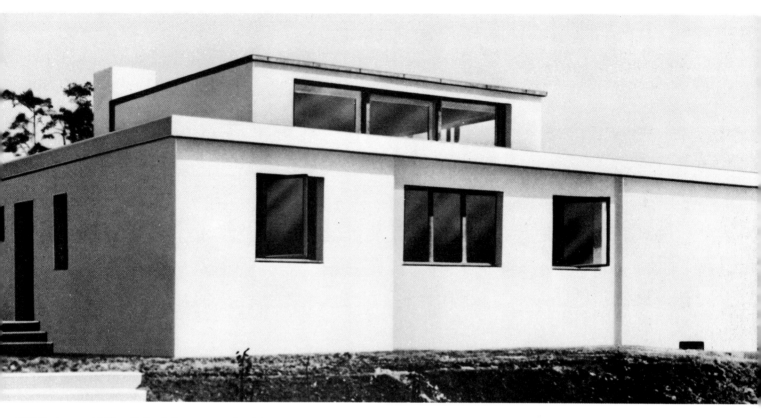

1923 Bauhaus exhibition. *Below left*, an unrealized quasi-utopian plan for a Bauhaus housing estate, next to Gropius's practical plan for new housing at Dessau after the move; *below right*, a pair of chairs by the student/teacher Marcel Breuer: that on the left a romantic object from the Weimar phase (1921), the other a classic piece of technological modernism from Dessau (1925). The change could be represented by a dozen other examples, covering the whole gamut of the school's activities.

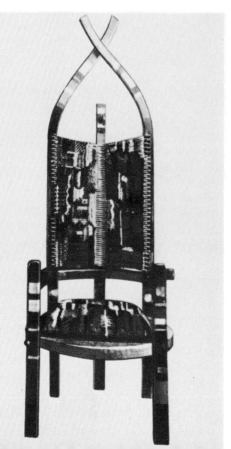

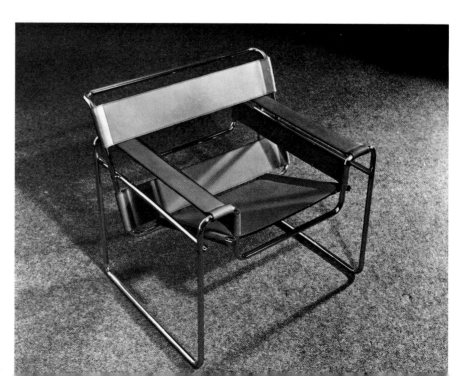

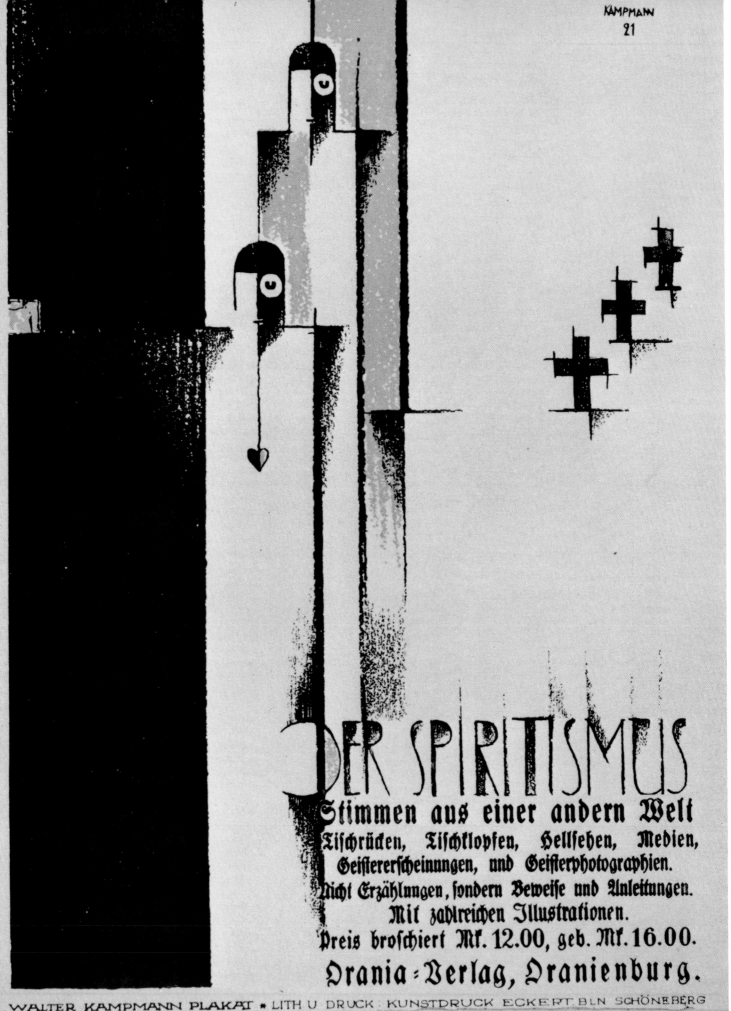

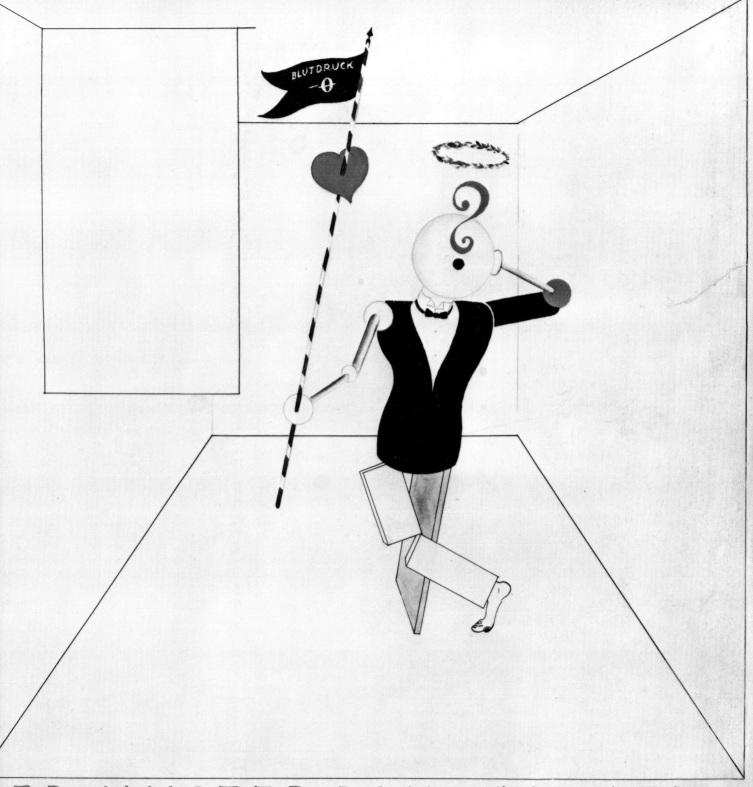

ER MUSTER·BAUHÄUSLER

THE BAUHAUS TURNS: ETHOS AND LIFE-STYLE

Though the left-hand design, dating from 1921, is not by a Bauhaus member but by the November Group artist Walter Kampmann, its use of abstract symbolic forms to suggest psychic mysteries is analogous to Kandinsky's concept of 'Das Geistige' or 'spiritual har-mony'. The book it advertises deals with 'table-turning and table-rapping, clair-voyance, mediums, spiritual pheno-mena and spirit photography', none of which would have seemed incongruous to the early students with their Mazdaist diet, folksy costume and visits by wan-dering mystics. Two years later Herbert Bayer's 'perfect Bauhaus-ite', *above*, uses Dada-Metaphysical conventions parodistically to suggest the new cool breed of technological student equipped with an inquiring mind in a faceless head.

A similar change took place in all the arts. In the theatre, the prolific dramatist Georg Kaiser, whose typically Expressionist 'station drama', *Hell Road Earth*, was performed in Berlin in 1920 with sets by Cesar Klein (*below left*), wrote the down to earth 'people's play' *Side by Side*, performed three years later with witty Cubistic décor by Grosz (*below right*). In architecture, the utopian Wassili Luckhardt, after planning such impossible structures as the crystalline *House for an architect* in 1920 (*bottom left*), joined the practical partnership of Luckhardt und Anker whose austerely rectangular *Living room in the architect's own house* (*bottom right*) dates from 1925. *Opposite*

are works by two artists who made the passage from Expressionism via Dada to a form of Constructivism influenced by Soviet examples. *Top*, Max Burchartz's *Woman with Flowers* of 1919, *left* contrasts with his *Girls' Heads* of *c.* 1922; *bottom*, Schwitters's 'Merz' picture *The Alienist*, 1919 (*left*), made partly of rubbish, contrasts with the cooler and more abstract lithograph of 1923. Both artists knew Lissitzky well, designed extensively for advertising, and later, in 1927, joined with Willi Baumeister and other avant-gardists in a 'Circle of New Publicity Designers'. For an instance of Burchartz's publicity work see p. 128.

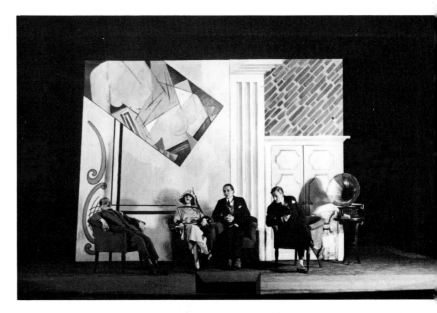

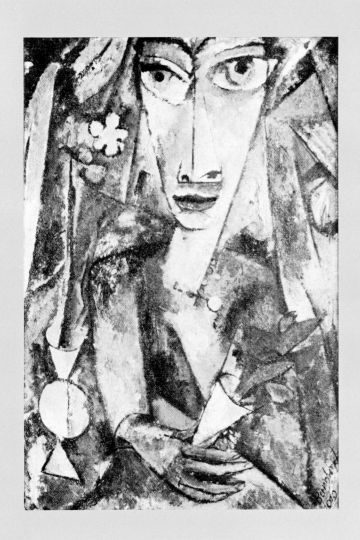

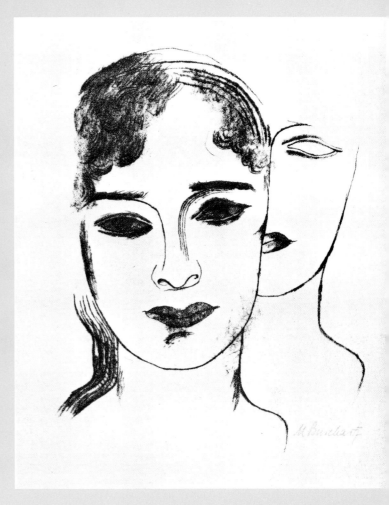

THE NEW VISION: RIGHT-ANGLES

Both in and out of the Bauhaus, the designers and architects were absorbing the language of Cubism, which had been taken back to first principles by Mondrian, Van Doesburg and the De Stijl group. The square-cut shapes and heavy black lines of their new 'elementarism' began to crop up in typography (see pp. 44–5), in architectural externals and fittings (as in Breuer's 1923 cupboards and the projected house by Farkas Molnár, *bottom, centre and right* – both by Hungarian members of the Bauhaus) and even in the plans and layout of the new buildings. Thus Mies van der Rohe's project, immediately *below*, resembles an abstract painting as closely as did some of Le Corbusier's plans, while Gropius's projection of his Törten housing estate (1926), *opposite, above*, seems equally arbitrary. The classic instance remains Josef Hartwig's Bauhaus chess set (*bottom left*), which is still made today. Willi Baumeister's view of *The Architect*, 1924 (*right top*), grasping his T-square like a fig-leaf, is the comment of a painter himself trained in the Cubist tradition.

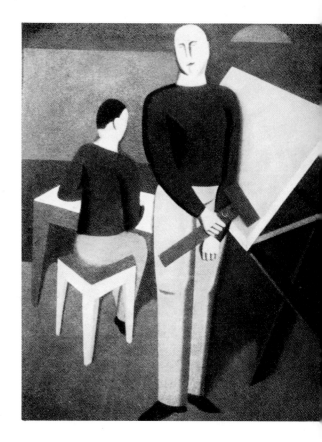

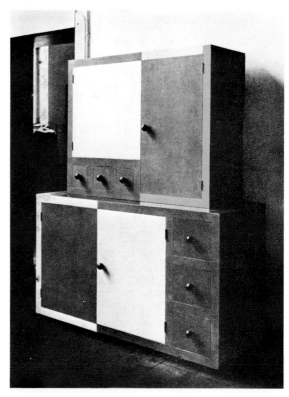

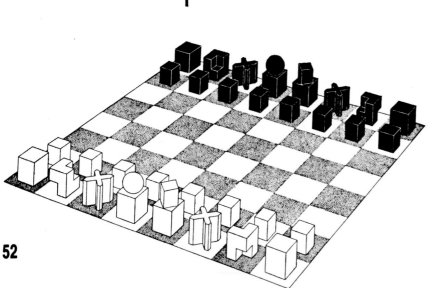

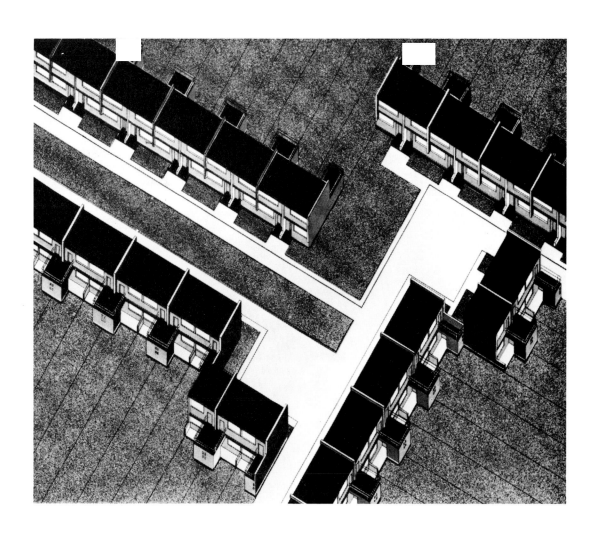

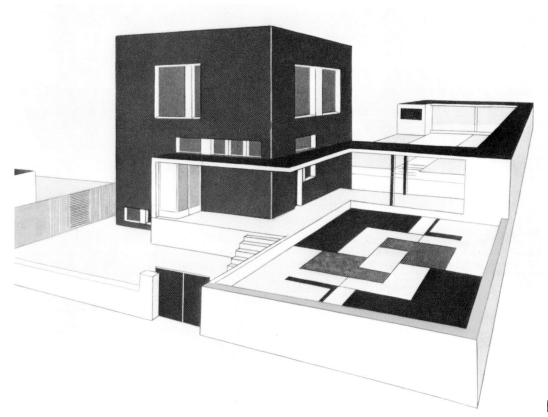

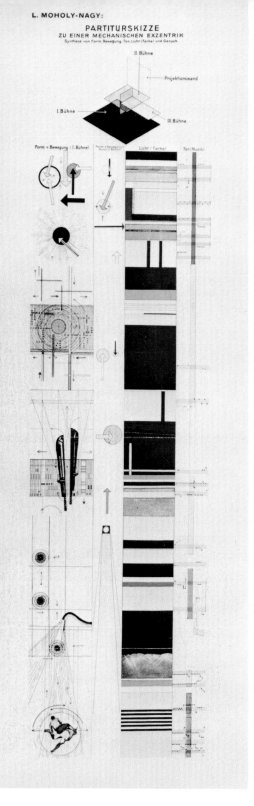

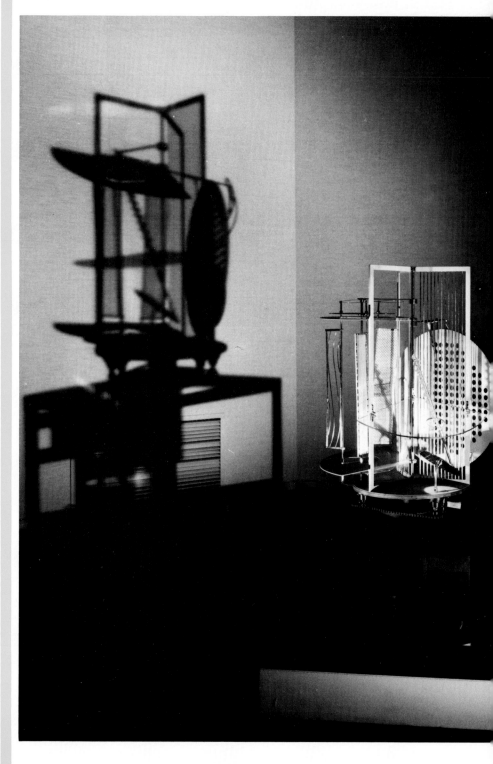

THE NEW VISION: PLAY WITH LIGHT

The other new element, particularly in photography, exhibition design and the theatre, was the conscious use of light, particularly in the form of multiple transparency and reflections. Though experiments had been made earlier, notably Christian Schad's first photograms (or camera-less light prints)

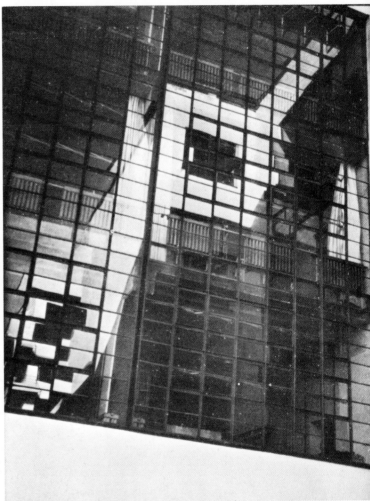

and the colour organ of Scriabin's *Prometheus*, the real centre of ideas was the Bauhaus, particularly after the arrival of Moholy-Nagy in 1923. Having already begun working on the complex projector-reflector shown above (*centre*), he used his new eye for light effects not only in photography and the theatre – where he devised the *Score for a Mechanical Eccentricity* (*left*) and helped in Gropius's very radical 'Total Theatre' project for Piscator – but also in the highly original interpretation of the new architecture which he put forward in his book *Von Material zur Architektur* (1929; American version: *The New Vision*): Lux Feininger's inter-penetrative photograph of the Bauhaus buildings (*right*) was among his examples. Another who worked in the same field was Ludwig Hirschfeld-Mack, a Bauhaus student who finished up in Australia as art master at Geelong Grammar School.

Sober reality 1924–8

In the spring of 1924 the international Dawes commission drew up a new scheme by which Germany could meet its reparation obligations under the Versailles Treaty. Following the currency stabilization of a few months earlier, this was the start of five years of comparative peace and economic progress for the Republic, based on an influx of short-term foreign capital mainly from the United States. On top of the tendency towards a new sobriety in the arts now came the economic capacity to realize it, notably in architecture, theatre and the opera; on top of the fruitful Russian influence came the American. All these were decisive factors in turning the new ideas outlined in the previous section into what appeared to be an established culture. And what made it a unique one was the fact that so much had to be constructed from scratch. Only in Russia was there also a brand-new cultural administration with so many tasks before it, but in that country the material resources were nothing like the same. So it looked for a time as if Germany was getting the best of both worlds: radical solutions supported by established wealth.

There were two general elections in 1924, then none till 1928, and they showed a considerable weakening of the extreme Right and Left during the former year and a steady increase in the Socialist vote throughout the whole period. Yet it was not until right at the end of the period 1924 to 1928 however, that the SPD (or mainstream Socialists) entered the government, although they had been the largest single party since December 1924; moreover at the presidential election which followed Ebert's death in 1925 Hindenburg became the effective national leader, and remained so until the fall of the Republic. Throughout these five years however it was the SPD which controlled Berlin and the Prussian provincial government, and their policies were generally the most influential in the arts. The three great landmarks in the new socially-orientated architecture, for instance, were the institution of a rent tax in 1924 on the Viennese model, the appointment of Martin Wagner as head of the chief Berlin building society (which had Bruno Taut as its main architect) and the start of a ten-year plan in Frankfurt under Ernst May. In 1927, too, Gropius at the Bauhaus set up an architecture department under the Swiss Marxist Hannes Meyer, and himself built a new housing estate for the Left-centre local municipality. Similarly in music the Prussian government advised by Leo Kestenberg formed a new popular opera in 1924 in alliance with the old-established socialist Volksbühne, and in 1927 brought Klemperer in to run it; this was the Berlin Kroll Opera. Schönberg was brought from Vienna to teach at the Academy, Hindemith, Carl Flesch and Egon Petri at the High School for Music. Even Brecht and Piscator were at this stage working within the orthodox theatre.

Though the persistent weight of tradition should not be underrated, a new spirit permeated all the arts. It was

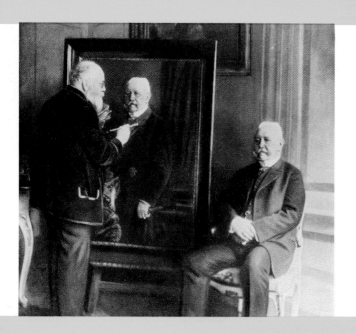

inspired partly by the new technology, partly by the tasks being set them by a self-renewing society which treated design as an aspect of social engineering and economic advance. The 'utilitarian graphics' or *Gebrauchsgrafik* of typography and advertising were followed by the *Gebrauchsmusik* of Hindemith, as he and his friends searched for new tasks for composers (such as writing film scores or for mechanical instruments), and the light, pointed *Gebrauchs*-poetry of the satirists Kästner and Tucholsky. It was all very functional and unpretentious, yet modern in form. One model here certainly was the 'production art' which had evolved out of Soviet Constructivism; another was the Anglo-Saxon mythology of jazz, sport, easy humour and a hard-headed respect for facts. This was when Brecht and his friends went to boxing matches and wrote for a sports magazine called *Arena*; when Ernst Krenek's boxing opera *Heavyweight, or The National Honour* was performed at the Kroll Opera; when large editions were published of Gorky and Ehrenburg, Upton Sinclair and Sinclair Lewis; when books of fact began dominating the publishers' lists. Concerned very much with its own time – hence the Weimar concept of 'theatre of the times' and 'opera of the times' – it was a middle culture for middle-class middle Europe, but at the same time it was utterly modern. Its poles were *The Gold Rush* and *The Battleship Potemkin*, and they were not really very far apart.

Before we look at the hopeful culture of the mid-1920s, we should recall some of those figures who remained largely outside and above it. Thus Hindenburg, who took over the presidency after Ebert's death in 1924, was not exactly a patron of the arts – you see him (*far left*) sitting to the 'Photographer and Royal Portrait Painter' Arthur Fischer – but he was highly respected by the over-40s, and there was an element of Restoration in his appointment. Next to him is Max Liebermann, the most 'distinguished' artist of the time, whose portrait of Richard Strauss shows the one German composer then of unquestioned international stature. Then comes Thomas Mann, winner of the Nobel Prize for literature in 1929; his reputation dated from 1900. Finally, two men of the theatre: Gerhart Hauptmann, whose *The Weavers* was the great Naturalist drama of the 1890s and Max Reinhardt, before 1918 Germany's greatest director and subsequently her greatest showman/impresario.

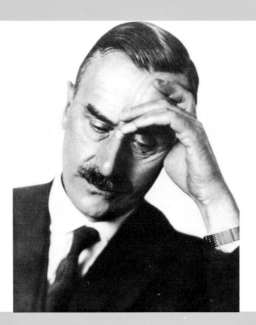

THE WEIGHT OF TRADITION

Pre-1914 attitudes persisted throughout the 1920s, not least among 'progressive' circles. Here are Social-Democratic girls on a May Day demonstration (*left, top*), looking like nymphs in a Hans Thoma painting as they proclaim 'Down with Reaction'. The young Communist 'propaganda orchestra' of 1927, below them, comes straight from the *Wandervogel* movement; the 'Free Gymnast' nude from the Arts and Crafts Society. The advertisement for 'age-old' schnapps, *bottom*, turns to the middle ages for its knightly antiquity. *Below*, the Cologne burgher photographed by August Sander has the buttoned-up look of those lawyer-fathers who produced unhappy sons like the writers Becher and Fallada. In his *Engagement Party* (*opposite*), Karl Hubbuch portrays the knick-knacks of the smaller bourgeoisie with a special mixture of cruel accuracy and unholy fascination.

DIE FREIE TURNERIN

ARBEITER-TURNVERLAG A.-G., LEIPZIG BERTH. KREUZBURG, LEIPZIG, FICHTESTR. 36
12. JAHRGANG / LEIPZIG, 4. FEBRUAR 1925 / NUMMER 2
ERSCHEINT VIERWÖCHENTLICH REDAKTIONSSCHLUSS 10 TAGE VOR ERSCHEINEN

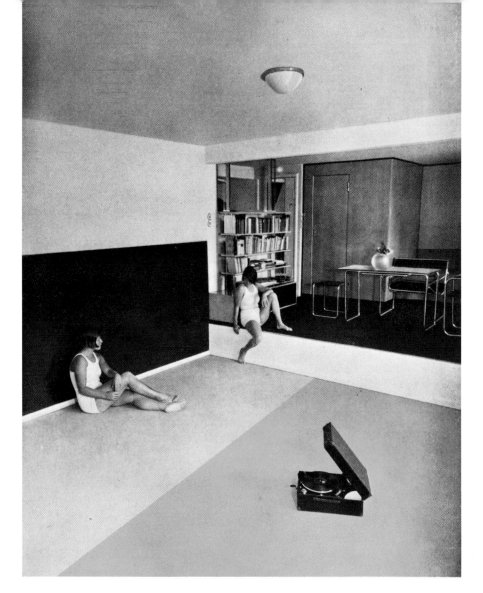

NEW COMMUNICATIONS

But too much was changing for the clock yet to be put back in the arts. The Opel motor factory near Frankfurt was now mass-producing one car every 4 minutes 50 seconds according to the full-page advertisement of 7 June 1925 (*right*); Breuer's private gymnasium of 1929 (*left, above*) shows the gramophone as a central adjunct to modern living, though apparently more conservative types too could appreciate the new wireless receivers, to judge from Karl Günther's painting of a 'radionist' in 1927 (*left, below*). At that time, public broadcasting in Germany had existed for only four years, but already it was attracting a number of the younger writers and musicians – thus it was the broadcast of Brecht's play *Man equals Man* in the spring of 1927 that led to the start of his collaboration with Weill, who had to review it for Germany's weekly radio magazine. Brecht also adapted *Macbeth* (1927) and *Hamlet* (1931) for Berlin radio and in 1929 wrote two original radio works with Weill (see p. 99); that year Hindemith devoted part of his music festival to music specially written for the new medium. Finally, to suggest how fresh the cinema medium still was, we have Chaplin directing *A Woman of Paris* (1923), a movie that fell flat at the time but is now recognized as a work of genius.

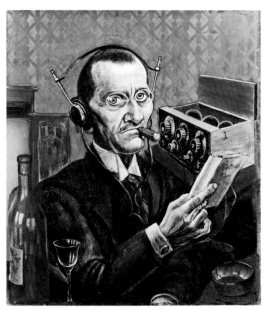

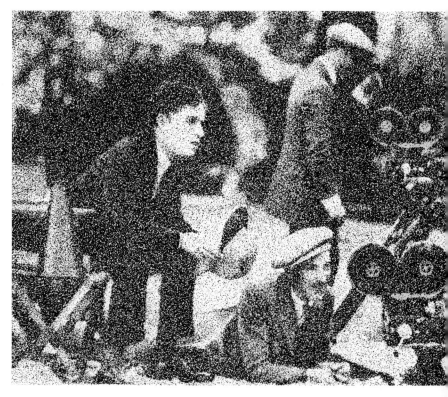

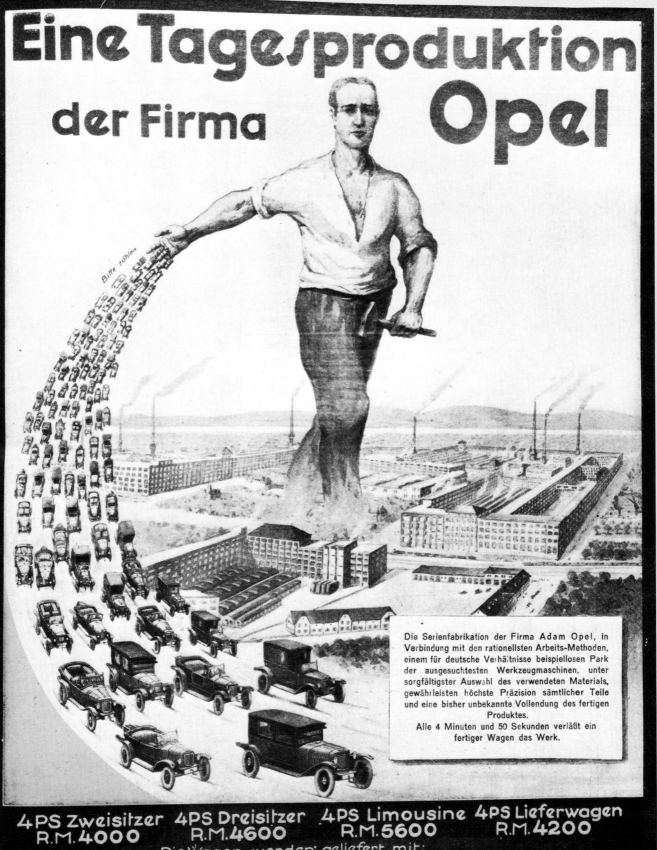

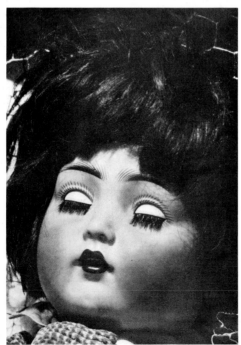

ARTISTS TAKE TO THE CAMERA

It was above all the Constructivists and ex-Dadaists who took up this cheapest and most individual of the new devices. *Centre*, Moholy-Nagy, though a novice when he first went to the Bauhaus, used the camera most imaginatively, for montages, photograms, negative pictures and straight shots from unorthodox angles as here, in *Street, Berlin* (1928). *Left, above*, 'Umbo' (Otto Umbehr), who made this photogram, was perhaps the best-known professional photographer to emerge from the Bauhaus, but he too started out as a painter. So did Max Burchartz, *left, below*, whose work is also seen on pp. 50 and 128; in the later 1920s he taught photography at Essen. Werner Gräff, *below*, started as a student designer poised between Bauhaus and De Stijl, then was made responsible at Stuttgart for the publicity for the Weissenhofsiedlung (see p. 71) and the 1929 'Film und Foto' exhibition; his seminal book was called *Look out, the new photographer is on his way!*. This new photographer was the man who broke all rules – using wide-angle lenses, tilting the camera and so on – rather as Degas had broken the rules of pictorial composition.

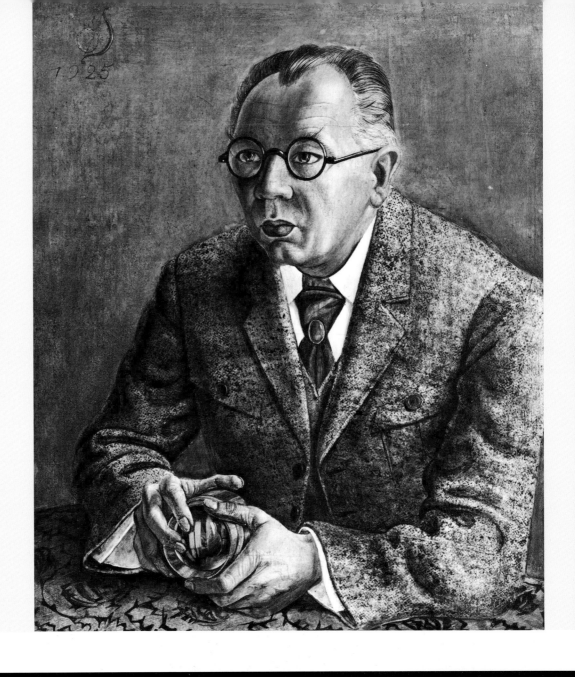

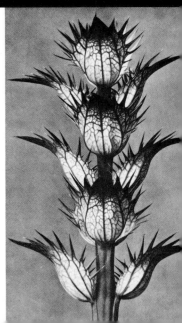

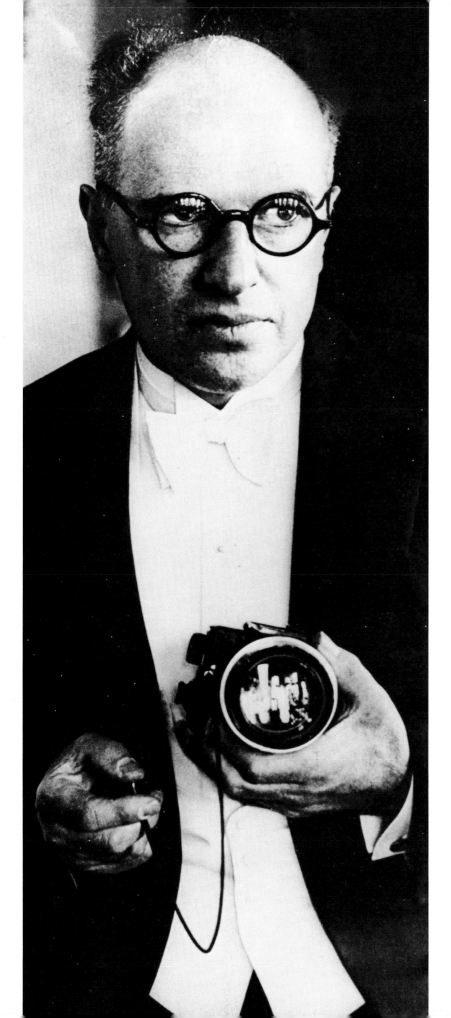

PHOTOGRAPHERS ENTER ART

The 'old' photographer, who had come up via his own craft, was not to be left behind. Hugo Erfurth (*opposite, above*), the Dresden photographer here portrayed by Dix with a big-aperture lens in his hands, photographed leading artists and architects, including Schlemmer, Dix and Gropius. Erich Salomon (seen *left* in white tie and tails) moved from publicity into photojournalism when he discovered the Ermanox miniature camera; a typical instance of his ability to catch important people unawares is his picture (*below*) of General von Seeckt, the organizer of Germany's secret rearmament, in the Reichstag restaurant. *Opposite, below* are three neutral pictures, all of some significance for photography's changing relationship to art. The microphotograph of crystals (*left*) was singled out in the classic album *foto-auge* (*Photo-Eye*) as an example of the new visual insights provided by the unconscious camera. The still-life by Walter Peterhans (*centre*) shows the kind of advertising-orientated photography which he taught at the Bauhaus from 1929, when the subject first entered the curriculum. His father was director of Zeiss Ikon in Dresden, so photography was in his blood. *Right* is a typical picture by Karl Blossfeldt (born as early as 1865) from his *Art Forms in Nature* (1932), one of the most revealing albums of the time. He taught at the Berlin Hochschule für Bildende Künste. Other photographs by this utterly professional wing of the movement are scattered throughout the present book, notably work of the unflattering August Sander (b. 1876) from Cologne.

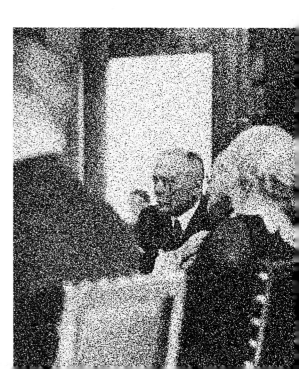

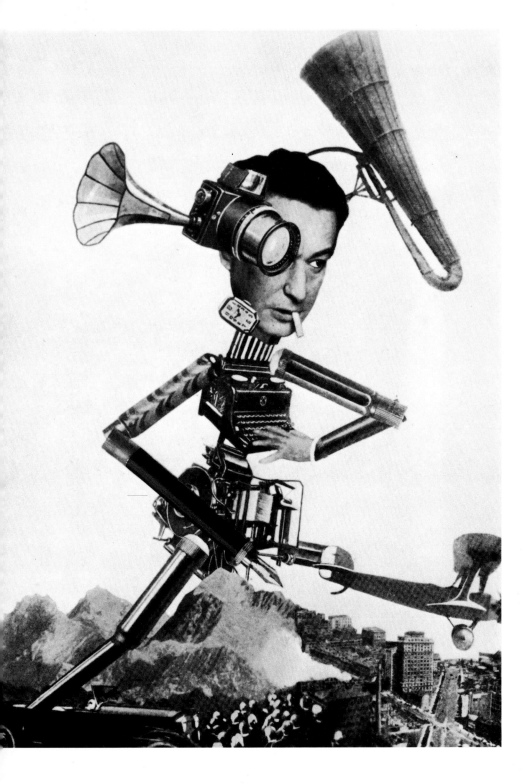

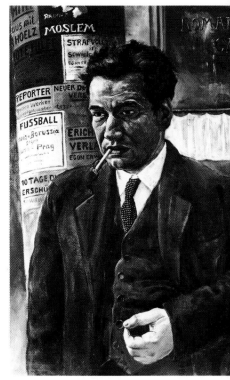

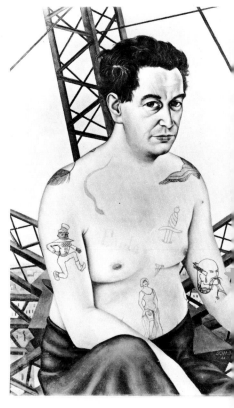

If reportage was one of the distinctive new approaches, photo-reportage was another. Together, they helped build a documentary tradition that is still very relevant today. The master reporter was the Austrian Communist Egon Erwin Kisch, here depicted by three leading artists: *right, above*, Rudolf Schlichter (*c.* 1927) shows him outside Berlin's Romanisches Café against a poster column featuring the Prague football team for which Kisch once played and John Reed's pioneer reportage *Ten Days that Shook the World.*

Christian Schad, 1928 (*right, below*), sets Kisch among Eiffel-Tower-like girders, while Umbo's montage (*above*) makes him a well-articulated body out of all the paraphernalia of modern communications. *Opposite* are two anonymous illustrations from the brilliantly edited picture magazines of the time – in this case, the *Kölnische Illustrierte* (*left*) and the Berlin *Weltspiegel* (*right above*). *Below right*, Willi Muenzenberg's appeal for 'worker photographers' able to record what the capitalist press could not or would not see.

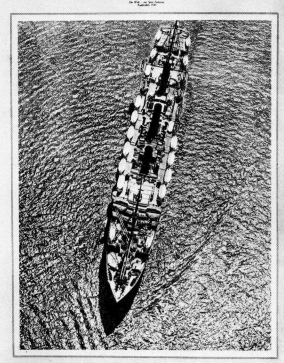

Der Chikagoer
Billardball-
trick
Der geheimnisvolle
rote Ball ...

... verwandelt sich
in einen weißen,

... den der Zauberer
graziös zwischen
Daumen und Zeige-
fingerspitze hält,

... um aus ihm zwei
— drei Bälle hervor-
zuzaubern

Sichtbar verändert er
die Plätze der Bälle,

... um einen vierten
Ball ...

... auf unsichtbarem
Wege zwischen den
Fingerspitzen erschei-
nen zu lassen.

Der Gipfel aller
Billardballkunststücke:
Der aus acht Bällen
bestehende Conradi-
sche „Konzerttrick"

Der Welt Spiegel

Nr. 31 · Berlin, 29. Juli 1928 10 Pfennig

Der silberne Ozean

Ausfahrt des neuen kanadischen Riesendampfers «Empress of Australia» bei strahlendem Sonnenschein

Der Arbeiter-Fotograf

Offizielles Organ der Vereinigung der Arbeiter-Fotografen Deutschlands

UNSERE
WERBEPOSTKARTE

Nun liegt das Ergebnis des von Redaktion und Verlag veranstalteten Preisausschreibens vor. Die technische Kommission der Vereinigung der Arbeiter-Fotografen brauchte mehrere Stunden, um die vielen eingegangenen Arbeiten zu prüfen, und es war ihr nicht gerade leicht, von den in die engere Auswahl genommenen Arbeiten diejenige zu bestimmen, die den ersten Preis davontragen sollte.

Wenn wir ein Gesamturteil abgeben sollen, so müssen wir sagen, daß alle Prüfenden von den oft vortrefflichen und originellen Ideen, die den Arbeiten zugrunde lagen, überrascht waren. Aber wir haben auch die Bestätigung dafür erhalten, daß unsere Warnung vor komplizierten Fotomontagen angebracht war, denn so manche gute Idee wurde durch Zusammenstellung zu vieler Bilder unübersichtlich, ging also in ihrer Wirksamkeit verloren. (Nicht das Plakat wirkt, auf dem möglichst viel — wenn auch nur Richtiges — geschrieben steht, sondern dasjenige, welches in wenigen klaren Worten Aufgaben und Ziel hinausschreit.)

Wenn der Leser den hier wiedergegebenen Entwurf der Werbepostkarte betrachtet, für den sich die Preisrichter entschieden haben, so wird er mit uns

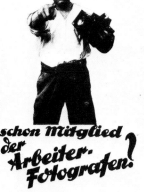

Bist Du
schon Mitglied
der Arbeiter-
Fotografen!

übereinstimmen, daß gerade durch die Anwendung einfachster Mittel — ein zielbewußter Arbeiter, der seine Waffe zu gebrauchen versteht — die wirkungsvollste Propaganda entfaltet werden kann.

Der Preisträger, der Gewinner des Fotoapparates, ist Genosse W i l l i Z i m m e r m a n n aus D r e s d e n, der außer dieser Arbeit noch drei weitere geliefert hat, die alle ziemlich gut gelungen sind.

Aber es gab auch noch einen Entwurf des Genossen M a x W o l f f aus L e i p z i g, den wir gern bevorzugt hätten, wenn die technische Ausführung besser gewesen wäre. Wir haben diese Arbeit angekauft und werden sie in der nächsten Nummer veröffentlichen.

So wird also die erste Werbepostkarte aussehen, die die Vereinigung herausgibt. Sie wird sich zum Versand an bekannte Fotofreunde und zum Verkauf auf Ausstellungen vorzüglich eignen, denn ihre Herstellung in Lichtdruck oder als Fotokopie garantiert überall den Erfolg. Der Verkaufspreis wird voraussichtlich 15 Pf. pro Karte betragen. Wir ersuchen alle Interessenten, vor allem die Ortsgruppen, uns schnellstens ihren vorläufigen Bedarf aufzugeben, damit mit der Herstellung begonnen werden kann.

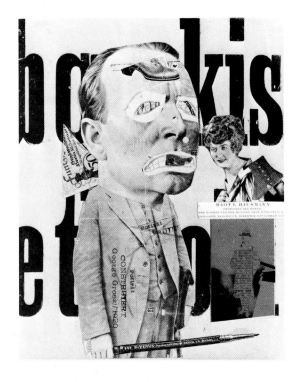

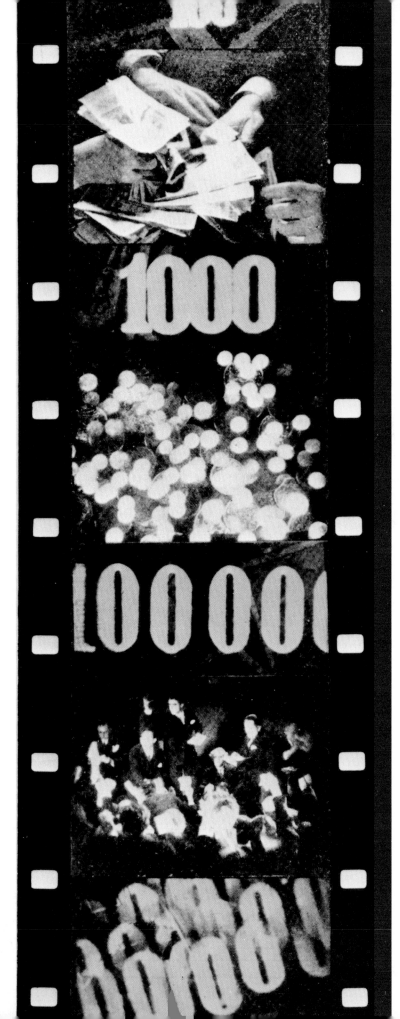

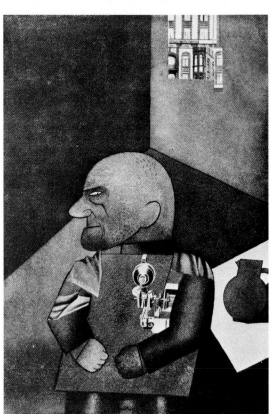

A NEW STRUCTURAL PRINCIPLE

From around 1920, when it was a form of ·Dadaist game (*opposite, left*: Raoul Hausmann's *Art Critic* (*top*) and Grosz's *Monteur Heartfield*), montage spread not only to the cinema (*opposite, right*, a strip from Hans Richter's *Inflation*) but also to many other artists and media of the period. Thus it was adopted by painters like Schwitters (*Figurine*, 1921, *left, above*) and Baumeister (*Head*, 1923, *left, below*) and used, probably by the former Bauhaus student Paul Citroën, to advertise Fritz Lang's film *Metropolis* of 1925 (*below*). Much the same technique of disjointed selectivity

was applied in literature by such writers as Joyce, Hašek, Dos Passos and Feuchtwanger, where it comes close to the 'each scene for itself' 'epic' dramatic structure practised by Brecht. The Brecht-Weill opera *Rise and Fall of the City of Mahagonny* is indeed a scissors-and-paste patchwork, matched closely by the designer Caspar Neher's piecemeal realism in his construction of Brecht's sets. Heartfield's montages were seen mostly on Malik-Verlag book-jackets or were full-page political photomontages for Muenzenberg's 'Workers' Illustrated', the *AIZ*.

ARCHITECTURE FOR MODERNS

Top left, Wilhelm Schnarrenberger's very Neue Sachlichkeit portrait of an unknown architect, with a bricklayer behind him and a remover's waggon in the yard below, presides over his distinguished colleagues (like Le Corbusier and Mies van der Rohe, photographed at Stuttgart in 1927, *centre*) and some outstanding examples of their work of the mid-1920s. These are Erich Mendelsohn's Luckenwalde hat factory of 1923 (*left, centre*) and Mies's Guben house for the Wolf family, 1925–6 (*left, below*). To the *right* are three even more influential items. Gropius's Bauhaus buildings at Dessau, 1926 (*top*),

inaugurated that school's most purposeful and successful period, when architecture was at last introduced as a subject there. This drew in such teachers as Hannes Meyer, Mart Stam and Ludwig Hilberseimer, as well as Gropius himself (who however resigned in 1928). Bruno Taut's Berlin comprehensive school in Berlin-Neukölln, 1927 (*centre*) exemplified a new type of open-air, open-plan school which became important for English school building some twenty years after. Finally, the Stuttgart Weissenhofsiedlung, *below*, was planned by Mies for the German Werkbund – or national design

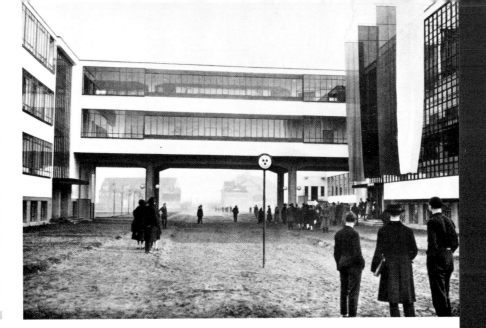

association – in 1927 as an experimental housing estate with houses by all the above-mentioned except Mendelsohn and Meyer (and Schnarrenberger's unknown sitter no doubt). It remains a classic showpiece to this day, though its significance lay perhaps less in the individual merits of the houses than in the co-operation of so many leading architects. Out of this came the meeting in Switzerland a year later which set up the CIAM or Congrès Internationaux d'Architecture Moderne, directing body of the new 'functional' International style.

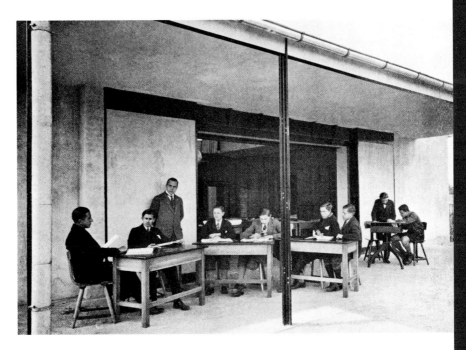

BUILDING FOR PEOPLE

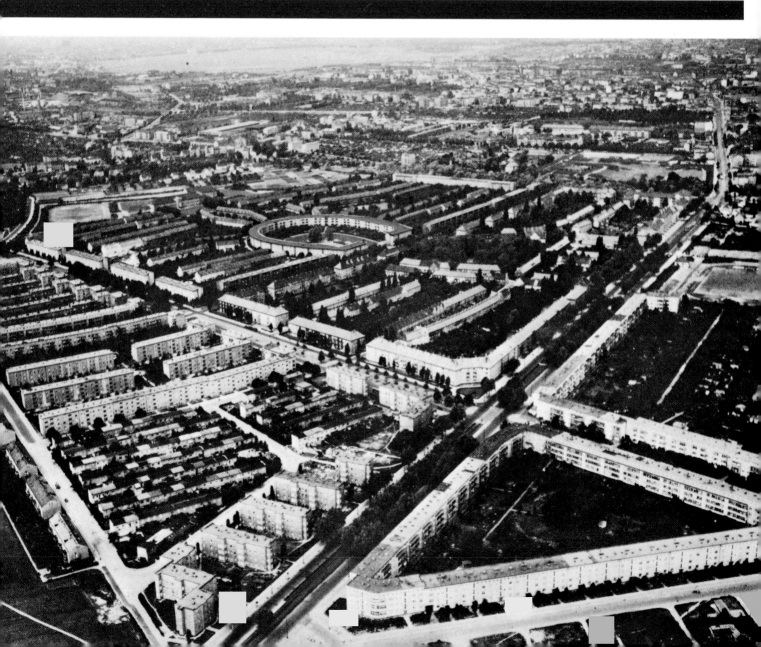

The same modern architectural idiom, along with the concepts of economy and purposefulness on which it was largely based, was applied to the major social problems of rehousing and rebuilding the cities. Based on the Austrian housing tax which financed the great socialist schemes in Vienna, a modified form of rating was introduced to support the Berlin and Frankfurt building societies; and for this the SPD or Socialist Party (election poster, *left*) took credit. Thus in Berlin the GEHAG society under Martin Wagner, with Bruno Taut as his chief architect, built such vast estates as Britz, with its horse-shoe central block (*below*) and the Carl Legien 'city' (*right, top*), both started in 1925. In Frankfurt (see pp. 121–3) the chief planner Ernst May rehoused about nine

per cent of the population between 1925 and 1930, largely on the garden-city principle which he had learnt working in England with Raymond Unwin. Other socially aware architects concerned with the problem of 'minimal dwellings', subject of the CIAM's second (Frankfurt) conference in 1929, included Otto Haesler, architect of the Hanover satellite of Celle since 1923, Walter Gropius, Gropius's successor Hannes Meyer and the Dutchman Mart Stam. Mies van der Rohe was less interested, though in 1926 even he built the Berlin block in the Afrikanerstrasse (*right, centre*). None of them was anything like so extreme as Le Corbusier or the Bauhaus teacher Ludwig Hilberseimer, whose city projects (*bottom right*) were fortunately never carried out.

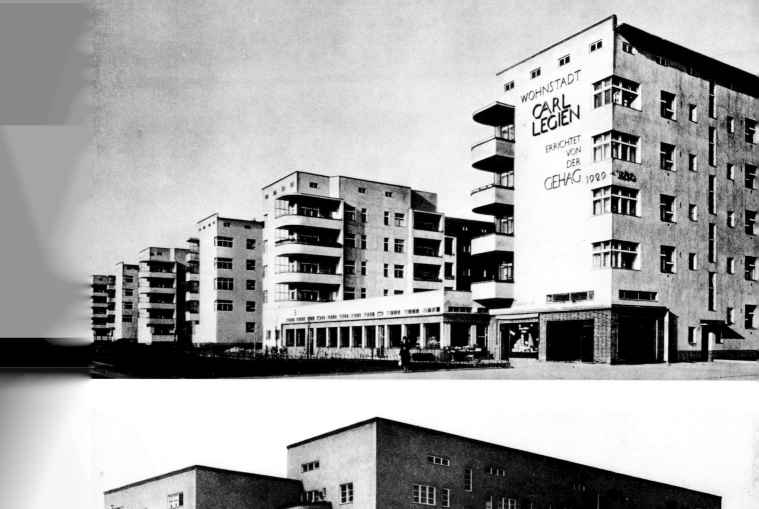

73

DAS FRANKFURTER REGISTER 12
PH-LEUCHTEN

PH - 3 Schirm - System — rein „licht-technische" Formung — „offene" Anordnung der Schirme begünstigt volle Licht - Ausbeute (ohne daß direkte Lichtstrahlen der Glüh-lampe das Auge treffen können!) Kombination von Oberschirm, Mittel- und Unterschirm verschie-dener Größe ergibt in Verbindung mit verschiedenen Schirmmateria-lien (Opal-, Mattglas, Lack, Bronce, Silber-, Rot-, Grün- und Gelb-Lackierung) die für den jeweiligen Verwendungszweck günstigste Lichtverteilung.

Nach der Wahl jener Kombinationen und Materialien richten sich die Preise für PH-Leuchten; so kosten z. B. PH-Hängeleuchte, normal hängd., Mod. 3.3 in Opal- oder Math-glas 28.— RM, PH-Wandarm, hängd., Mod. 3.3 aus Opalglas 30.— RM, PH-Tischleuchte mit Opalglasschirmen 70.— RM, usw.

DEUTSCHE PH-LAMPENGESELL-SCHAFT MBH. KARLSRUHE·BADEN

PH-Tischleuchte für 25—60 W.

PH-Wandarm, stehd., Mod. 3.2—5.3

PH-Wandarm, hängd., Mod. 3.3—4.4

PH-Hängeleuchte niedr. häng., Mod. 4.3—5.3

PH-Außenleuchte für 100—2000 W.

PH-7-Schirmleuchte für 100 W.

PH-Standleuchte

Beilage zu „Das Neue Frankfurt" 1930, Heft 2/3, Verlag Englert u. Schlosser, Frankfurt a. M.

DEUTSCHE STAHLMÖBEL G.M.B.H.
BERLIN SW 61
TELTOWERSTR. 47-48

Much the same principles of design were applied to everyday living, with results that remain modern today. Four examples shown here were commerci-ally manufactured, including, in Mies's Barcelona chair, 1929 (*top right*), at least one that is still made today. The other chairs are four typical 1930 tubular-steel models (*above*) from a Berlin firm, and a bent-wood example by Heinz and Bodo Rasch from the Werkbund's Stuttgart 'The Chair' exhi-bition of 1928 (*right*). The light fittings (*top left*) came from the pioneer Design Register published by the Frankfurt city planners to encourage their tenants to furnish their flats economically and well. The same planners also had their own excellent furniture designer, Ferdinand Kramer.

The remaining instances all come from the Bauhaus, whose move to Dessau in 1925 coincided with a new drive to get the school's designs taken up by indus-try. *Above* are lamps, two by Marianne Brandt of a still current type, such as were marketed by Korting and Matth-iessen from 1928 on. *Far right*, metal-work by Brandt, *c.* 1928 (the teapot) and Christian Dell (1929) and commercially made pottery by T. Bogler and O. Lindig. *Right*, the prototype limousine designed by Gropius for the Adler firm after his return to private practice. This elegant vehicle was apparently never put on the market but represents per-haps the first serious attempt to capture the motorcar for quality design and away from the 'stylists'. Besides all this, the Bauhaus was able to market its wallpaper designs and to run a scheme by which royalties were divided with the responsible students.

IE NEUEN FEDERNDEN
TAHLMÖBEL

ben durch ihre Formschönheit, Zweckdienlichkeit
unerreichte Bequemlichkeit größte Erfolge erzielt.

FORDERN SIE KATALOG NR. 291

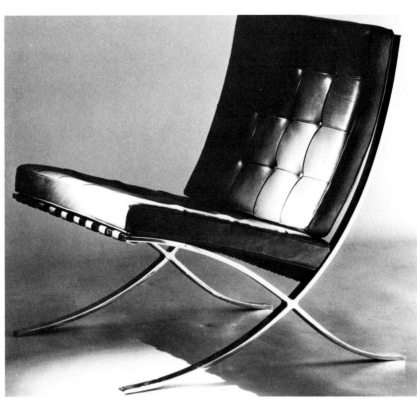

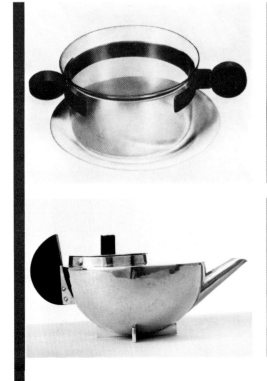

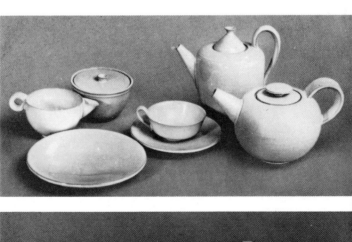

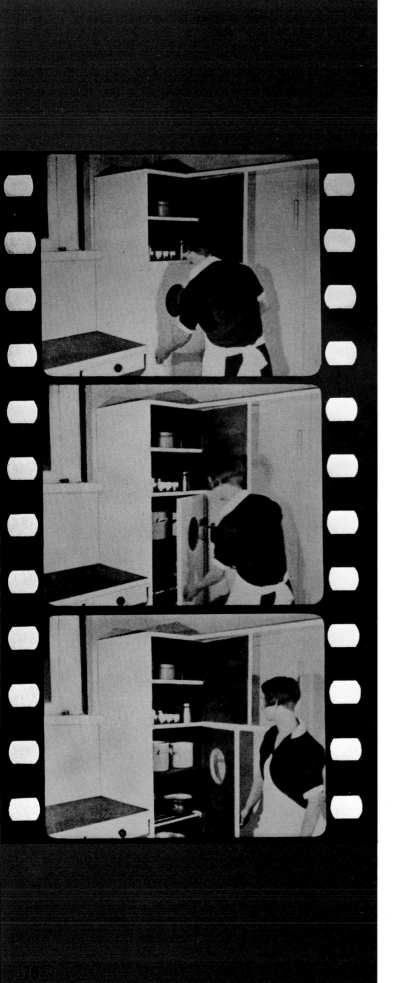

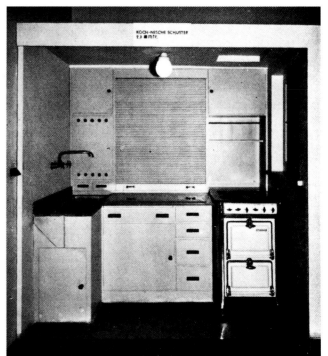

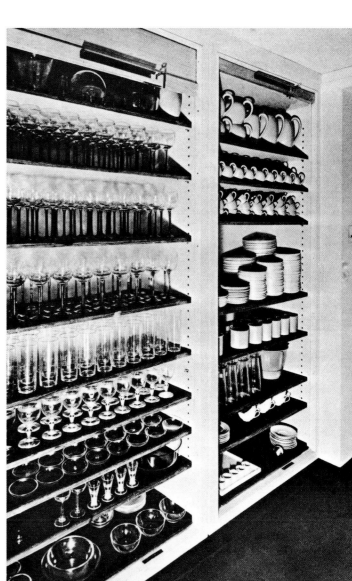

KITCHENS BY DESIGN

Built-in kitchen furniture now became available to all strata of society. No longer just a lavish convenience for the rich, it was a sheer necessity in economical new dwellings when space was short. Thus, besides the 'Frankfurt Kitchen' of May's planning team (p. 123), there was the Schuster compact 'cooking alcove', *left*. The two pictures *below* show what must have been the height of modern luxury: Erich Mendelsohn's kitchen in the Berlin villa which he designed for himself in 1930, a building that struck Count Kessler as embodying a whole new approach to life. *Far left* and *right*, the kitchen in Gropius's own self-designed house at Dessau, with its early eye-level oven, its built-in cupboards and its laundry chute. Clearly, this was run with at least one maid.

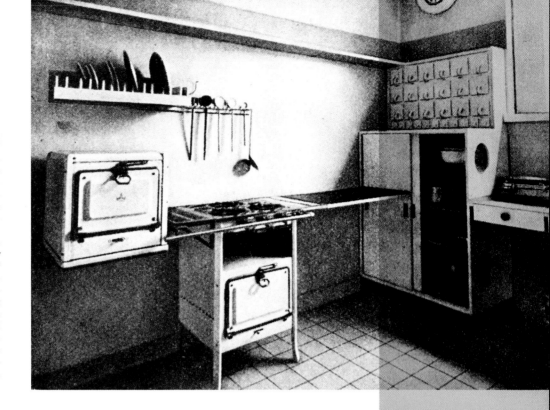

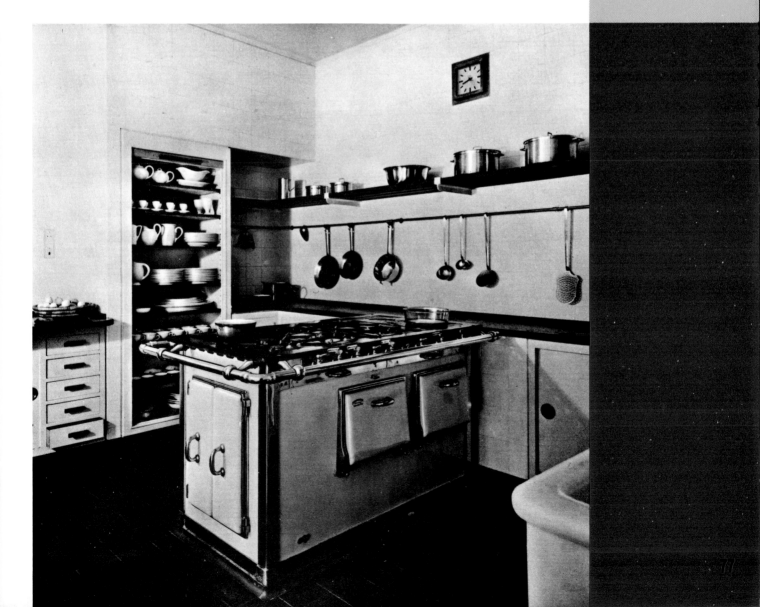

EL El

Лисицкий

LIS**ITZ**KY

MOSKAU

SCHAU DER ARBEIT

1919–23

There has been no subsequent typographical upheaval to compare with that of the 1920s. One of the most influential figures in this was Lissitzky (*left*) who was working in Germany for most of 1922–5 and returned on visits later. Schwitters, a close associate of his, also collaborated with Van Doesburg of De Stijl, whose use of rules and rectangularity inspired the layout of the 1923 Dutch issue of Schwitters's magazine *Merz* (*left, below*). Walter Dexel designed the book cover *far right, top*. Schwitters, Lissitzky, Moholy-

TSCHICHOLD

NAPOLEON

PHOEBUS PALAST

ANFANGSZEITEN:
4.00 6.15 8.30
SONNTAGS:
1.45 4.00 6.15 8.30

3

KOE GROOTE

DADA

ISMUS IN HOLLAND

DADA

in Holland ist ein Novum. Nur ei n Holländer, I. K. BON-SET, ist Dadaist. (Er wohnt in Wien.) Und ei n e Holländerin, PETRO VAN DOESBURG, ist Dadaistin. (Sie wohnt in Weimar.) Ich kenne dann noch einen holländischen Pseudo-dadaisten, er ist aber kein Dadaist. Holland aber,

HOLLAND IST DADA

Unser Erscheinen in Holland glich einem gewaltigen Sieges-zug. Ganz Holland ist jetzt dada, weil es immer schon dada war.

Unser Publikum fühlt, daß es DADA ist und glaubt, dada

Nagy, Burchartz and other avant-gardists contributed to the seminal 1925 issue of the Book Printers' Union's *Communications*, devoted to 'elemental typography' (*right, below*) and edited by Jan Tschichold (whose poster of 1927 for the film *Napoleon* is *above*). The visual principles of Constructivism and De Stijl are here combined with the newer ideas about letters enunciated (*far right, below*) by the critic Franz Roh: abandonment of upper-case letters and gothic or even seriffed typefaces in favour of lower-case grotesque faces like Paul Renner's Futura (1926). Renner and Tschichold both taught in the Book Printers' Master Course at Munich, more influential than even the Bauhaus (card, 1926, *right, above*).

RICHTFEST BAUHAUS NEUBAU
EINLADUNG

● 4h führung durch den bauhaus-neubau
● 7h richtschmaus im volks- und jugendheim bauhofstraße
anschließend tanz
sonntag
21. 3. 26

HERTHA RIESE
DIE SEXUELLE NOT UNSERER ZEIT

typographische mitteilungen

zeitschrift des bildungsverbandes der deutschen buchdrucker leipzig ● oktoberheft 1925

sonderheft

elementare typographie

natan altman
otto baumberger
herbert bayer
max burchartz
el lissitzky
ladislaus moholy-nagy
molnár f. farkas
johannes molzahn
kurt schwitters
mart stam
ivan tschichold

warum 4 alphabete, wenn sie alle gleich ausgesprochen werden (großes lateinisches, kleines lateinisches, großes deutsches, kleines deutsches)? warum 4 verschiedene klaviaturen einbauen, wenn jede genau dieselben töne hervorbringt? welche verschwendung an energie, geduld, zeit, geld! welche verkomplizierung in schreibmaschinen, schriftguß, setzerkästen, setzmaschinen, korrekturen usw.! warum hauptwörter groß schreiben, wenn es in england, amerika, frankreich ohne das geht? warum satzanfänge zweimal signalisieren (punkt und großer anfang), statt die punkte fetter zu nehmen? warum überhaupt groß schreiben, wenn man nicht groß sprechen kann? warum die überlasteten kinder mit 4 alphabeten quälen, während für lebenswichtige stoffe in den schulen die zeit fehlt?

die kleine schrift ist „schwerer lesbar" nur, solange sie noch ungewohnt. „ästhetischer" ist sie nur für die verflossene zeit, die in der architektur das auf und ab von dächern und türmchen wollte.

unser vorschlag wäre puristisch? im gegenteil: wir sind für bereicherung aller wirklichen lebensregungen. aber alle 4 klaviaturen drücken ja dieselben lebensregungen aus.

und das „deutsche lebensgefühl"? hatte unser eigenstes gut, die deutsche **musik** etwa nötig, eine deutsche (und vierfache) notation hervorzubringen?

franz roh

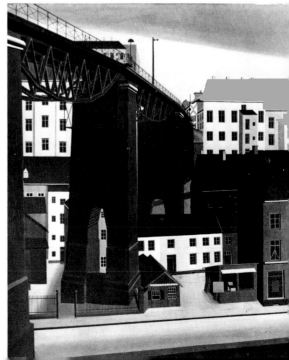

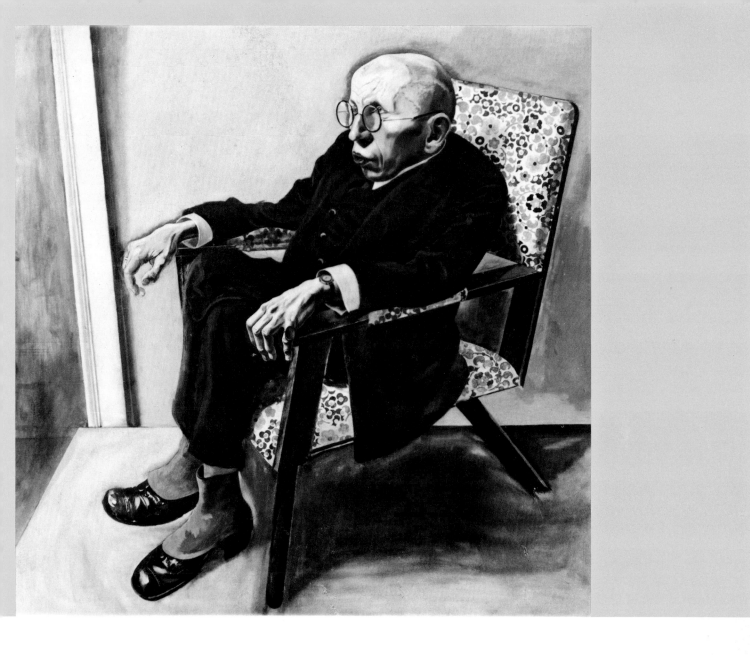

AMBIGUITY OF THE NEW -ISM

'Sachlichkeit' really means 'matter-of-factness' rather than mere 'objectivity', and the organizers of the 1925 Neue Sachlichkeit exhibition at first thought of its unflattering approach as necessarily implying an element of social criticism. This is true of George Grosz, whose portrait of the poet Max Herrmann-Neisse, 1924 (*above, right*), was bought for the city collection, and also of Scholz's now vanished *Banker*, 1924 (*right*), which has none of the alienating distortions of his later work. Carl Grossberg's *Wuppertal Viaduct*, 1927 (*left*), seems more neutral but its subject is still an industrial city, of which even a photograph would have social implications. The former Dadaist Hannah Höch, however, (*far left*) achieves objectivity in her *Glasses* (1927) not only by her style but also by her impersonal choice of objects to paint, though there seems a conscious symbolism which brings her close to the 'Magic Realist' wing of the movement. This Magic Realist element in Neue Sachlichkeit was due to the Munich critic Franz Roh, who selected a number of south German artists for the Mannheim exhibition, including Alexander Kanoldt (see p. 126) and the former Verists Mense and Georg Schrimpf (*above left* is his *Girl in Southern Bay*) who had now gone over to a gentler form of classicism based on the new establishment art of Fascist Italy. The 'magic' aspect of its rather artificial stillness links it somewhat remotely to Surrealism and seems quite different from the cold detachment of Neue Sachlichkeit proper.

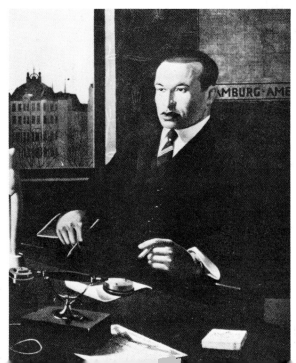

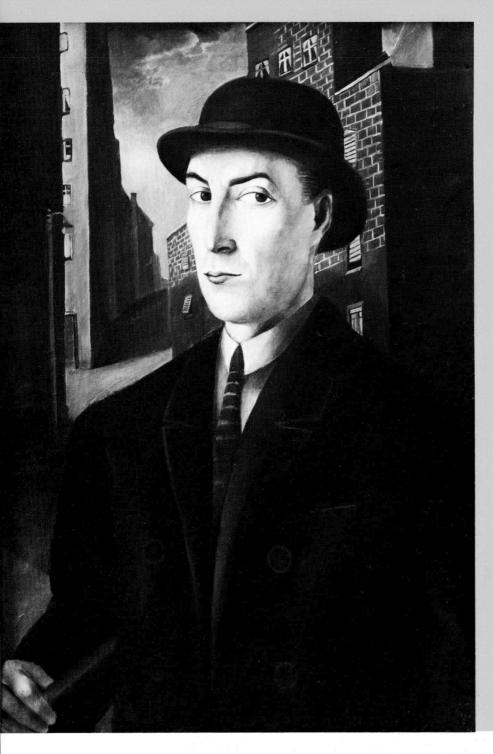

PAINTING WITH A HARD EDGE TO IT

Hard hats and a gloomy urban background characterize these works – all but one self-portraits – by artists of the original Neue Sachlichkeit exhibition: *centre*, Anton Räderscheidt (*Man and Lantern*, 1924); *below right*, Max Beckmann (etching, 1924); *left*, H. M. Davringhausen as painted by Carlo Mense (1922); and Georg Scholz (1926). This cool but still uncompromising style

derived from the earlier Verism and
formed the main element in the Mann-
heim show, where it could also be seen
in portraits by Dix and Grosz (see
previous page).

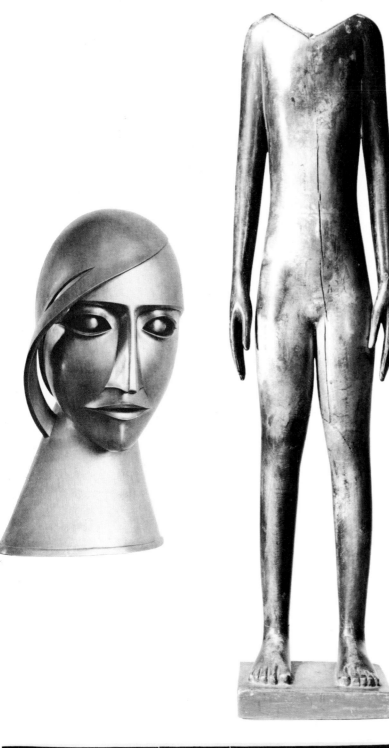

SCULPTURE PUBLIC AND PRIVATE

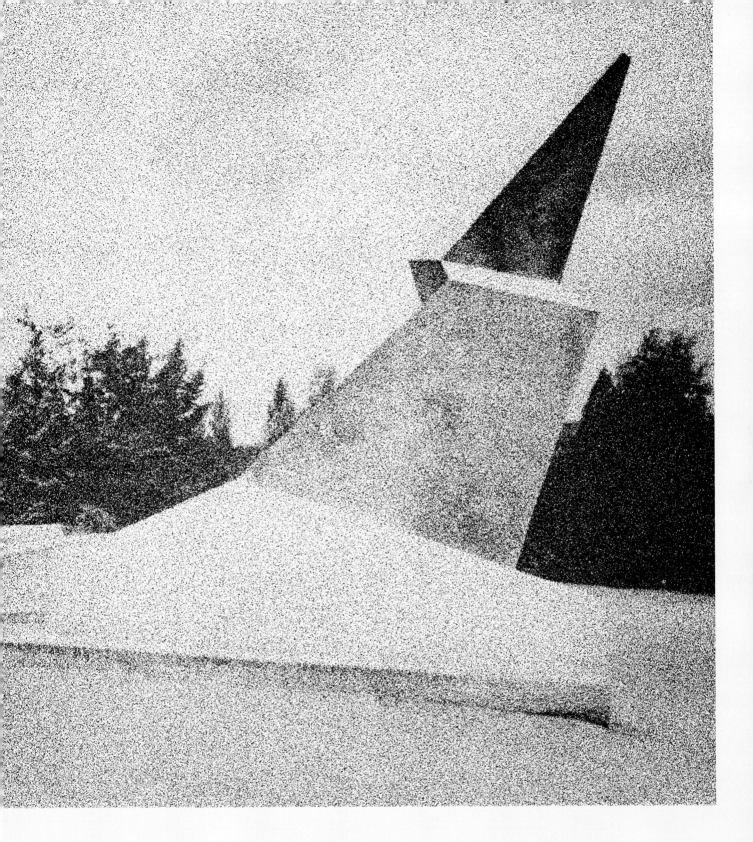

The Novembergruppe produced two notable sculptors, Rudolf Belling and Ewald Mataré. At one time quite prolific, Belling is now largely forgotten outside Germany, but after being the leading Expressionist sculptor in the years 1918–22 he moved into a calmer and more formalized phase as in the brass head of 1925 (*far left above*). Mataré was best known before 1930 for his near-abstract carvings of cows. His standing wooden figure (*left above*)

relates to the neoclassical figures of traditionalists like Kolbe, Adolf von Hildebrand and Gerhard Marcks; but it also recalls the sculpture of Ancient Egypt. *Left, below*, the triply-photographed plaster head and torso by Oskar Schlemmer dates from 1921–3, when he was teaching at the Bauhaus. In it his particular vision of 'man' – a central subject of his painting, teaching and theatre work – gets its most perfectly balanced expression. All

these examples are figurative, unlike the abstract-symbolic public sculpture (*above*) which Gropius made for Weimar in 1922. This memorial to nine local workers killed resisting the Kapp *putsch* seemed to suggest that Gropius's new unpolitical stance was not wholly in accordance with his convictions. This stance might serve the Bauhaus's interests while things were quiet, but in the long run it was not believed.

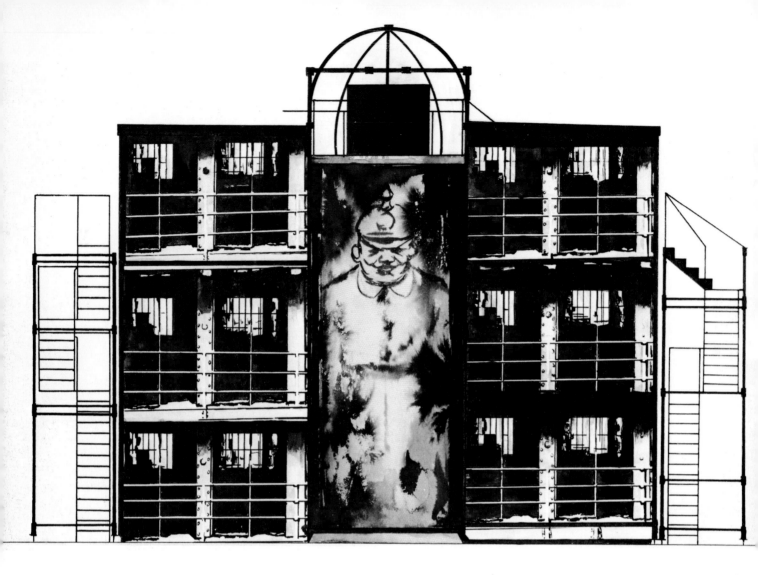

PISCATOR'S POLITICAL THEATRE

The two practitioners of 'epic theatre' were Erwin Piscator and his sometime *Dramaturg* Bertolt Brecht. Piscator formed his own Berlin company, after working for the Volksbühne, a Socialist-led 'People's Stage', and staging some early Berlin agitational productions for the Communist Party. With his new company he used a variety of new mechanical techniques – film, projections, lifts, treadmills, multiple and hemispherical sets – to keep the action moving and provide historical and documentary background. *Above, left and right*, the first production: Toller's *Hoppla, We're Living* (1927) about a disillusioned revolutionary returning, like its author, from gaol: *left*, Traugott Müller's stage design; *right*, the set itself with Piscator's shadow on its screens. *Below*, the last production after an interlude of bankruptcy: Walter Mehring's *Merchant of Berlin* (1929), about an immigrant Jewish financier in the inflation period. Its sets and film were by Moholy-Nagy, its music by Hanns Eisler. Privately financed and dependent on a moneyed audience, the company was (voluntarily) subject to the Communist Party to which Piscator and a number of his collaborators belonged.

PISCATORBÜHNE

Ludwig Klopfer
im Theater am Nollendorfplatz

Anfang 7½ Uhr

Der Kaufmann von Berlin
ein historisches Schauspiel aus der deutschen Inflation
von
Walter Mehring
Inszenierung: Erwin Piscator

Gesamtausstattung: L. Moholy-Nagy Musik: Hanns Eisler
Bühnentechnik: Herbert Selinger Assistenz:
Film: Herbert Breth-Mildner
 Regie: Moholy-Nagy Orchester:
 Aufnahmen: Alex Strasser Weintraub Syncopators
 Zeichentricks: Elwitz-Schönfeld (m. Genehm. d. „Wintergartens")
 Rhythmik: Claire Bauroff

P e r s o n e n :

Kaftan	Paul Baratoff	Kneifer	Erich Bartels
Lodenrock	Hermann	Arbeiter	Albert Venohr
	Speelmans	Schreiber	E. Bornträger
Bauersfrau	Edith Angold	Schaffner	Fritz Erpenbeck

Gepäckträger: Karl Hannemann, Leopold Lindtberg, Friedrich Gnas
Huren: Ilva Günten, Lotte Loebinger, Felicitas Niedermayer.
Marta John, Frieda Bohm, Hella Bialer

Greise Männerstimme	Jacob Schöps	?. Polizist	Kurt Lieck
Heisere Männerstimme	Friedrich Gnas	Alter Mann	Ernst Busch
Wurstmaxe	W. Bernhardy	Arme Frau	Ilva Günten
1. Polizist	Erich O. Peters	Kleines Kind	Grete Merory

Frauen: Edith Angold, Bertl Eisenberg, Felicitas Niedermayer, F. Bohm, Kaethe de Neuf

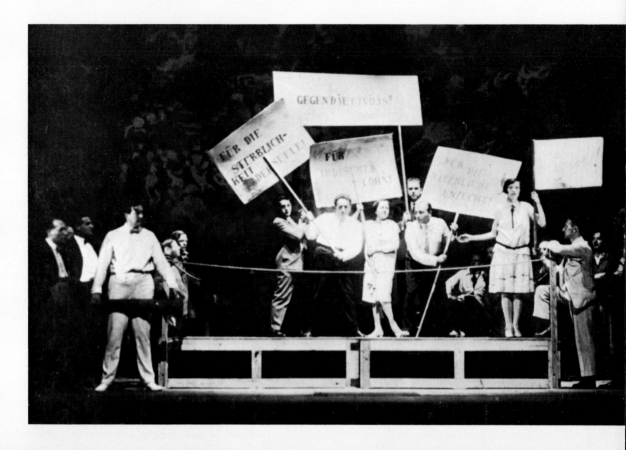

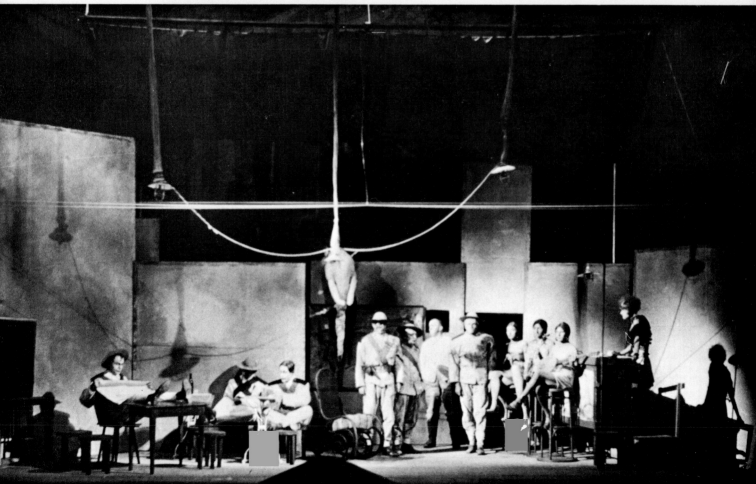

BRECHT'S EPIC THEATRE

Brecht arrived in Berlin from Bavaria in 1924, after having had his prize-winning play *Drums in the Night* staged all round the country. The first work which he wrote after settling there was *Man equals Man*, an immensely long farcical play about Kipling's India and the malleability of human identity. In 1926 this had simultaneous premières at Darmstadt (*left, below*) and Düsseldorf, and though at first it only reached Berlin in the form of a broadcast it made a great impression on the 27-year-old Kurt Weill, who forthwith wanted to collaborate with the writer. In the spring of 1927 they began working on the opera *Rise and Fall of the City of Mahagonny*, but this was interrupted first by the need to produce a short version (or *Little Mahagonny*) for Hindemith's Baden-Baden music festival that summer (*left, above*), and then in early 1928 by a Berlin producer's commission for a version of *The Beggar's Opera*. This resulted in *The Threepenny Opera*, the greatest Berlin theatrical success of the decade. The firm yet elegant sets for all these works were designed by Caspar Neher, whose Essen colleague Hein Heckroth drew the very Neue Sachlichkeit portrait of Brecht in 1926 (*left*). Brecht himself helped stage the *Little Mahagonny* in a form of boxing-ring: he is seen on the right of the ring, with raised leg; Weill's wife Lotte Lenya, then a wholly untrained singer, is holding her placard next to him. It was just at this time that Brecht began elaborating his theory of 'epic theatre', which differed from Piscator's in making no appeal to the audience's emotions and having no didactic or topical, political element. Rather it was concerned with narrative structure – with such principles as the appeal to reason, the renunciation of empathy, the clear separation of the dramatic components and the inducement of a detached attitude in the spectator. At that stage, Brecht, though already intrigued by Marx, was some way from being a Communist.

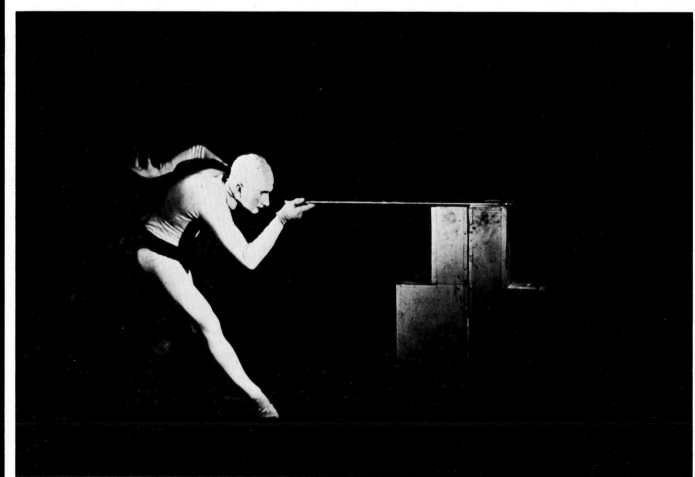

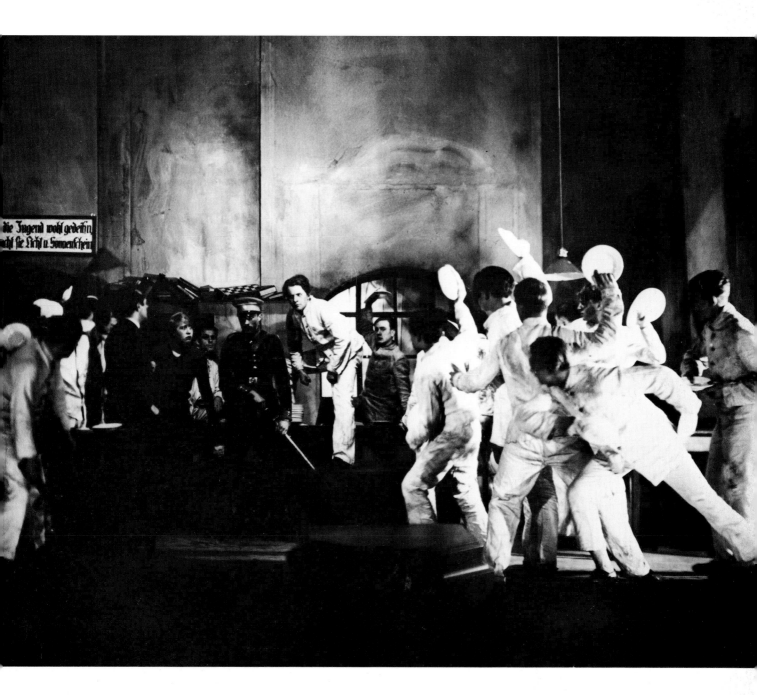

TOWARDS THE FRINGE

Following the collapse of the first Piscator company there were two developments which largely shaped the remaining years of the republican Berlin theatre. The 'Zeitstück', topical play or "play of the times', became a recognized genre usually with a social rather than political theme. And left-wing actors, drawn in the first place from those used by Piscator or attending his four studios, now began forming their own cooperatives. *Rebellion in the Rehabilitation Centre*, 1928 (*above*), by P. M. Lampel was one of their most

outspoken plays and also among the few to be successfully revived in the 1970s: it was acted by the new 'Group of Young Actors' led by Fritz Genschow (centre, with raised leg); others included Ferdinand Bruckner's *The Criminals* and Friedrich Wolf's pro-abortion play *Cyanide*. Of true 'fringe' theatres, that of Oskar Schlemmer's at the Bauhaus was the most remarkable, up to and even after its dissolution in 1928. Here a number of wholly experimental projects were worked out, whether in the form of Schlemmer's

own dances (like the 1927 'building block game' *below left*), or mechanical happenings (like the 1923 *Mechanical Ballet* by Kurt Schmidt, Bogler and Georg Teltscher; *above left*). There were various links here with the recognized theatre: thus Gropius worked on Piscator's 'Total Theatre' design – still in some ways more advanced than any theatre yet built – while Moholy-Nagy designed sets for him and for the Kroll Opera and Schlemmer too designed for the latter. For cabaret, see pp. 104–5.

SILENT CINEMA
AFTER THE STABILIZATION

Part of the price of American financial support was a deal of 1925 between Paramount, MGM and the German UFA by which the Germans committed their film industry to a subordinate place. Nevertheless, they continued to produce first-rate silent films even after the end of the Expressionist wave so highly esteemed by critics like Siegfried Krakauer. Here, for instance, are examples of work by two major directors – Fritz Lang and G. W. Pabst – and by Hans Richter, the former Dadaist who became a leader of the European avant-garde. *Far left* are two stills from *Metropolis* (1926) by Lang; (*above*) a futuristic street scene from this strange techno-utopian fantasy, with (*below*) a slightly Schlemmer-style figurine seemingly walking away from it. The strip immediately *left* comes from Richter's *Ghosts before Breakfast* (1928), a short experimental film for which Hindemith wrote a musical accompaniment. *Below*, Greta Garbo plays her first role outside Sweden in Pabst's *The Joyless Street* (1925), one of a series of urban 'Street' films.

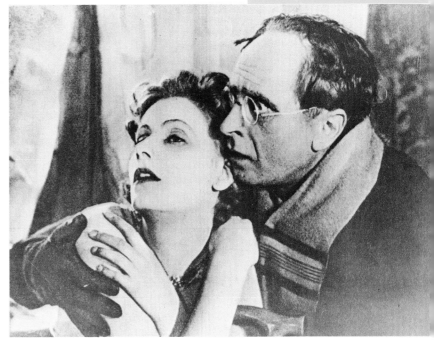

REGIE:
S.M. EISENSTEIN

Panzerkreuzer
„Potemkin"

94

FILM AND PUBLIC OPINION

The German Left embraces the movies. During 1925 Willi Muenzenberg's book *Conquer the Film* (*below, left*) proposed to the workers that they should take over the new medium for their own ends, rather as they were to take over photography. It was he who thereupon set up the Prometheus import company which gave Eisenstein's *Battleship Potemkin* (poster, 1925, *far left*) and other Soviet revolutionary films their first foreign distribution. The same year Chaplin's *The Gold Rush* made an impact comparable with that of *Potemkin* (which itself was to be more warmly received in Berlin than in Moscow), playing to full houses at Hans Poelzig's newly opened Capitol Cinema, *left*, one of several outstanding cinema buildings. *Bottom right*, Muenzenberg's weekly *AIZ* opens its arms to Chaplin, here featured on its cover in 1929 between Upton Sinclair and Egon Erwin Kisch under the heading 'Three people pulling in the same direction'.

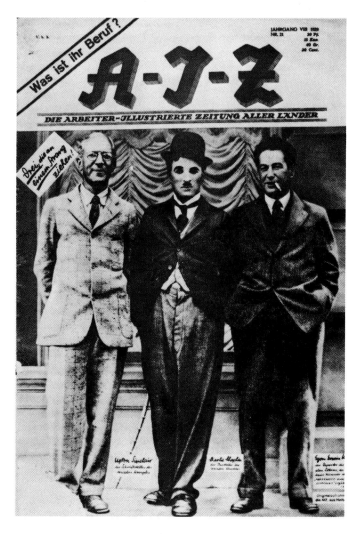

Following the world première of Berg's *Wozzeck* in December 1925, given in the Prussian State Opera with Leo Schützendorf in the title part (*right, below*), modern opera mushroomed. Forty new operas were premièred in Germany in 1926, another forty-three in 1927, sixty more in 1928. At the heart of this development was Otto Klemperer, who took over the second state opera or Kroll-Oper in autumn 1927 with a policy of rehabilitating the classics (using singers who could act, and modern designers) and staging some of the most important new works. *Far right, below*, he is seen with Stravinsky, whose *Oedipus Rex* had its stage première here in February 1928. *Below*, his assistant conductor Alexander Zemlinsky, himself a composer and brother-in-law to Schönberg – whose then unknown *Erwartung* and *Die Glückliche Hand* were among the works performed, along with operas by Hindemith,

Krenek and others. (*Top*) two examples of the Kroll's radically new staging: (*left*) Janáček's *From the House of the Dead* in sets by Caspar Neher (1931) and (*right*) a Moholy-Nagy design for *The Tales of Hoffmann* (1929). Though no other theatre quite approached the Kroll, operas as novel as Krenek's jazzy *Jonny spielt auf*, Max Brand's *Maschinist Hopkins* with its factory setting, Grosz's *Achtung, Aufnahme!* set in a film studio and Antheil's *Transatlantic* were staged in provincial houses across Germany.

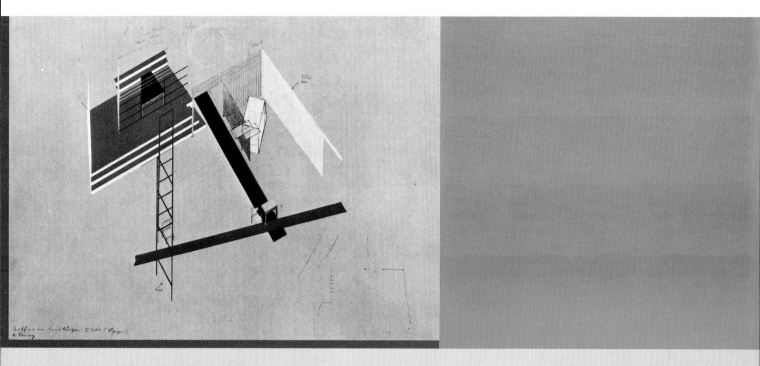

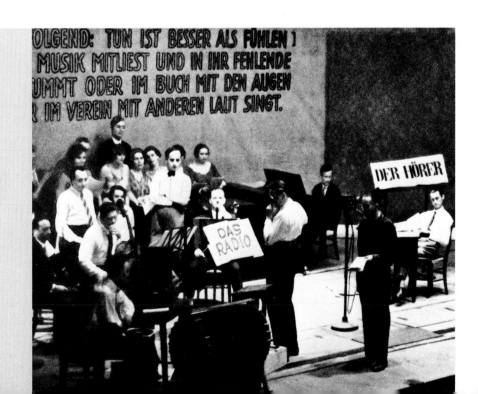

NEW FORMS OF MUSIC

The musical innovations of the 1920s were not confined to such matters of harmony and structure as Schönberg's twelve-note system. Rather they involved new uses, new levels and new instrumentation. One major influence here was American jazz, which the young Paul Hindemith (photographed, *far left*, by August Sander in 1926) first heard in 1921 and found a model of economical orchestration and dynamic drive. Even more than in France jazz was also taken seriously by writers and artists; thus Lux Feininger, the painter's son, photographed two members of the Bauhaus band (*right*) in 1928, while Carl Hofer painted his six-man band a year earlier (*below*). Hindemith's concern, however, broadened to embrace the whole problem of music's changing functions in a modern society, to which he devoted four of his small-scale festivals at Donaueschingen and Baden-Baden. Among the new avenues explored at Hindemith's festivals between 1926 and 1929 were mechanical music, radio and film music and miniature operas (like the *Little Mahagonny*) – all subsumed under the term *Gebrauchsmusik* (or 'utility music') – and music for children, amateurs and instructional use – known as *Gemeinschaftsmusik* (or 'community music'). It was in this connection that Brecht collaborated with Hindemith and Weill in 1929 to write the first two *Lehrstücke* or didactic pieces: a new cantata-like form combining drama and concert performance. One of these, *Lindbergh's Flight* (inspired by the first solo Atlantic flight in 1927) was designed for broadcasting (*left, below*). Hindemith's own instructional opera for children *We're Building a City*, 1931 (*left, above*), recalls the SPD poster on p. 72. Both utility and community music were seen at the time as an extension of Neue Sachlichkeit.

THE BALLET

Ballet in Germany had developed outside the main Russian-Italian-French tradition (and the only German ballet commissioned by Diaghileff – Richard Strauss's *Josephslegende* on a libretto by Count Kessler – has never been a success). The eurhythmic element is stronger, closer to modern dance, as may be seen overleaf. Nevertheless there was one outstanding new ballet by the Essen choreographer Kurt Jooss, a satire on international conferences called *The Green Table* (*far right, bottom*) first staged in 1932 with music by F. A. Coen and designed by Hein Heckroth. Schlemmer's *Triadic Ballet* (1922, *right*), an experimental Bauhaus work, later acquired music by Hindemith and a number of professional stagings. *Far right, top*, Wilhelm Grosz's *Baby in the Bar* was a very 1920s ballet with a jazz orchestra on stage; it was produced at Hanover in 1928. *Below* is Teo Otto's collage-based design for the Kroll Opera's performance (1930) of Debussy's *Jeux*, whose sporting subject and athletic choreography also fitted the new ethos of the times, as expressed in Hannes Küpper's poem of 1928 'Suzanne the Divine' (she being the Wimbledon champion Lenglen).

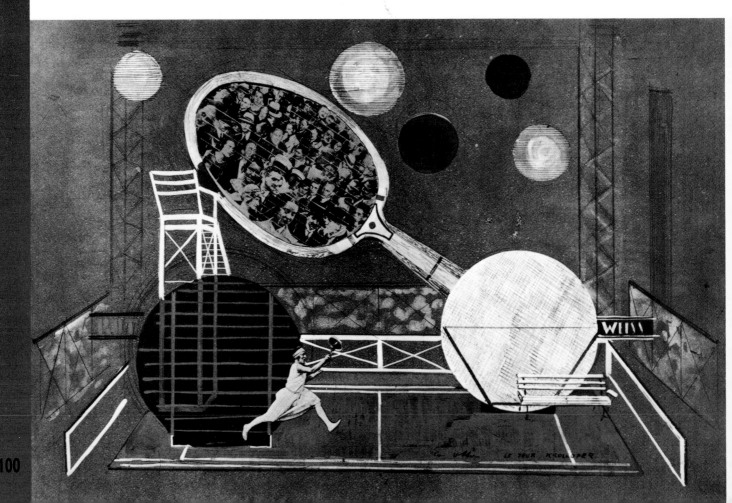

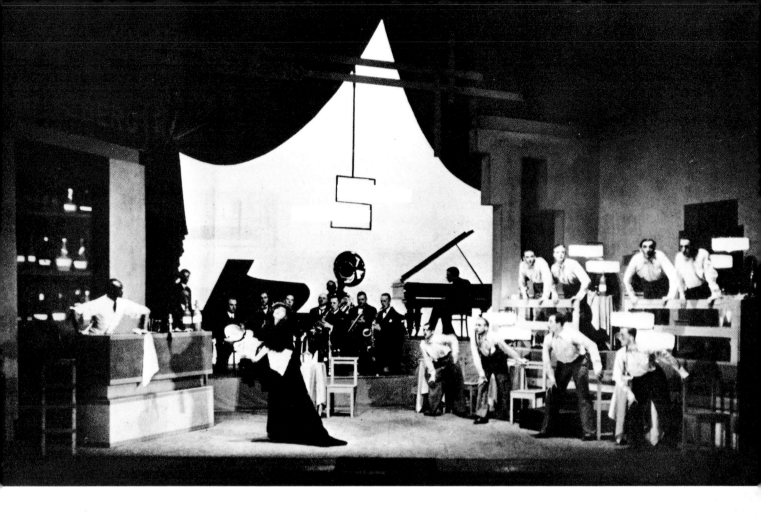

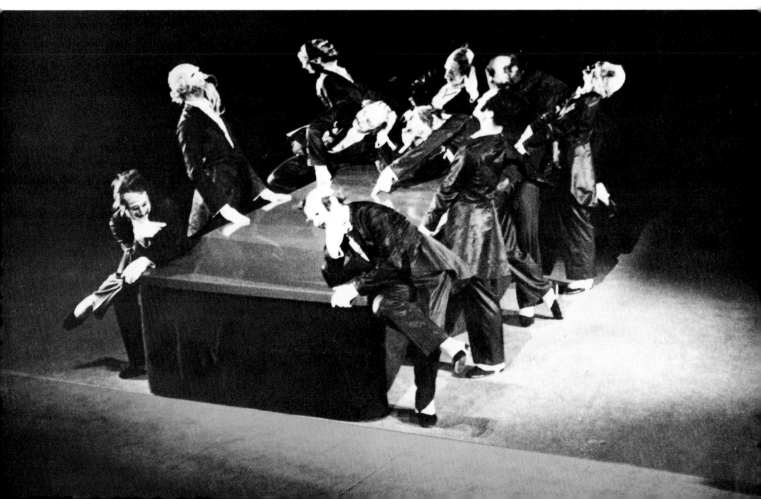

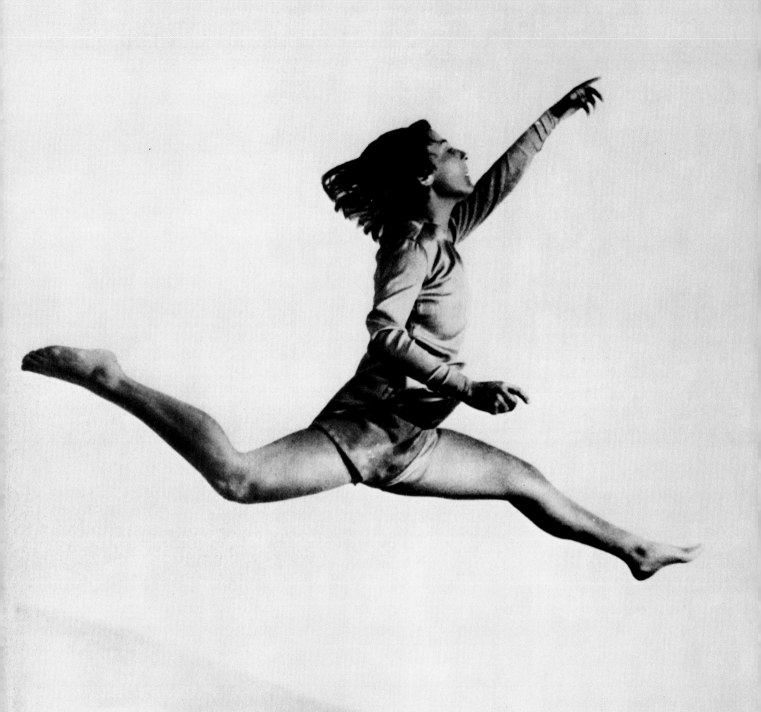

A DIFFERENT DANCE

The basis of German ballet was a school of dancing whose great figures were not Enrico Cecchetti and the Russians but Jaques-Dalcroze and Rudolf von Laban. The former brought his school of eurhythmics (a highminded blend of gymnastics and Isadora Duncan) from Geneva to Hellerau, where he was later succeeded by Grete Wiesenthal. Male dancers were rare, the best known being Harald Kreutzberg, who performed Schlemmer's *Triadic Ballet* in 1926. He and many of the women were pupils of Mary Wigman (*below*), herself a disciple of Laban's. Gret Palucca, photographed by Hugo Erfurth around 1929, *left*, was remarkable for her athleticism. One critic saw German dance as essentially Expressionist and related it to the women's movement: 'sanctification of the body, without recourse to men'. Artists could use it: thus Kandinsky (*top centre*) caught Palucca's rhythms (1926) while Schlemmer graphically planned the evolution of a 'gesture dance' (*below*).

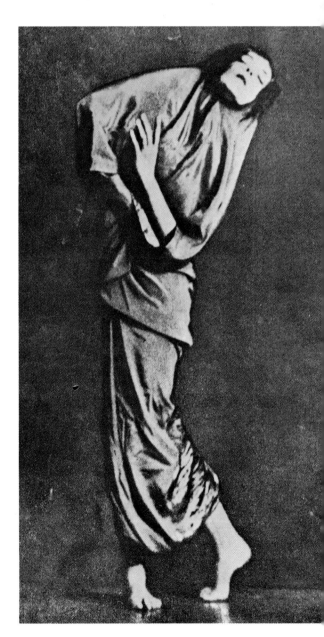

In the romantic (or 'golden twenties') image of Weimar the cabaret plays a central part. Its links with the other arts were indeed important, even though they stem from an older tradition, going back to the Paris of Steinlen and Bruant and to Frank Wedekind's Munich. *Bottom left*, it certainly appealed to the ex-Dadaist Rudolf Schlichter, a boot fetishist and brother of a well-known

Berlin theatrical restaurateur, while (*bottom right*) Grosz and Heartfield made the poster (1919) for Reinhardt's 'Noise and Smoke' cabaret beneath the Grosses Schauspielhaus. *Below*, an artist from that stable provides the background for Trude Hesterberg to sing Walter Mehring's 'Stock Exchange Song' in a dress decked with dollars. Among other serious writers involved

in cabaret were Kurt Tucholsky and Erich Kästner; Brecht too made occasional contributions, particularly in his more 'political' phase after 1929. Among the performers the archetypal figure is Marlene Dietrich, seen (*right*) with Margo Lion and Oskar Karlweis in the 1928 musical *Es liegt in der Luft* featuring Marcellus Schiffer's song about Neue Sachlichkeit.

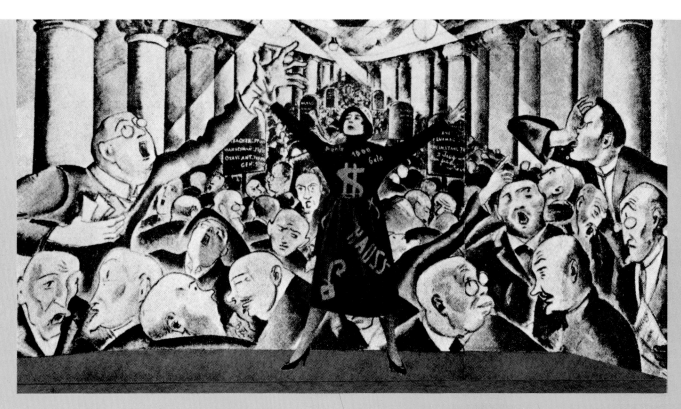

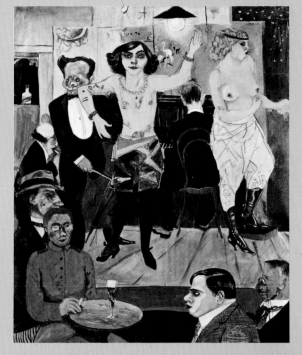

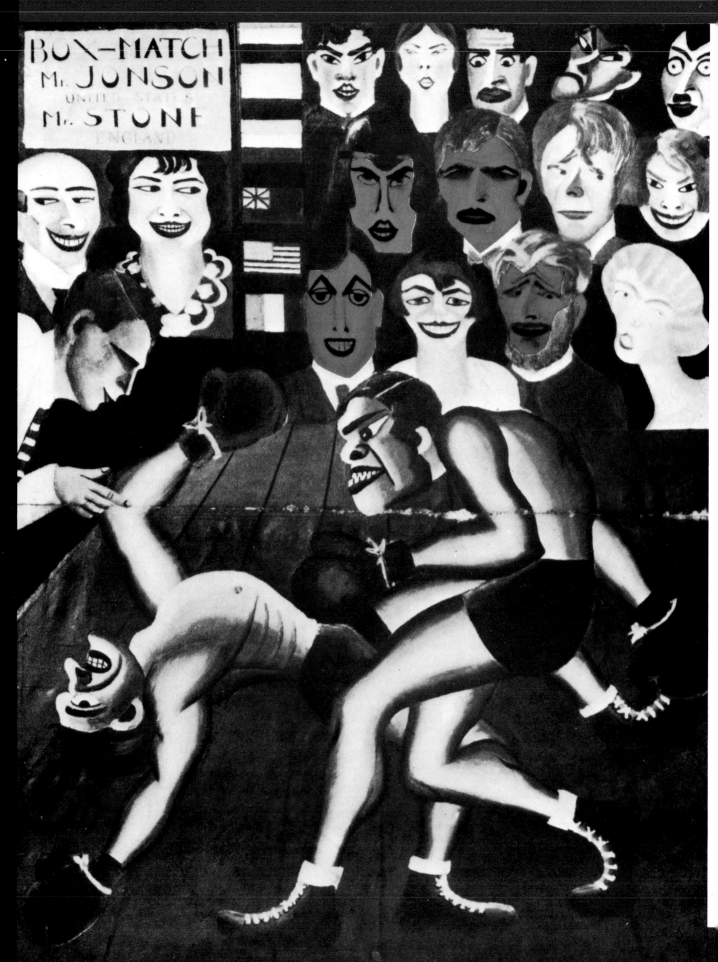

BOXING TOO

The intellectual vogue for boxing attracted artists like Krenek, Piscator and Brecht and reached its peak with the half-highbrow Berlin sports magazine *Arena. Far left*, a contest between a British and an American boxer provides the subject of this painting of 1919–20 by Karl Günther, a member of the Dresden Sezession. Among the audience are not only the artist's future wife Viola Schulhoff (middle of second row) but his friends Otto Dix (right of her) and Otto Griebel (below, with beard). Erwin Schulhoff, the Prague composer, can be seen behind the boxer's head. He became one of those who, like Weill, Wilhelm Grosz and, more briefly, Krenek, began making effective use of jazz for serious musical ends.

George Grosz also used boxing imagery as part of his cult of toughness and hard-boiled Americanism. The posed contest (*right*) between him and little John Heartfield, refereed by the latter's brother Wieland Herzfelde, poet and director of the Malik publishing house, looks rather tame, but his painting of 1926 (*above*) deals in Neue Sachlichkeit vein with a more serious pugilist. Max Schmeling, its subject, was the best-known German boxer of the decade – he shared the national light-heavyweight title that year, won the heavyweight championship in 1928 and beat Sharkey for the world title in 1930.

AND FOOTBALL: THE NEW ACTIVE AESTHETIC

Few who contributed to Weimar culture can themselves have been former footballers as was the Communist journalist Egon Erwin Kisch (p. 66). But here are three masterly renderings of the game, starting (*top*) with what must surely have been one of the finest sporting photographs to date. It was taken by Max Schirner around 1929 and was included by Franz Roh and Jan Tschichold in *foto-auge* (*Photo-Eye*) which they published at the time of the Stuttgart 'Film und Foto' exhibition that year. *Left*, Max Beckmann's painting *Rugby Players*, now in the Duisburg gallery, comes from the same year.

Generally his pictures of the 1920s have a certain coolness and detachment that relates them to Neue Sachlichkeit. Much the same applies to Willi Baumeister whose photomontage, *right*, also dates from around 1929. Usually thought of as a follower of Léger who subsequently abandoned figuration, he in fact produced a number of paintings of sportsmen and athletes between 1925–30. Perhaps the essence of all such work is that it applied a modern vision to genres that the urban population found entertaining, and produced skilful, artistic but also intelligible results.

The culture of cities

The most evocative name, at the centre of all Weimar culture, is always Berlin. *Cabaret* (another magic word) goes back to *I am a Camera*, which in turn derives from *Goodbye to Berlin*, Isherwood's marvellous sketches of life in that city as the Republic was collapsing. The name of the then undivided capital of the country actually suggests a sharper picture than does Weimar, which to anyone versed in German history conjures up the Weimar of Goethe's and Schiller's time, if not also that of Nietzsche and the early twentieth-century court which employed Kessler and Henry van de Velde. And yet the picture is wrong. Too often it is suffused with a golden glow: marvellous theatre, hectic premières at the three opera houses, unique political cabarets, golden girls like Marlene Dietrich and Lilian Harvey, husky-voiced singers, all performing on a thin but brilliant crust which hid the sad realities to come. Half-way to kitsch, this image matches the Paris of Art Déco, that show of fashionable modernism which the Germans were in fact excluded from in 1925. For it too is superficial.

One of the features which so differentiate Germany (and for that matter Italy) from more centralized states is its comparatively recent unification. Even before the Weimar Republic the country's culture had many centres, and some of the most important institutions were outside Berlin: the Gewandhaus orchestra at Leipzig, the Dresden court opera, the Bavarian royal collections in Munich, not to mention all those individual artists and writers who seldom went near the Prussian capital. This applied also in the early years of the modern movement, when such lesser places as Hagen (with the Folkwang Museum) or Darmstadt (with its artists' colony) or Hellerau (the home of eurhythmics) sponsored significant new ideas; indeed neither the Brücke nor the Blaue Reiter movements originated in Prussia. So it should not be surprising that such major elements of Weimar culture as the Bauhaus and the Weissenhofsiedlung (see pp. 70–71) were located away from Berlin, or that well-established provincial art schools like Dresden and Karlsruhe generated their own Dada and Verist movements which developed to a great extent independently of the capital. As for the theatre, Berlin might employ most of the major critics (Bernard Diebold in Frankfurt being an exception) but important premières could equally well take place in Munich, Frankfurt, Hamburg, Düsseldorf, Leipzig and Dresden, and much the same applied in opera too.

In this section therefore we try to show one of the essential features of Weimar culture: its generally even spread over many German cities. These varied – Munich, with its Italianate art and increasingly reactionary politics, being special – but the modern movement was much more widely practised and assimilated than we can illustrate here, and it had many less-known practitioners who were hardly inferior to those now famous. What is very clear

however is that this enviable diffusion was overwhelmingly urban; that is to say that Weimar culture was a culture of city-dwellers, and that a great part of the population remained outside it. During the 1920s the concepts of the Big City, 'Asphalt Literature' and so forth dominated all the arts, and influenced the rare depiction of non-urban people and subjects, which are not on the whole very sympathetically seen. Few of the Neue Sachlichkeit artists even painted landscapes at that time, let alone the country people who live and work there. Brecht may have allowed the feeling of the South German landscape to permeate his early work, but from 1924 on he became wholly preoccupied with 'mankind's rush into the great cities'; his friend Zuckmayer was a rare exception with his warm-hearted comedy *The Cheerful Vineyard* (1925); the modern architecture of Hugo Häring's Garkau farm is seemingly unique. Hence the attitudes that we try to show as linked to Weimar culture – the widely accepted view of women, the abortion law and other topical issues of the time which are echoed in its works of art – remained quite strange to the non-urban population. The political significance of this is easy enough to see. The culture in question was felt to have permeated society because it permeated the centres where culture was practised and judged. The views which prevailed in the country areas outside these were still largely latent, but soon they would come as a massive shock.

The design below was intended for Piscator's 1929 production of *The Merchant of Berlin* (see pp. 86–7), though we are not sure in what connection it was used. Attributed sometimes to Moholy-Nagy, who was responsible for the scenery and projections on that occasion, it is clearly not by him: it is however very like other urban photomontages by the Dutch ex-Dadaist, Paul Citroën, a former Bauhaus student, and may have been meant for projection. The composite city which it features is likewise difficult to identify. The interesting point perhaps is that its buildings are not all that modern. An oppressive congestion relieved only by a steady flow of vehicular and human traffic: that is the main feeling conveyed. Even the signs of industry seem old.

THE CITY STREETS

Three doubtful trios represent urban womanhood. *Left*, Rudolf Schlichter's *Passers-by* lurk – presumably for men. *Top centre*, Dix's *Three prostitutes in the street* (1925) appear to be hurrying each on a different errand. The three women in Karl Hubbuch's *In the dance hall*, 1925 (*bottom*), seem to be allies, all of one mind unaffected by commercial rivalry. Such images of prostitution are frequently associated with German life in the 1920s and particularly with life in the capital, which we still think of as a centre of sexual licence. None the less there were police and other restrictions as noted, *right*, by John Heartfield whose photomontage jacket for Heinrich Wandt's novel *Eros and Espionage in the Ghent Sector* was altered twice in 1928–9 under threat of prosecution, the second time because of the caption 'This is where the censor came in'.

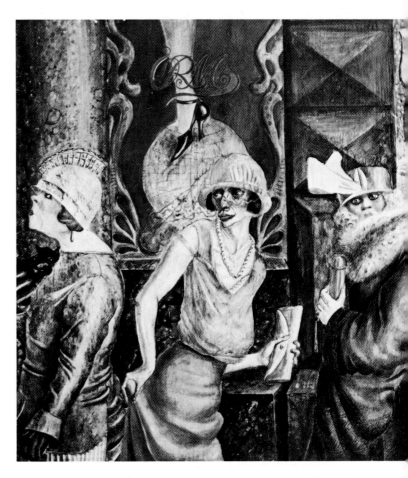

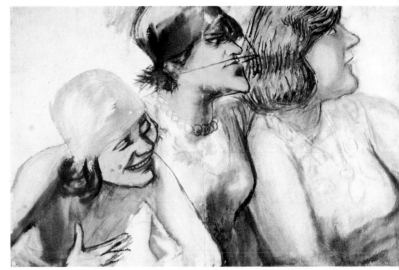

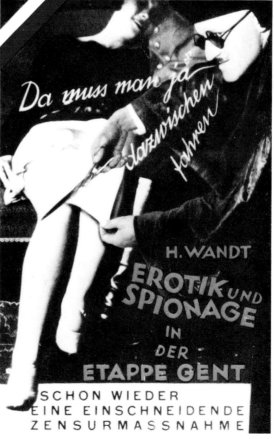

Berlin remains a powerful myth even today. In 1927, when Walter Ruttmann completed his silent 'symphony of a great city' *Berlin* (*right*), it was by all accounts the most modern city in Europe, and it was still booming. The alarm-clock is symbolic of what the composer Hanns Eisler called the 'Tempo of the Time', with its rush and bustle and its 'plays of the time' and 'operas of the time'. Christian Schad's portrait *below* of *The Woman of Berlin* (1928) expresses an equally up-to-the-minute charm.

At the same time there was also an older and shabbier Berlin, which can even now be found, particularly in the Eastern sector. It was frequently painted by Gustav Wunderwald, whose *Underground Station*, 1927 (*above*), has a curiously antiquated air despite its depiction of the station entrance and a cinema. Some of the characteristic inhabitants of this Berlin are to be seen in Otto Nagel's now lost painting *Die Budike*, 1927 (*below*), a quasi-altarpiece for a bar in the working-class district of Wedding, grouped around the central figure of the publican. Nagel, a friend of Käthe Kollwitz, was the organizer of the exhibition of German art in Moscow in 1924, whose emphasis on prostitution struck at least one critic there as disproportionate. In 1928 he played a leading part in the new German Revolutionary Artists' League or ARBKD, a body which seems to have been strongest in Berlin and Dresden.

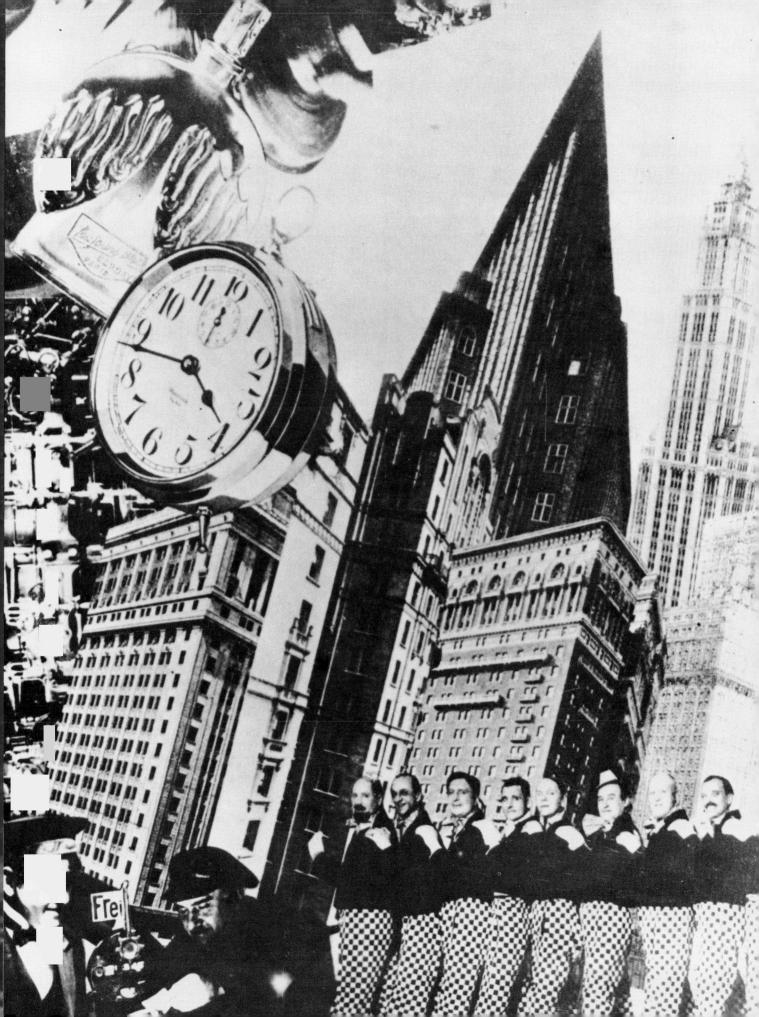

HANOVER

Among the most modern provincial centres, culturally speaking, was Hanover. This was not because of its new architecture, which was less remarkable than that of its satellite Celle, where Otto Haesler designed what seems to have been the Republic's first modern flat-roofed housing estates. Haesler's gymnasium in that town is *bottom right*. But it was a pubishing centre where Paul Steegemann produced Expressionist writings by Kasimir Edschmid, Carl Hauptmann and Heinrich Vogeler and important Dada works by Arp, Hülsenbeck and Schwitters. Schwitters ran his 'Merz' operation from his house there which later became a *Merzbau* (*bottom centre*); as a successful publicity agent he organized a national 'Ring of new publicity designers' in 1927. He had made a close ally of Lissitzky, whose photomontage portrait of him (*top left*) dates from 1924, and both men designed for intelligent local patrons (e.g. Lissitzky for Günther Wagner, *top centre*). The private 'Kestner Society' of art lovers published Lissitzky's *Prouns* and *Victory over the Sun* prints, and in 1928 he designed the local museum, a unique gallery for abstract art (*top right*). At the same time there was a flourishing school of Neue Sachlichkeit artists like Greta Jürgens (*bottom left*).

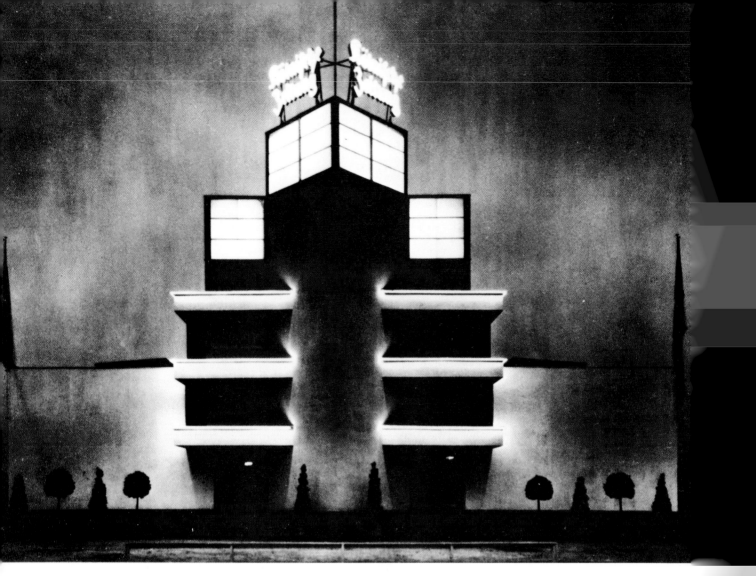

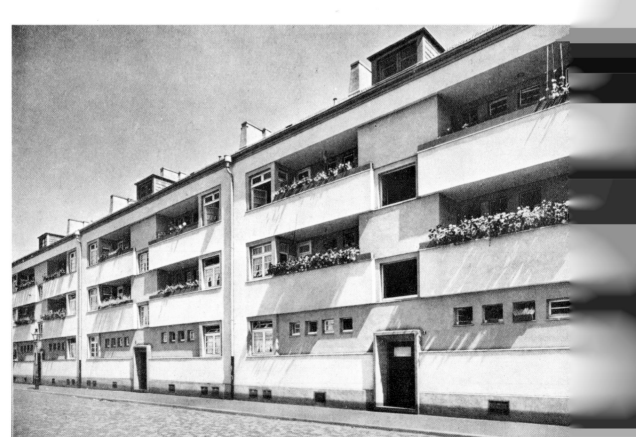

COLOGNE

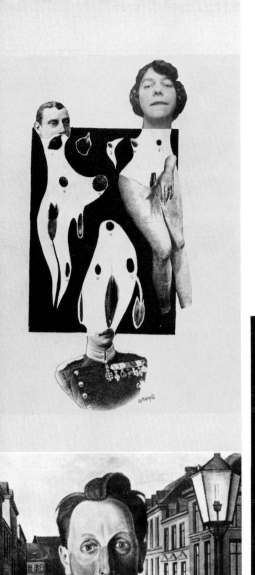

Cologne too had its Dada movement, centring on Johannes Baargeld (*left, above*) and Max Ernst. Access to the 1920 Cologne Dada show was through a public convenience; then in 1921 Ernst moved to Paris and Baargeld abandoned art. There was also an active socialist artists' group called 'The Progressives', with Heinrich Hoerle, F. W. Seiwert, Anton Räderscheidt (p. 82) and Peter Abelen, linked also to Sander the photographer and to the Munich revolutionary writer, Ret Marut, better known later as the Mexican novelist B. Traven. *Bottom*: Seiwert's painting of working men (1925). Heinrich Hoerle's *Contemporaries* (*below*) portrays five other local eminences (1931): left to right, a singer, the mayor Konrad Adenauer, an actress, one of the Domgörgen brothers (who became light- and middleweight champions of Europe) and the artist Hoerle. Outside both groups, F. W. Jansen's *Self-Portrait* (*left, below*) is a good example of provincial Neue Sachlichkeit. Cologne was also a centre for exhibitions such as the 1928 Pressa exhibition when Lissitzky designed the Soviet exhibit and Walter Riphahn the local paper's pavilion (*opposite, above*). Riphahn also designed modern housing, like the 1925 flats in the suburb of Bickendorf (*opposite, below*).

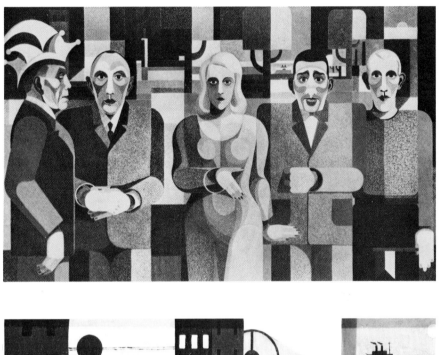

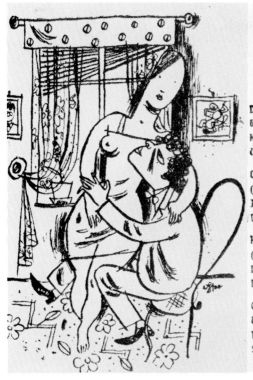

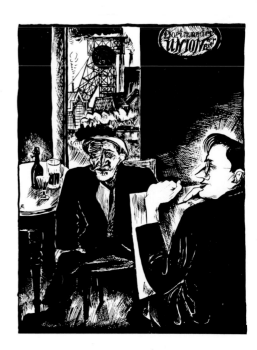

Abendlied

des Kammervirtuofen

von **Erich Käſtner.**

Du meine neunte Sinfonie!
Wenn du das Hemd an haſt mit roſa Streifen . .
Komm wie ein Cello zwiſchen meine Knie,
Und laß mich zart in deine Seiten greifen!

Laß mich in deinen Partituren blättern.
(Sie ſind voll Händel, Graun und Tremolo) —
Ich möchte dich in alle Winde ſchmettern,
Du meiner Sehnſucht dreigeſtrichnes Oh!

Komm laß uns durch Oktavengänge ſchreiten!
(Das Furioso, bitte, noch einmal!)
Darf ich dich mit der linken Hand begleiten?
Doch beim Crescendo etwas mehr Pedal!!

Oh deine Klangfigur! Oh die Akkorde!
Und der Synkopen rhythmiſcher Kontraſt!
Nun ſenkſt du deine Lider ohne Worte . . .
Sag einen Ton, falls du noch Töne haſt!

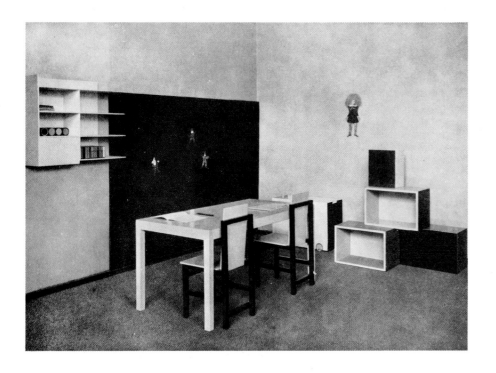

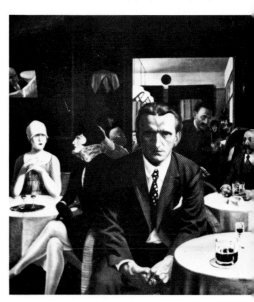

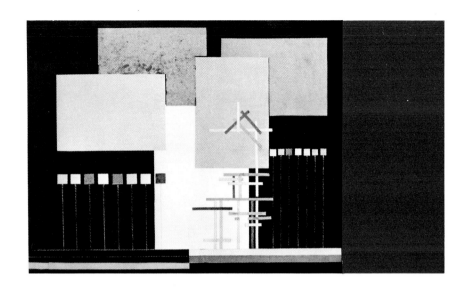

DRESDEN AND BRESLAU

The Dresden theatre and opera have staged important productions ever since the days of the Saxon court. Richard Strauss conducted and had his operas premièred there, while 1916 saw the first German production of Hasenclever's *The Son* at the Albert-Theater, an epoch-making Expressionist play with Ernst Deutsch (*left, centre*) in the leading part. The Academy trained some outstanding draughtsmen, of whom Grosz and Dix were the best known, and throughout the 1920s there was a tradition of socially critical art which developed through Verism (Felixmüller draws *The Proletarian as Model, left, above*) and Neue Sachlichkeit (Griebel's self-portrait, *left, below*) to the actively Communist art of ARBKD painters like Günther (p. 60), Querner (p. 132) and the Grundigs. *Far ,left, above*, another fine artist, Erich Ohser, illustrated that poem by Erich Kästner, master of *Gebrauchslyrik*, which got the poet sacked from the Dresden daily paper for mocking the Beethoven centenary. *Far left, below*, Alma Buscher designed this child's-scale nursery with Marcel Breuer's collaboration.

Breslau too had an active academy, where Schlemmer taught on leaving the Bauhaus in 1929. His design for Stravinsky's *Nightingale* at the Stadt-theater (1929) is *top right*. That year, two years after the Weissenhofsiedlung, the Werkbund sponsored a Breslau scheme whose architects included Heinrich Lauterbach, designer of the terrace, *centre right*, and severely modern lady's bedroom, *below right*. Outstanding among them was the former Expressionist Hans Scharoun, a local member of the 'Ring'.

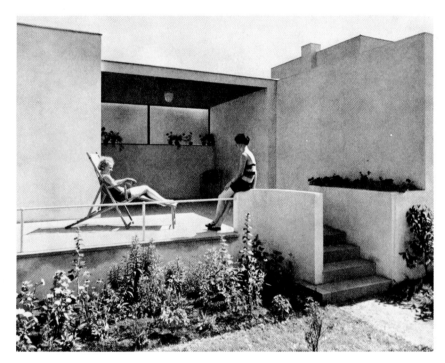

VERLAG ENGLERT UND SCHLOSSER FRANKFURT AM MAIN

V. JAHRGANG · JANUAR 193

1

DAS NEUE FRANKFURT

INTERNATIONALE MONATSSCHRIFT FÜR DIE PROBLEME KULTURELLER NEUGESTALTUNG

adolf loos

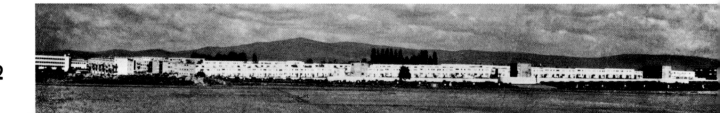

DAS FRANKFURTER BETT

KINDERSCHLAFZIMMER ALS ARBEITSRAUM

Der Einbau von Frankfurter Betten ge-
währleiſtet große Baukoſten-Erſparnis,
ohne die Bequemlichkeit der Bewohner
zu beſchränken. Gleich gut geeignet für
EINFAMILIENHÄUSER · SIEDLUNGEN
HOTELS · HEIME · SANATORIEN
In einfachſter und in Luxusausführung lie-
ferbar, jedoch ſtets in gleicher Stabilität.

HEERDT=LINGLER
G. M. B. H.
FRANKFURT AM MAIN

Beilage zu „Das Neue Frankfurt" 1930, Heft 4/5, Verlag Englert u. Schlosser, Frankfurt a. M.

MODELL 1871 ÜBER DIE SCHMALSEITE KLAPPBAR

MODELL NZ ÜBER DIE BREITSEITE KLAPPBAR

 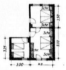

KINDERSCHLAFZIMMER
IN EINEM KLEINSTHAUSE

ELTERNSCHLAFZIMMER
UND ZWEI DOPPELBET-
TIGE SCHLAFZIMMER

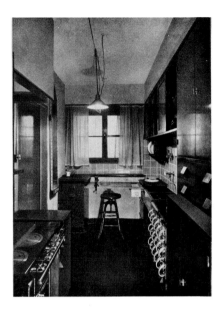

FRANKFURT-AM-MAIN

The New Frankfurt (*opposite*) was a magazine founded by Ernst May's department in 1926 primarily to publicize his city plan, of which three aspects are here seen in the 'Frankfurt Kitchen' (*above*) by Greta Schütte-Lihotsky, the 'Frankfurt bed' (*above left*), for clipping into the local Design Register, and the Römerstadt suburb (*opposite*) so admired by Maillol (p. 15). The principle was to overcome the problem of fitting old-style furniture into the more economically designed new homes by enabling couples to choose and acquire light but well conceived designs. But the magazine ranged much wider, both internationally (e.g. with a study of the Viennese modernist Adolf Loos) and over the very active local scene. Beckmann (whose *Iron Bridge*, *left*, dates from 1922) was teaching at the Städel art school, as was Baumeister. Hindemith was based in Frankfurt till 1927; a number of important theatre and opera premières were held there (or at nearby Darmstadt); while the *Frankfurter Zeitung* with Rudolf Olden as editor was arguably the best German daily paper.

STUTTGART

Stuttgart, like all these cities a publishing centre, was particularly active in propagating the new architecture and the new vision. Not only the various Werkbund exhibitions (like 'Film und Foto', *far right*) and the Weissenhofsiedlung but also the architecture of the city itself showed Stuttgart's will to practise what it preached. Paul Bonatz's railway station is an impressive, if relatively conservative building: Osswald's building for the *Stuttgarter Tageblatt* is one of the first high-rise buildings in Germany: while Mies van der Rohe's project for a mainly glass building next to the station looks very fine in his montage (*left*). Even more remarkable is the Waiblingen sanatorium (*below*) by a local architect, Richard Döcker, which was Germany's first hospital in the modern style.

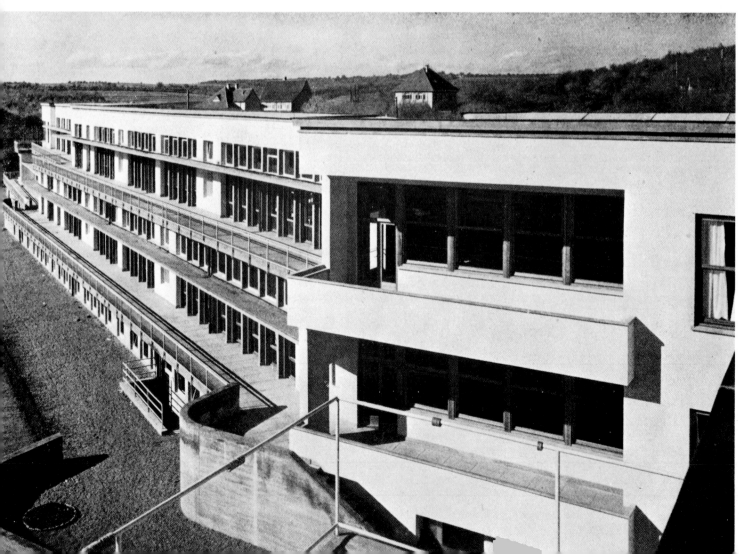

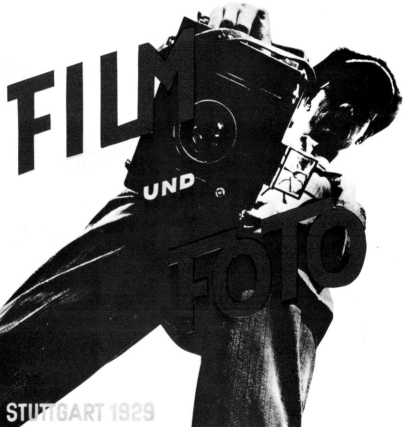

Stuttgart furthermore was a formative centre for artists, thanks to the teaching of Adolf Hoelzel, a colourist who was breaking away from figuration well before 1914, Schlemmer and Baumeister being among his pupils. The latter was a more varied and resourceful artist than is often thought. His designs for Toller's *Die Wandlung* (*above, left*; compare the Expressionist setting in Berlin, pp. 28–9) are simple and resourceful. *Left*, his near-abstract paintings in one of Le Corbusier's two houses at the Weissenhofsiedlung (1927) recall those of Léger for the 1925 Pavillon de l'Esprit Nouveau in Paris. They came about because Le Corbusier never chose to superintend the building of the house or see to its furnishing, which consequently was improvised and sparse. Stuttgart also had a noted writer in Dr Friedrich Wolf, the Expressionist playwright who joined the Communists in 1928. However, theatre and opera in Stuttgart at that time were not so important, and Wolf's reputation was made in Berlin.

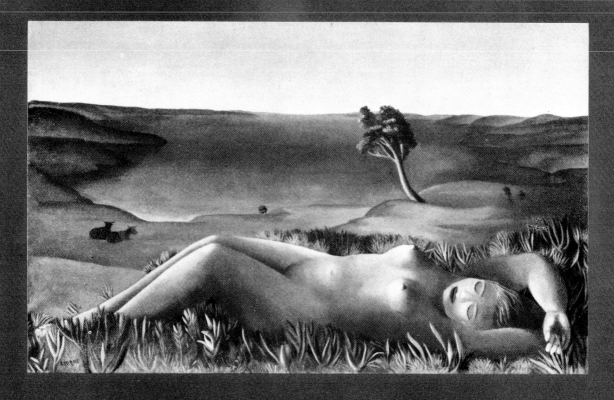

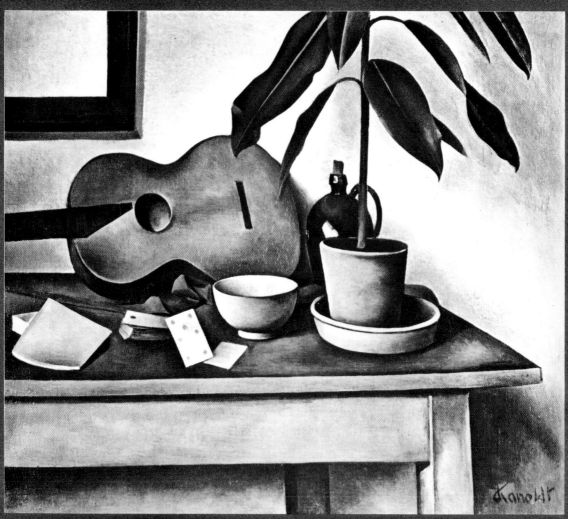

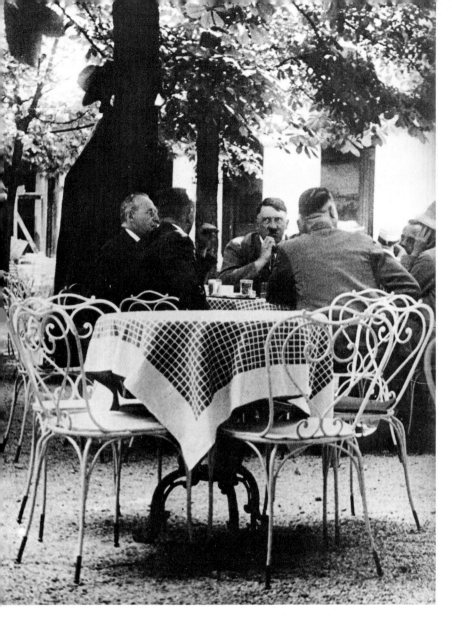

MUNICH

Among the cities already examined – with which we might group Essen, Dusseldorf, Hamburg, Leipzig or Kassel – the odd one out is Munich, artistically the most interesting of them all before 1918. Modern building was not encouraged there in the 1920s, when there was barely a single building with a flat roof. Apart from the typographers Renner and Tschichold the majority of designers there were craft-orientated. Not surprisingly, the local variety of modern art, Roh's 'Magic Realism', signified an artistic reaction in a way that Neue Sachlichkeit proper, with its socially critical eye, did not. Once cofounder of the Neue Künstlervereinigung with Kandinsky, Alexander Kanoldt (*Still-life with Guitar*, 1926, *opposite below*) was perhaps the least compromised, but both Schrimpf (pp. 39 and 80) and Mense (p. 82 and *opposite above*) made sad concessions to the new Italian art. The political analogy is startlingly close. Unwelcome perhaps to the disgruntled beer-drinker (*below*) featured by Tucholsky and Heartfield in their *Deutschland über Alles* (1929), this kind of painting suited the shifty tea-drinker seen the same year in a famous Munich photograph by Tim Gidal (left).

Radkörper zu Radsätzen für Lokomotiven, Tender und Wagen der Voll-, Neben- und Straßenbahnen im In- und Ausland.

Radsterne mit Speichen von 400 bis 2000 mm Durchmesser (Herstellung im Jahre mehr als 30 000 Stück).

Die Einformung erfolgt nach neuesten Erfahrungen, in der Regel auf Rüttelform-Maschinen. Als Material wird je nach Vorschrift und Wunsch der Bahnen Flußeisenguß oder Flußstahlguß in ausgesuchten Qualitäten verwendet. Mechanische Werkstätten mit umfangreichem Arbeitsmaschinenpark bearbeiten diese Radkörper für die Lieferung als Einzelteile oder zum Zusammenbau zu fertigen Radsätzen.

Alle Stahlgußsonderteile wie:

Ober- und Unterteile für Motor-Mantelgehäuse
Motor-Brücken
Rahmenverbindungen
Achslagergehäuse
Federspannschraubenträger
Ausgleichhebelträger
Gleitstuhlträger
Achslagerführungen
Bremswellenlager
Bremsgehängeträger
Lagerschalen usw.

Auch für elektrisierte Bahnen stellt die Stahlgießerei des Bochumer Vereins alle besonderen Werkstücke her, die bei hoher Festigkeit und großen Abmessungen möglichst niedriges Gewicht, also geringe Wandstärken aufweisen müssen. Ein Musterstück dieser Art ist das abgebildete Lagerschild für elektrische Schnellzuglokomotiven Type 2 C 2. Bei 5,6 m Länge und 2,5 m Höhe beträgt das Gewicht nur 4000 kg.

Die Stahlgießerei des Bochumer Vereins besteht seit 1858

Radsterne für Tender- und Straßenb...

THE INDUSTRIAL EYE

Industry was a common aspect of the Weimar scene, though it might be handled either as economic reality or as socio-political myth. In Germany as in other countries the working class was often viewed as an undifferentiated mass even by those who saw it as the hope of mankind. Thus Karl Völker, *left, above*, presents his *Workers' Canteen* (1923) as a group of featureless adjuncts to the factory wall. Carl Grossberg on the other hand (see p. 80) became known for his almost photo-realist approach to such scenes as *Oil Tanks*, 1933 (*below*), sometimes featur-ing the odd fantastic creature but rarely a human being; there are suggestions here of the English artists Edward Wadsworth and Tristram Hillier – buildings and technical installations frozen like a monster still-life. *Left, below*, the photographers too could indulge their interest in objects, as in this folder by Max Burchartz of Essen, who applies Bauhaus principles to the products of a big Bochum steel and coal combine. His development from Expressionism via Dada to high-quality industrial public relations can be traced via pp. 51, 62.

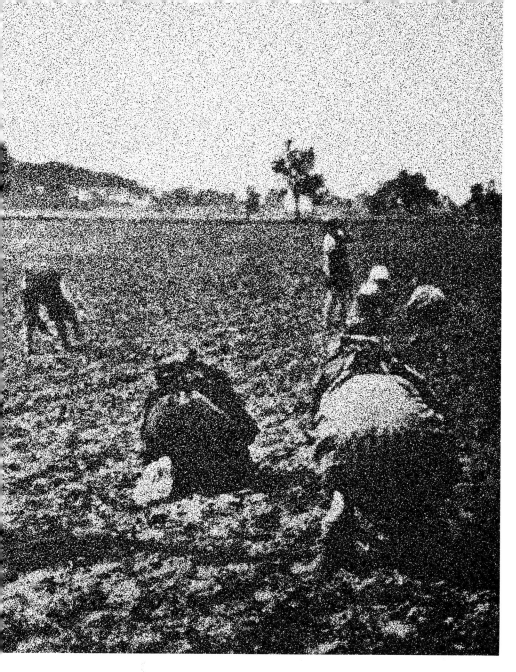

NEW VIEWS OF THE LAND

It was rare for the Weimar artists to turn a critical or constructive eye on the country. *Left*, this view of 'the master' or bailiff supervising land workers is not consoling like Max Liebermann's early paintings or those of the Barbizon painters from whom he learned. It is seen through the unflattering lens of a 'worker-photographer' who sent it to Muenzenberg's *Der Arbeiter-Fotograf*. *Far left*, Hans Fallada's exceptional first novel after his return to writing at the end of the 1920s dealt with the Social Democrats and their difficult relations with the countryfolk whom, as Prussia's majority party, they had to govern. The surly farmer on the cover is by the Munich draughtsman Olaf Gulbransson. *Bottom left* is the only recorded agricultural building by an architect of the modern school, Hugo Häring's Gut Garkau near Lübeck. Häring was secretary of the 'Ring' group to which Gropius, Mendelsohn and other leading figures belonged. *Bottom right*, the unending furrows of the North German plains were photographed about 1928 by Arvid Gutschow, a senior civil servant who pursued photography as a brilliant amateur. Generally, these pictures seem to relate to the relatively poor, sandy and unsmiling countryside of Prussia and the Northern borders, home of the Worpswede artists and of Barlach's sculptures. It is not what is customarily thought of as 'artists' country'.

ARE PEASANTS PEOPLE?

If it was rare for artists to see 'the workers' as individuals, the peasants were even more remote from them. Barlach (*below*) set an example of stylized animality which was hard to break away from. But there were some exceptions. Thus Karl Hubbuch could make credible *Duck Thieves* (*left, below*) in the no-man's land between town and country, while Curt Querner (*left, above*) takes a human yet equally unromantic view. *Opposite* are three farm workers photographed for posterity by August Sander in 1929.

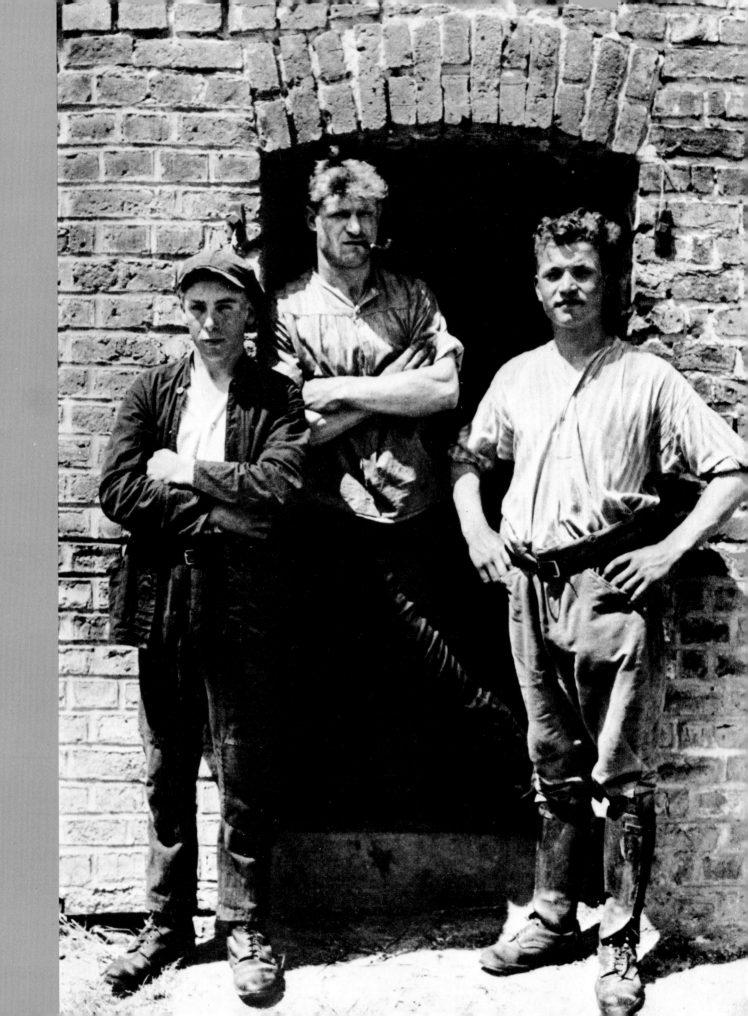

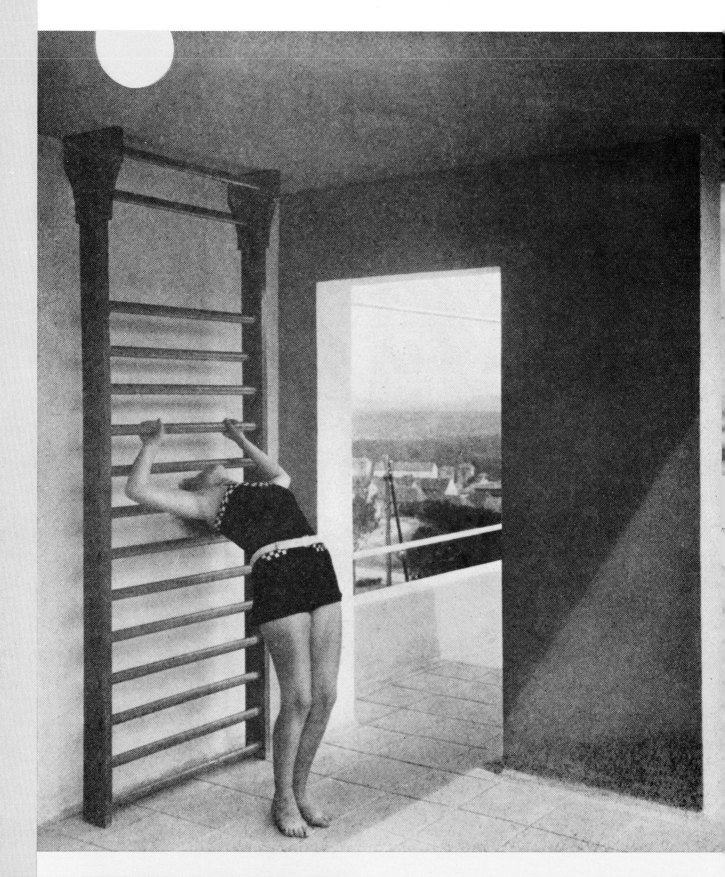

THE CITY WOMAN

The healthy outdoor woman cultivating her physique was no more rural a figure than were the boxers and footballers of male athleticism. In the new urban architecture there was frequently room for gymnastic apparatus, as in Piscator's Berlin flat designed by

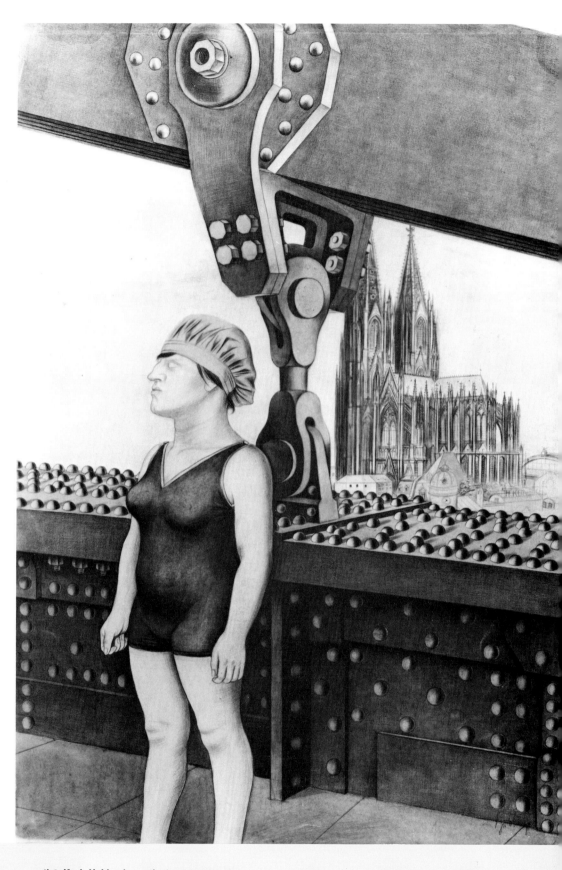

Gropius and Marcel Breuer, and here, *left*, we find an unknown person in a bathing-dress exercising on the roof terrace of Döcker's Weissenhofsiedlung house in 1927. *Right*, a more imaginative conjuncture, where another bather is arbitrarily placed by the artist Karl Hubbuch against a great city's best known monuments: the cathedral at Cologne and the massive nineteenth-century girders of the Hohenzollern railway bridge across the Rhine nearby. Painted in 1927, he called her *Die Schwimmerin von Köln*.

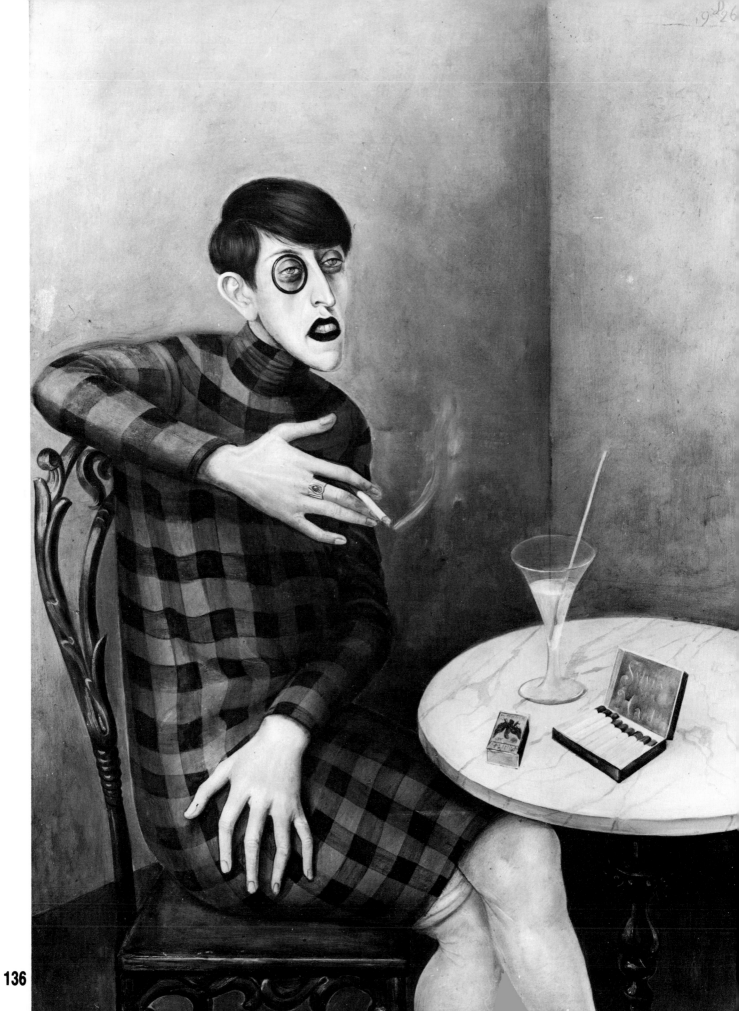

FEMININITY AND NEUE SACHLICHKEIT

Athleticism apart, the artist's eye was seldom flattering. *Left*, Otto Dix's portrait of the Dresden journalist Sylvia von Harden (1926). *Below*, a secretary at the West-German radio (1931) by Sander.

THE CAMPAIGN FOR LEGAL ABORTION

'Away with paragraph 218' says the banner carried in a Hamburg women's demonstration, *opposite*. 'People's struggle against para. 218' says the poster *below*, announcing a speech by a Communist deputy and a showing of the film *Cyanide* in spring 1929. *Right*, Nagel's paragraph 218 looms like a back street abortionist above a sleeping woman. 218 was the paragraph of the Prussian civil code making abortion illegal, and many Weimar artists joined the campaign against it. Brecht wrote a poem, which Eisler set to music, featuring a nationalist doctor. Wolf wrote *Cyanide* as a play and was prosecuted under the code: the poster shows a still from the film. Another play, *§218* by Carl Credé, was staged by Piscator in 1929 as a performance-cum-discussion and successfully toured round Germany.

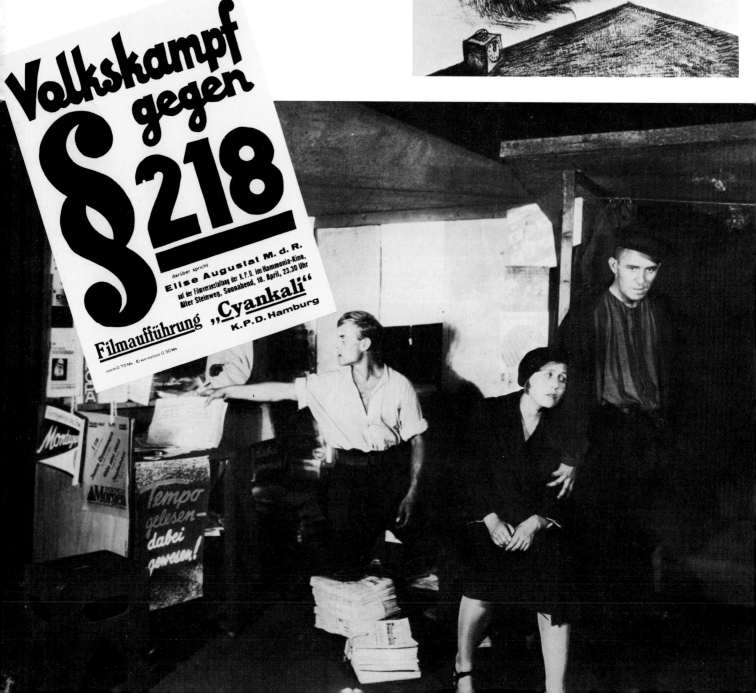

Volkskampf gegen § 218

darüber spricht
Else Augustat M. d. R.
auf der Filmveranstaltung der K.P.D. im Hammonia-Kino,
Alter Steinweg, Sonnabend, 18. April, 23.30 Uhr

Filmaufführung „Cyankali"
K.P.D. Hamburg

Eintritt 0.70 Mk. Erwerbslose 0.30 Mk.

Hinweg mit dem Paragraph 218

MEDICINE MEN

Besides Friedrich Wolf and Richard Hülsenbeck, such significant literary figures as the novelist Alfred Döblin and the poet Gottfried Benn were also doctors, while Käthe Kollwitz's husband Karl was a clearly most devoted general practitioner in the working class area of Berlin where they lived. Nevertheless, the image of the Weimar doctor was not entirely benevolent, as can be seen from these Verist and Neue Sachlichkeit examples. *Above*, Otto Dix painted the Düsseldorf urologist Dr Hans Koch in 1921; the doctor stands alarmingly there, with a slight smile almost indistinguishable from his duelling scars, amid the fascinating apparatus of his speciality. *Right*, Christian Schad's *Operation* of 1929 was painted when he was living in Berlin: again the tools are depicted with great exactness and a certain gruesome relish. Even the photographs on the opposite page show something of the same fascination. *Above* is a technical medical photograph which was included in *foto-auge* (1929); by definition it must have appealed to the editors' eyes. *Below*, the great Berlin surgeon F. Sauerbruch, famous for his innovations in thoracic surgery, is seen by the insidious Salomon examining a patient in front of a medical seminar. While his colleagues concentrate on the demonstration the camera focuses on the dangling skeleton.

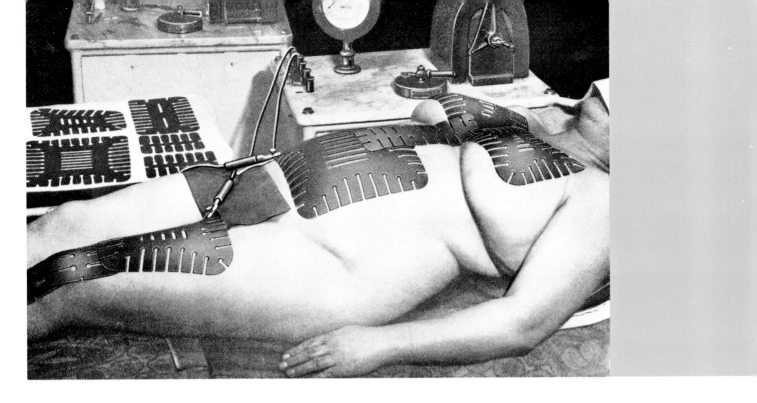

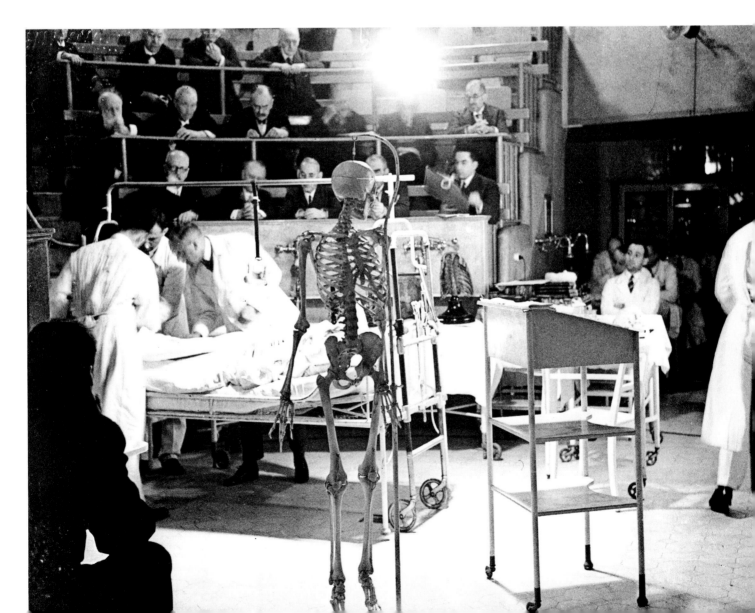

BODY CULTURE FOR ALL

The cult of exercise and bodily exposure, which Count Kessler explained as part of the same way of life as the new architecture, went back to Germany's first gymnastic movement, that of 'Father' Jahn, and the 'artistic' nudity of nineteenth-century academic painting. Here are all three aspects, each of them in its way 'progressive'. *Left*, a still from UFA'S very successful high-toned nudist film of 1925, *Ways to Strength and Beauty*. *Right*, members of a 'democratic workers' sports association' in 1930 singing as they march in aid of a 'sporting festival of the [Weimar] Constitution'. *Centre*, the blonde, shingled American model posing in the new tennis shorts comes from the small book *Liberated Living* by the Swiss art historian Sigfried Giedion, secretary of the CIAM and lifelong super-pundit of modern architecture. The cult needed only minor changes to make it acceptable to the Nazis.

RADBALLSPIELE · FLUGVORFÜHRUNGEN · MASSENPYRAMIDEN
GYMNASTIK · GERÄTETURNEN · RIESENFEUERWERK · KONZERT

Das neue praktische Tenniskostüm, dessen allgemeine Einführung in Amerika angestrebt wird. Spezialdienst.

SPORTLICHE VERFASSUNGSFEIER
10 AUG 1930 · 19 UHR · FLUGPL FUHLSBÜTTEL ZUR FRE
VORFÜHRUNGEN DURCH DAS ARBEITERSPORTKARTEL

Economy and backlash 1929–33

In the summer of 1928 the first Socialist-led government since 1919 came to power, and within a few months German politics were polarized as they had not been since 1923. Partly this was the effect of Comintern policy, which demanded that the KPD (or German Communist Party) should treat social-democracy as its principal enemy and divide all those organizations, whether trade-union or cultural, where the two movements had previously formed a common front. Partly it was the result of the world economic crisis of 1929, which turned many of the new unemployed into Nazi supporters and made Hitler's the second biggest party after the 1930 elections. Partly it was due to the death of Stresemann, whose sense of international realities had led him to check any ultra-nationalist feelings in his right-centre party; the Rapallo policy of friendship with Russia quickly came to an end. The upshot was that from 1929 the Nazis were once again a major political force and a rival of the KPD for the popular vote. Meanwhile instead of uniting against the growing danger the Left was being deliberately split.

With the re-emergence of the Nazis (who had only twelve parliamentary seats before the elections) came their new campaign against all forms of 'un-German' (i.e. foreign-, Jewish- and especially negro-influenced) art. This certainly helped to orchestrate the growing opposition to works like Piscator's *Merchant of Berlin* production and the Brecht-Hauptmann-Weill *Happy End* in 1929 and to *Mahagonny* a few months later, though as yet it was

only decisive where there was a Nazi administration, as in the case of the former Bauhaus buildings in Weimar, where Schlemmer's murals were now painted out. The major threat however came at first from short-sighted economy measures, such as led to the closure of the Kroll Opera and the Dessau Bauhaus – in both cases with the assent of the Socialists – and to the shelving or rejection of controversial works. With the Communists now setting up their own independent writers', artists', amateur actors' and choral organizations and the formation of new professional actors' collectives (like the Group of Young Actors seen on p. 90) an 'alternative' left-wing cultural establishment came into being, with its own press and its own artistic forms which owed much to agit-prop. The old cultural links with Russia now became an exclusively Communist preserve.

Like the 'golden twenties' the red dawn that followed is something of a myth. True enough, the feeling that revolution was at last on its way stimulated some of the Republic's most exciting works during those final years when Walter Benjamin and Brecht were prophesying the fall of the bourgeois arts' 'apparatus' and, with Eisler, Piscator, Heartfield, the film directors Piel Jutzi and Slatan Dudow and the revolutionary writers Ludwig Renn, Anna Seghers and Friedrich Wolf, began developing new forms for a new kind of public. Moreover the confrontation with the Nazis – the 'Internationale' versus the 'Horst-Wessel Song' as it were – certainly gave their works a special

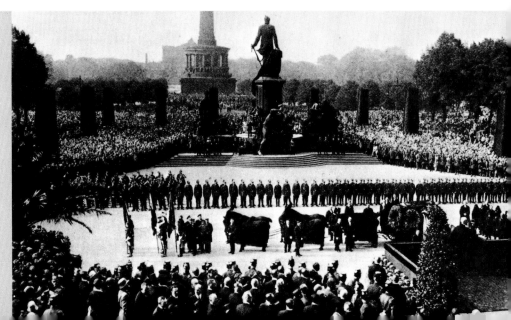

tension and bite. The trouble was however that the KPD remained under the spell of the Comintern's anti-Socialist policy, and however much it might dislike and despise the Nazis it never took them seriously. Even sceptics like Brecht thought that Hitler was a puppet, put in power by Hindenburg and his industrialist and landowner backers as a last desperate measure to stave off the inevitable social revolution. In fact, just because their eyes were closed to a large part of the German electorate (and maybe the German psyche), the more the Communists progressed at the expense of the moderate Left and the more satisfyingly comprehensive their alternative system became, the less they saw what was really happening.

Much of the excitement of Weimar culture is due to such ambiguities. The hopes with which it was born led straight to disillusion, the revolutionary expectations with which it ended helped let the Fascists in. Even the central period of stability, with its exemplary new cultural coherence, was based on borrowed money and borrowed time, so that its modernism proved to be no more than a thin, if surprisingly extensive, crust. Our last pictures can only give the briefest of hints as to what this meant. But the hearty masculine jollity of the new films, the blood-and-soil sexiness of the peasant nude and the burning of 'degenerate' books are symptomatic of what came next. And eighteen months after the final photograph was taken Hitler was president and the pathetic old body in the middle was under the earth.

On May Day 1929 there was a ban on the traditional processions in Berlin. The Communists defied it and were bloodily dispersed by the police (*far left*). Six months later, Stresemann's death and funeral coincided with the Wall Street crash. In the ensuing economic and political crisis the Socialist-led Great Coalition collapsed and with it the last hopes of democratic government. The new chancellor, Heinrich Brüning of the Catholic Centre party (photographed by Salomon, 1931) governed for two years by use of emergency decrees. Meanwhile six top-hatted Socialist leaders followed their ex-premier Hermann Müller to his grave: an act symbolic of their party's powerlessness and stagnation. Soon they had surrendered hold on the Prussian government and the Berlin police, and Hitler's way was clear.

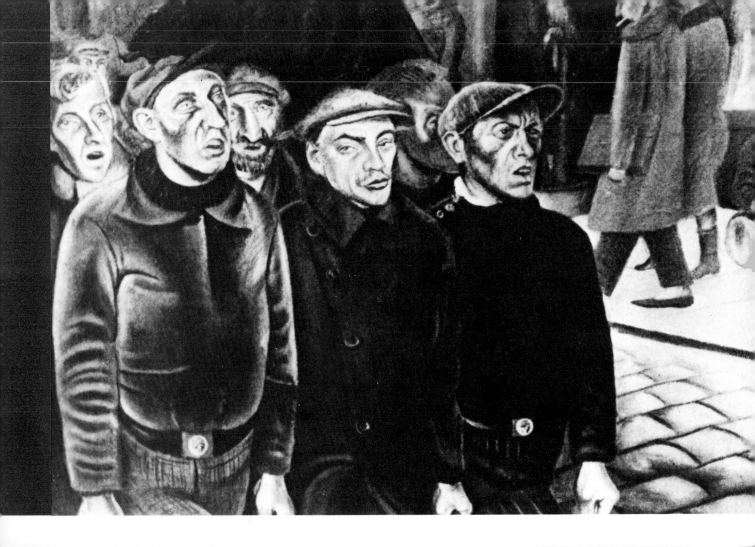

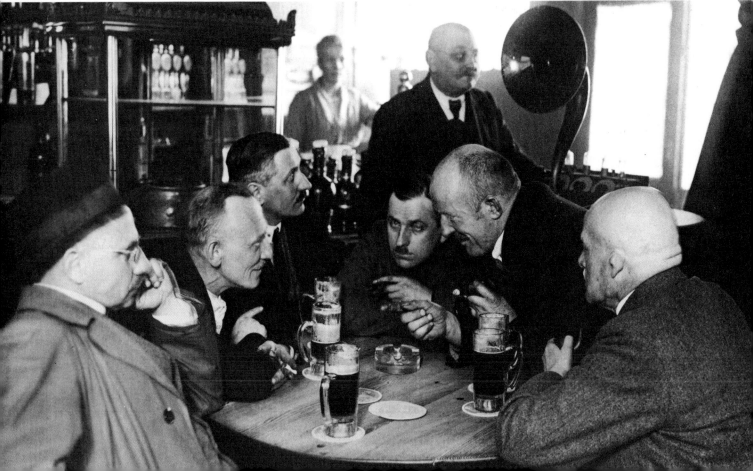

With the breakdown of democracy and the swelling unemployment the electorate favoured the extreme parties: the Communists and (for the first time since 1923) the Nazis. Particularly in Berlin, but also in Hamburg and middle Germany – in other words the old 'red' areas – the battle was carried into the streets. Here (*opposite, top*) Curt Querner of the revolutionary artists' association ARBKD depicts a 'demonstration' of class-conscious proletarians in 1930. *Below*, brown-uniformed SA Storm Troopers parade secretly in a wood: they were legalized by Brüning's successor Von Papen in mid-1932. *Above* them their allegedly martyred hero Horst Wessel, who was killed in a Berlin brawl over women and gave his name to the Nazi anthem, with its line 'Make the streets free for the brown battalions'. Delighted to be pushing the Social Democrats to the sidelines, the Communists underrated the effect of Papen's Prussian coup which gave the central government control of the biggest police apparatus in Germany, free now of any democratic checks. Their dismissal of the Nazis as capitalist puppets and their Marxist faith in the industrial working class ignored the views of the lower middle-class voter as seen about 1930, *opposite, bottom*, listening to a political broadcast. He meanwhile was moving towards Hitler in cultural affairs as well as in politics.

FAITH IN THE INTERNATIONAL

The International, subject of these pictures, was doubly significant for the short-sighted confidence of the KPD. On the emotional level, Pottier's hymn, here being sung by Käthe Kollwitz's idealized workers (*below*) and Otto Griebel's cleverly massed chorus of individuals (*right*), including the artist himself with his hand on a mineworker's shoulder, acted as ideological cement for the party and its friends. More practically, they relied on the actual machinery of the Third International to back them up in what they now saw as a revolutionary situation. Thus they felt able to lose ground temporarily to the Nazis, confident that they had a secure base in Moscow, which many Communists saw as a second home – and sometimes as their first. Griebel by this time was a leading member of the Dresden ARBKD, having graduated from Dada via the Neue Sachlichkeit as seen on p. 120. Though Kollwitz was outside all political groups she was promoted and reproduced (as in this case) by Muenzenberg's *AIZ*.

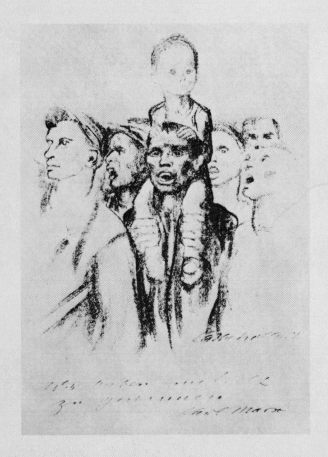

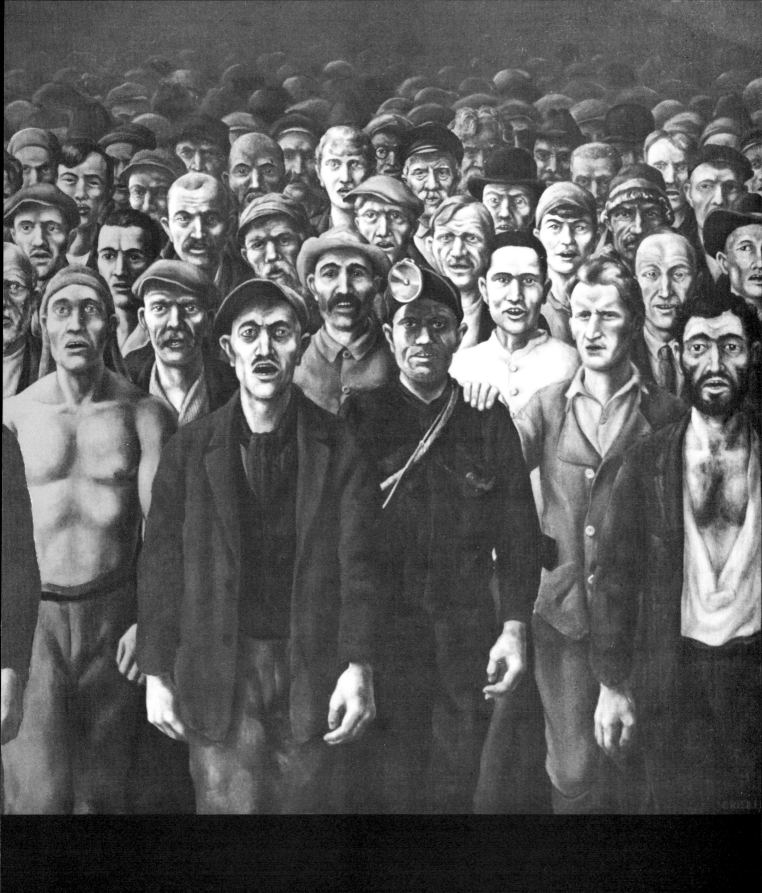

Thanks largely to Muenzenberg's sponsorship of progressive groups and magazines of all kinds, the Communists and their supporters could live almost uncontaminated by other ideologies. They had their own book-clubs (like Universum); their film clubs and (for a time) their own distribution company; their workers' sports organizations (see *right, below* at a meeting sponsored by the *AIZ*); their own press, complete with worker-photographers and worker-correspondents; their own songs and singers like Ernst Busch, seen twice (*right, above*) in a poster for a tour with Hanns Eisler (behind); and even their own radio transmissions. 'The good proletarian watch is here' says the 'Friends of the Soviet Union's' advertisement for this elegant model decorated with Soviet star, head of Lenin and hammer-and-sickle hands. *Below*, women, as now, were encouraged to learn unarmed combat, but here Muenzenberg's magazine *Weg der Frau* is telling them how to throw off Nazis, rather than mere rapists.

Opposite, 'The Camera is a Weapon' says a poster of the Arbeiter-Lichtbild-Bund in July 1930, encouraging readers to 'found working-class photo guilds'. This call however came not from Muenzenberg's communications empire but from a socialist imitation presumably aiming at independence.

TOURNEE
Busch-Eisler

DAS LIED DER ZEIT

Die gute proletarische Uhr ist da Verchromt, unzerbrechliches Glas, mit vollständiger Garantie. Zum Preise von 6.— und 6,25 RM. Auswärts-Versand per Nachnahme. Bezirks- und Stadtvertreter gesucht, (Meldungen schriftlich). Zu beziehen durch den **Bund der Freunde der Sowjetunion** Bezirkskomitee, Berlin NW7 Dorotheenstraße 77 und durch **Deutschland Uhren-Manufaktur** Berlin SW 19, Beuthstr. 74

EIN WALDFEST DER AJZ

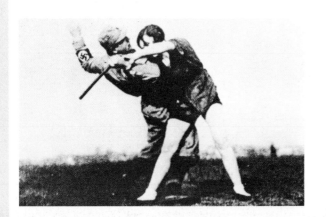

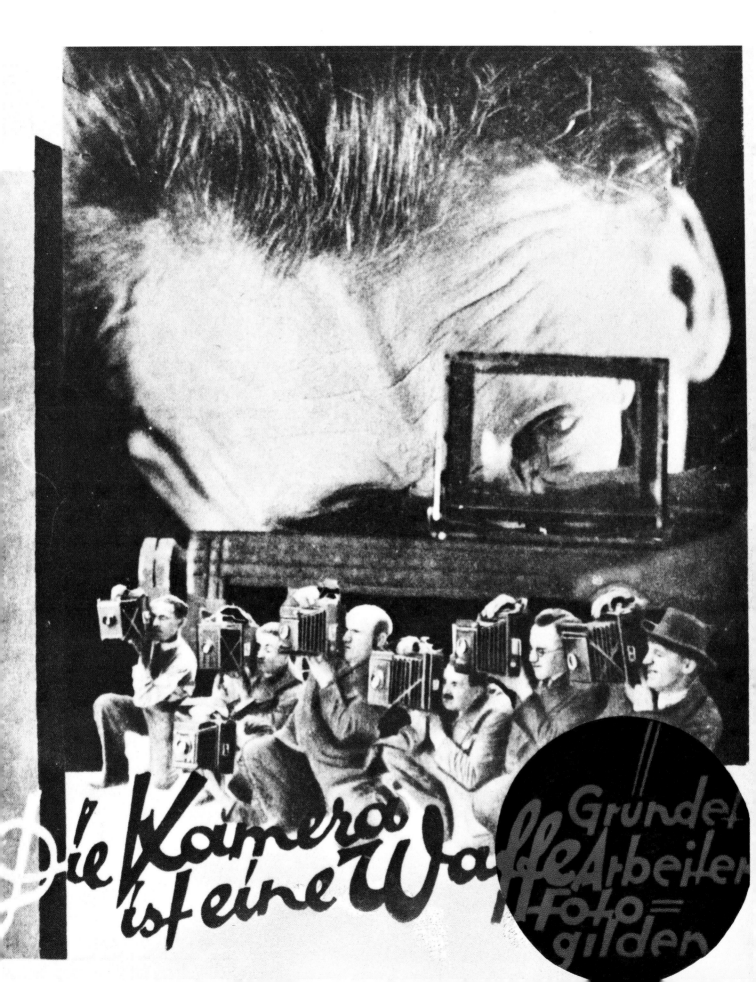

Die Kamera ist eine Waffe

Gründet Arbeiter Foto=gilden

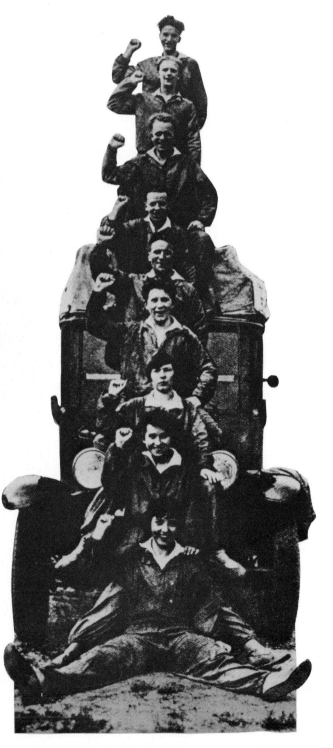

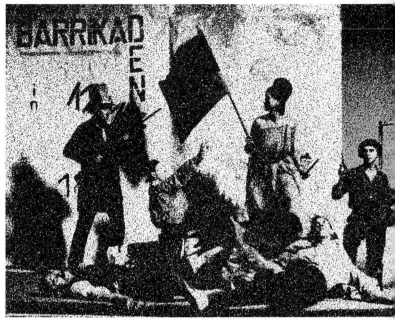

PERFORMERS WITH A PUNCH

Following the model of the Soviet 'Blue Blouses' and Piscator's early 'Red Revue' (immediately *above*) for the 1924 elections, agitprop groups like 'Proletkult Kassel' (*top*) proliferated from 1928 on. Here again Muenzenberg was influential, bringing the 'Blue Blouses' to tour Germany and sponsoring the Berlin group 'Kolonne Links' (or Column Left), here seen (*left*) forming a column and giving the Communist salute. By 1930 there were some 300 variegated groups with their own Communist-run magazine and national committee. Generally their material was simple and their manner aggressive (like the pose of the Breslau 'Drummers' group, *right*), but they were helped by gifted directors and composers (including Eisler) and their influence was apparent in plays and films, notably those of Brecht, Wangenheim and the actors' collectives.

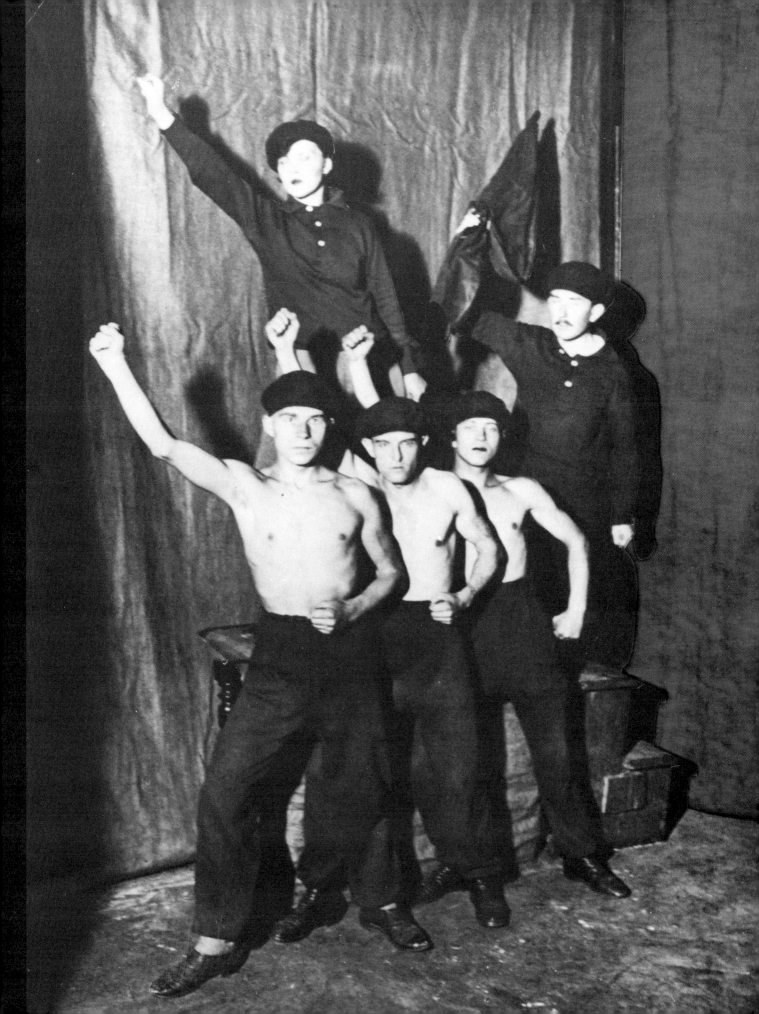

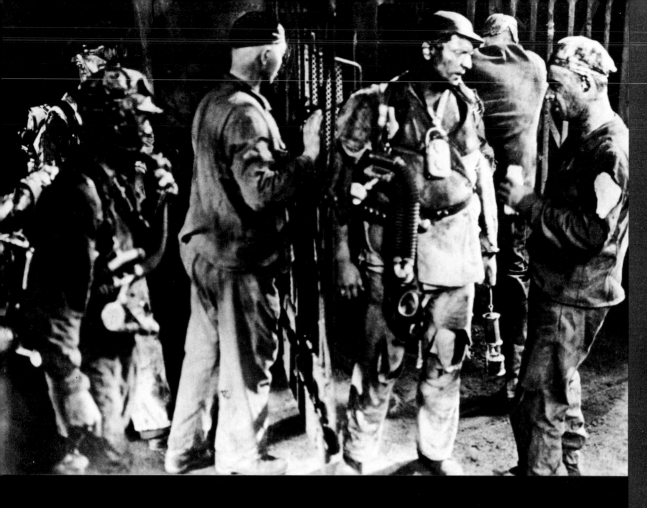

FILM LEFT AND RIGHT

Social and pacifist films flourished after the advent of sound, despite the cultural backlash. *Westfront 1918* and Lewis Milestone's *All Quiet on the Western Front* were released in 1930; Pabst's *Kameradschaft* (*opposite, above*) and Trivas's *Niemandsland* ('War is Hell') in 1931. The Brecht-Eisler-Dudow-Ottwalt cooperative film *Kuhle Wampe*, or *Whither Germany?* (*opposite, below*), a unique political film featuring the worker's sports organization and the 'Red Megaphone' agitprop group, scraped through the censorship in 1932. Muenzenberg's Prometheus firm went bankrupt early that year, but *Kuhle Wampe* continued to be shown until March 1933. At the same time, the more commercial companies were going over to fancy-dress historical romances like *The Flute Concert at Sans-souci* (about Frederick the Great) or Erik Charell's quasi-Viennese *Congress Dances* (1931), *above*. Another great success in this immediate pre-Nazi period was *Three at the Filling Station* (1930), *right*, with its blonde star Lilian Harvey and its ingratiating Hollywood-style smiles.

Hindenburg appointed Hitler Chancellor on 30 January 1933. Instantly Goering as ruler of Prussia made the SA and SS into 'auxiliary police' and a cultural purge began. Then came the burning of the Reichstag, followed by the banning and systematic mopping up of the KPD. What this did to the arts can only be hinted at. The idealized country woman, or 'Peasant Venus', painted by Sepp Hilz (*below*) with a clever mix of folksiness and eroticism, foretells the new healthy Nordic art centred on Munich. The burning of the books shown (*right*) in Heartfield's montage *Through Light to Night* took place on 10 May; Goebbels is in the foreground, the blazing Reichstag in the background and one can identify works by Remarque, Plivier, Becher, Ehrenburg, Marx and Lenin as well as Thomas Mann's *The Magic Mountain* and Hašek's *Schweik*. *Below right* is the visual counterpart, the catalogue for the Munich 'Degenerate Art' exhibition of 1937, with its poster featuring a clumsy, quasi-negroid sculpture by Otto Freundlich: such works were anathema. The old Field-Marshal on the opposite page is not known to have raised any objections. He is seen sandwiched between Hitler (then still in bourgeois dress) and the uniformed Captain (not yet Reich Marshal) Goering. It was then 21 March, the day when Hindenburg laid a wreath on Frederick the Great's tomb in Potsdam Garrison Church and declared a 'Day of the National Rising'. It was the official founding of the Third Reich.

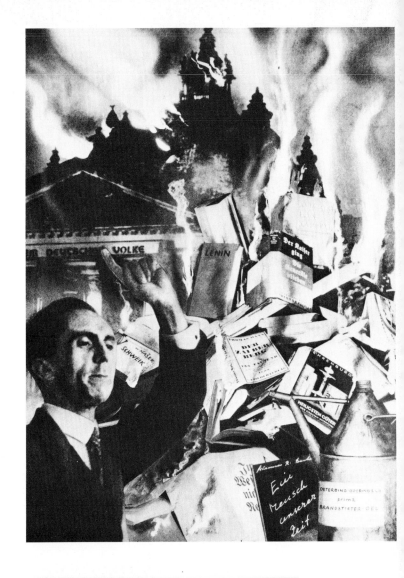

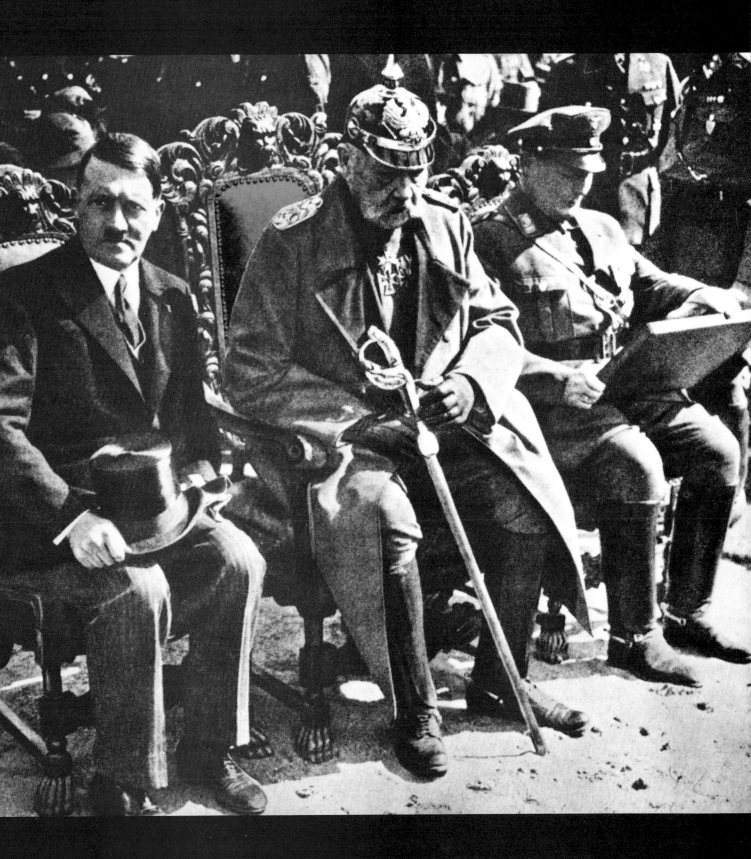

SELECTIVE INDEX of names, illustrations and credits